THE WATERCOLOR
SKIES & CLOUDS
TECHNIQUES
OF 23 *international artists*

international
artist

www.internationalartist.com

International Artist Publishing, Inc
2775 Old Highway 40
P.O. Box 1450
Verdi, Nevada 89439
Website: www.internationalartist.com

Edited by Larry Charles and Terri Dodd
Designed by Vincent Miller
Typeset by Cara Herald and Nikki Zacharatos

ISBN 1-929834-35-7

Printed in Hong Kong
First printed in hardcover 2004
08 07 06 05 04 6 5 4 3 2 1

Distributed to the trade and art markets
in North America by:
North Light Books,
an imprint of F&W Publications, Inc.
4700 East Galbraith Road
Cincinnati, OH 45236
(800) 289-0963

ATMOSPHERE SETS THE MOOD

Skies and clouds determine the atmosphere in a landscape. They also can be used to establish a mood, indicate seasonality, and give the viewer an added sense of being in the scene. An amateur meteorologist can tell what the weather was like when the artist was painting by looking at the cloud shapes and the sky color. Switching from Ultramarine Blue to Cerulean Blue in the sky can shift the temperature of the landscape, as well. Likewise, changing a cloud pattern from cirrus to cumulus telegraphs a change in weather conditions to the viewer on a subconscious level. Those decisions influence the color harmony and tones used throughout the rest of the picture.

Knowing how to represent all the different cloud patterns and sky colors gives you, the artist, added tools in creating a lifelike scene. The 23 international artists in this book show you how to accomplish these goals with step-by-step demonstrations and a gallery of possibilities.

The biggest challenge watercolorists face is how to create skies that don't look like the clouds were cotton balls attached to the paper. You will see examples of how to create more realistic edges in the chapters to follow.

Clouds have their own three-dimensional shapes and need for perspective. Learning to create the underbelly of a thundercloud with realistic shadow techniques will add to the overall mood of the whole landscape. Knowing the difference between creating a transparent cloud and a threatening cloud will help you achieve better contrasts between your skies and the foreground.

Skies, too, have gradual shifts in color from the top of the frame to the horizon. The blue becomes lighter and cooler as it nears the horizon. You will see firsthand how expert watercolorists accomplish this technique through gradated washes of surprising luminosity.

Just as there are no two identical snowflakes, every sky and cloud should be your own original observation. The more techniques you have in your creative skills, the more challenges you can take on to capture what you see before you today.

For that, we thank the generosity of our contributing artists, without whom this book would not have been possible: Arno Arrak, David Band, Sidney Cardew, Joe Cibere, Elizabeth Cochrane, Jon Crawley, Jeane Duffey, Gerald Green, Paul Jackson, Tony Lewis, Martin Lutz, Angus McEwan, Terry McKivragan, Ben Manchipp, Bruce Neville, Herman Pekel, Vivienne Pooley, Jack Reid, Xavier Swolfs, David Taylor, Lois Salmon Toole, Pierre Tougas and Manus Walsh.

Vincent Miller was responsible for the original concept and design of this book, which was compiled by a team of *International Artist* staff, including Editor/Executive Publisher, Terri Dodd, US Editor, Jennifer King, International Editor, Jeane Duffey and UK Editor, Susan Flaig.

All 23 chapters have a unique 6-page format so you can see how each international artist focuses on their personal approach to painting skies and clouds

THE ELEMENTS IN EACH 6-PAGE CHAPTER

THE 2 PAGE OPENING SPREAD IN EACH CHAPTER

Explains the artist's personal way of working and the main ideas you can use in your own art.

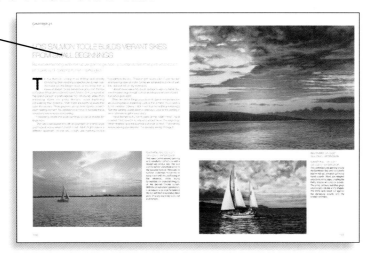

THE 2 PAGE DEMONSTRATION SPREAD IN EACH CHAPTER

A step-by-step sequence shows all the stages of development of a major painting. Full descriptive captions, plus a list of colors and materials used, turn each demonstration into an exercise you can follow.

THE 2 PAGE GALLERY SPREAD IN EACH CHAPTER

Magnificent gallery paintings reinforce the point of each chapter. Then find out a little about the artists themselves.

THE TURNING POINTS
Read the significant Turning Point moment that changed each artist's art, and even their lives.

CONTENTS

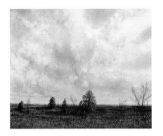
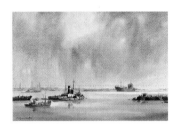
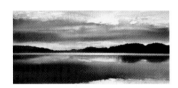
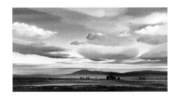
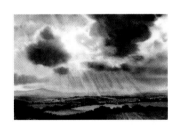
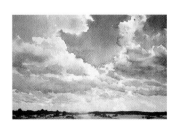
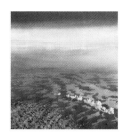
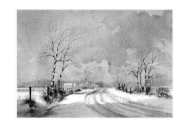

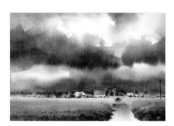
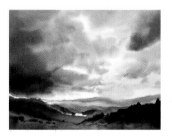
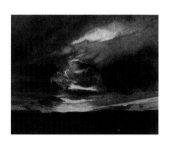

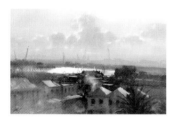
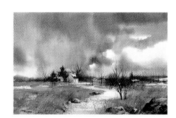
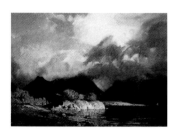

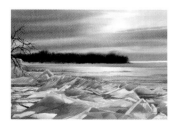

HOW DAVID BAND MANIPULATES TONE AND TEXTURE FOR IMPACT

Observation, experimentation, discovery and repetition are David Band's keys to bend-the-rules watercolors.

The noted English painter, John Constable (1776–1837), once said: "The sky is the source of Nature's light; it rules the entire landscape." A timeless and insightful observation. With just thirteen words, Constable gave us the key to understanding and appreciating the scope of the sky's influence.

As subjects, skies can make powerful, emotional statements and should not be viewed or rendered as insignificant or incidental backgrounds.

Everything you need to know about skies is right in front of you. They are unpredictable and constantly changing, unless it's a flat, cloudless sky. Painting them is an inexact art, lending itself to boundless possibilities of free expression and individuality.

Try to avoid the mindset of skies having to look a certain way to be believable. So many times, while watching the sky go through transitions, I would catch myself thinking, "Who would believe this?" or "How could I possibly capture that feeling?" That's when I knew that conventional, formula-based techniques would not be enough. I decided to take a few chances, bend the rules a little and experiment.

For the longest time I believed skies had to be "pure watercolor," meaning the technique was consistent, either wet or dry, and anything else indicated a loss of control. In the right situations, each method has its place, but, in combination, there can be spectacular results.

All things considered, the most significant breakthrough came several years ago by modifying the golden rule of light to dark during a salvage attempt. I was working on a large wet-in-wet sky, developing it gradually, when I realized the highlights were disappearing in an over-saturated mass of blending color. My standard response would be to toss it and start again, but,

ART IN THE MAKING ADDING TEXTURE FOR MORE DRAMATIC SKIES

WHAT THE ARTIST USED

Support
19½ x 19" (49x48cm)
140lb cold pressed
watercolor paper

Brushes
2", 1½", 1" Wash brushes
#10, #6, #1 Round
Liner brush

Other materials
Ordinary kitchen
sponge

Colors
Phthalo Blue
Cerulean Blue
Cadmium Yellow
Vermilion
Purple
Payne's Gray
Burnt Sienna
Yellow Ochre

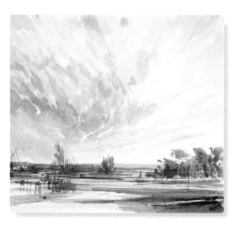

1 THE PRELIMINARY SKETCH
When I do a preliminary sketch, which is not that frequent for me, it is used to find the best size format for the finished painting. In this case, I rotated the format to a vertical 12 x 13" (30 x 33cm) composition, which was more compatible with the towering clouds.

2 PAINT IN THE SKY AREAS
Beginning with the dry technique, I use a #10 round and diluted phthalo blue to paint in the sky areas separating the clouds.

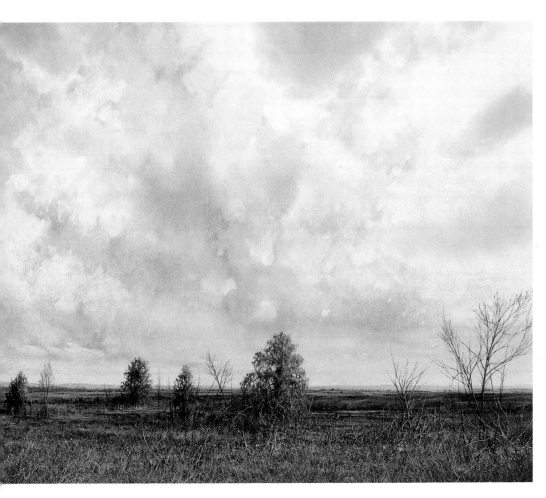

APPROACHING GUTHRIE,
15 x 18" (38 x 45cm),
WATERCOLOR

Working on a dry surface, the blue areas separating the clouds are painted in first with a #10 round and a diluted mixture of phthalo blue and cerulean blue. Next, I soften the blue edges by rubbing them gently with a sponge and clean water. Once the paper has dried, the clouds are lightly toned with a wash of greatly diluted cadmium yellow. Now, with the paper dry once again, the final color, texture and shadow are applied with a diluted mixture of purple and phthalo blue.

3 ADD TONE AND TEXTURE
Next, using a #6 round and a diluted mixture of purple and phthalo blue, I begin to add subtle tone and texture. Once this is dry, the hard edges are softened by gently wiping the surface with a sponge and clean water.

4 SOFTEN THE HARD EDGES THEN ADD SHADOW AND TEXTURE
Now, with the surface dry once again, I continue the gradual build-up of color and texture, using a #6 round and a diluted mixture of purple, phthalo blue, and a touch of Payne's gray. This is followed quickly with a sponge and clean water to soften and blend the color and hard edges.

Next, I use a 1" wash brush to apply a very weak wash of cadmium yellow over the entire surface. While the paper is still damp, I put on a diluted mixture of purple and Payne's gray to create stronger texture and shadow in the bottom half of the cloud formation.

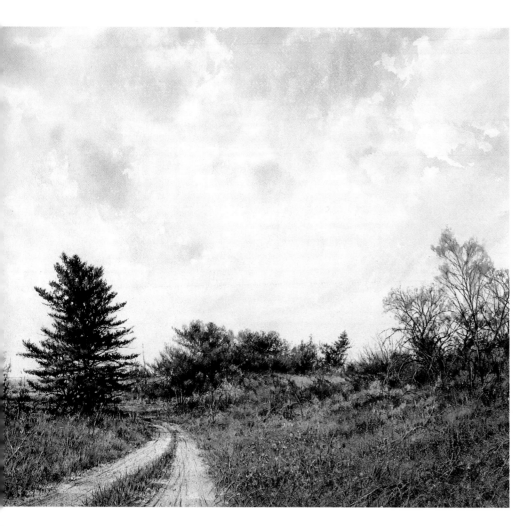

feeling there was nothing to lose, I began to work with it.

The paper was still quite wet, so I took some pale yellow and began dropping it into the dark clouds, followed by drops of clear water. As the colors began to flow and blend, unusual textures appeared along with a few surprise highlights. Realizing the possibilities, I continued until the sky was restored and the painting completed.

What began as an experiment is now a valuable tool.

ROAD TO THE SEA,
14 x 16" (36 x 40cm), WATERCOLOR
Although the technique used in this painting is wet-in-wet, the paper is dampened rather than saturated with water, so that soft edges are achieved with more control, and excessive bleeding and runs are avoided. First, I used a diluted mixture of phthalo blue and cerulean blue to paint in the sky areas and to begin defining the cloud masses. Next, I used a diluted mixture of Payne's gray and phthalo blue to create a light shadow, texture, and volume. At this point, the paper was drying, so when it had dried completely, I re-dampened the sky area by gently pressing a moist sponge into the paper and finished with a pale wash of cadmium yellow and vermillion over the bottom half of the sky.

5 INTENSIFY THE TEXTURE
Still working on a wet surface, I continue the gradual build-up of texture and color, using a #10 round and a slightly stronger mixture of purple, phthalo blue, Payne's gray and a touch of vermilion.

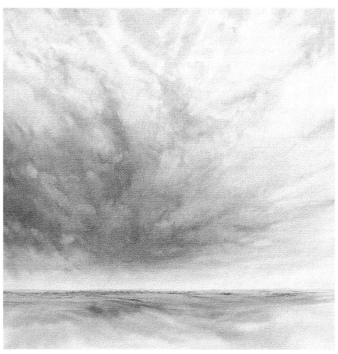

6 CREATE MOVEMENT AND ACTIVITY IN THE CLOUDS
As I continue this process, the paper begins to dry, creating a combination of soft and hard edges that provide a sense of movement and activity in the clouds. With the paper completely dry, I finish this stage with a wash of diluted cadmium yellow and vermilion over the entire sky

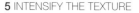

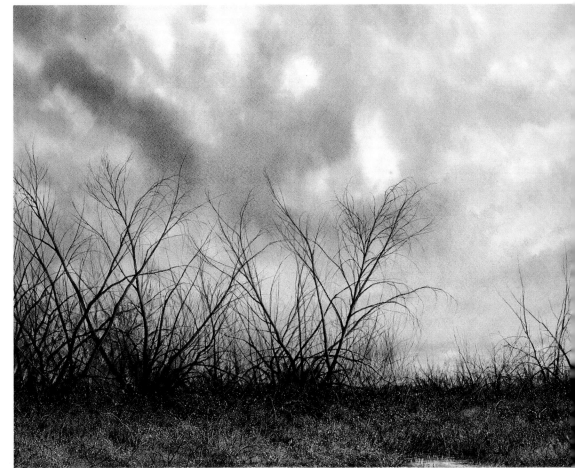

DUSK, 14 x 18" (36 x 46cm), WATERCOLOR

This is a very common scene during the winter months in north central Texas. With the spectacular sunsets, it never gets boring. Using the wet-in-wet technique, I dampened the sky area with a sponge and clean water. Next, I used a diluted mixture of cerulean blue with just a touch of cadmium yellow for the background. I followed this quickly with a diluted mixture of cadmium yellow and alizarin crimson for the basic cloud forms. Once the paper had dried, it was dampened again for a diluted application of cadmium yellow. Finally, using a mixture of alizarin crimson and Payne's gray, I reinforced the clouds with deeper color and texture.

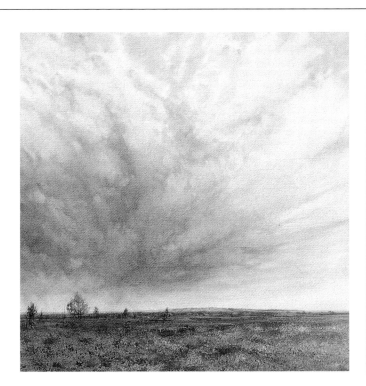

7 BEGIN THE LANDSCAPE

With the sky complete, I use a mixture of cadmium yellow, phthalo blue and yellow ochre to begin the landscape and establish the horizon.

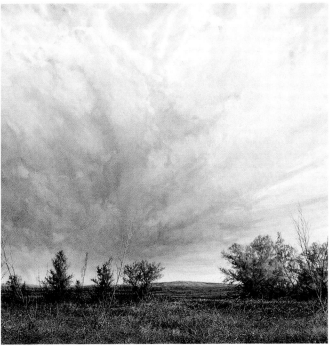

8 MATCH THE DRAMA BETWEEN THE SKY AND THE LANDSCAPE

Feeling that the activity and drama in this sky requires a landscape with compatible energy, I abandoned the soft rolling contours of the plains for a more energized, textured and detailed landscape, one that would be more suitable for the dramatic lighting this sky would produce.

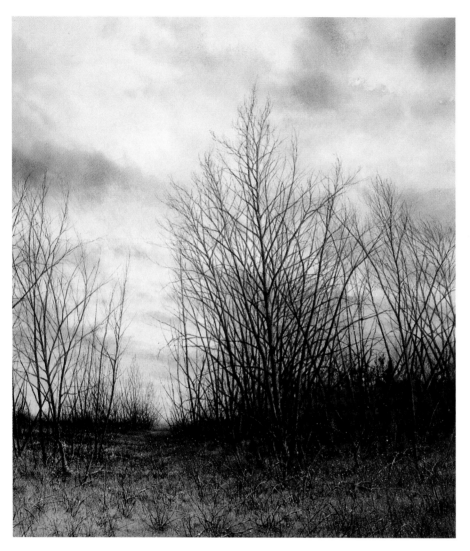

DECEMBER IDYLL, 14 x 12" (36 x 30cm), WATERCOLOR
Here I combined both dry and wet techniques. First, on a dry surface, I brushed on a diluted mixture of phthalo blue, cerulean blue and cadmium yellow for the background sky areas. When these areas had dried completely, I dampened the entire surface with a sponge and clean water to soften the edges of the sky areas. Once again, the paper was allowed to dry completely before the clouds were started. The clouds were dampened and a diluted application of cadmium yellow was dropped in, followed quickly with a diluted mixture of vermilion and mauve for additional color, texture and interest.

TURNING POINT

Early in my career, I had the good fortune to be represented by a gallery in Lubbock, Texas, whose owner and staff were as passionate about art as the artists themselves. I was spoiled by the rare combination of modest commissions, impeccable ethics, unquestioned support and genuine concern for their artists' well-being, both personally and professionally. The professional association ended with the owner's retirement, but the friendships remain. I believe that all good fortune I've experienced as an artist — or hope to have in the future — can be traced directly to this priceless and formative association.

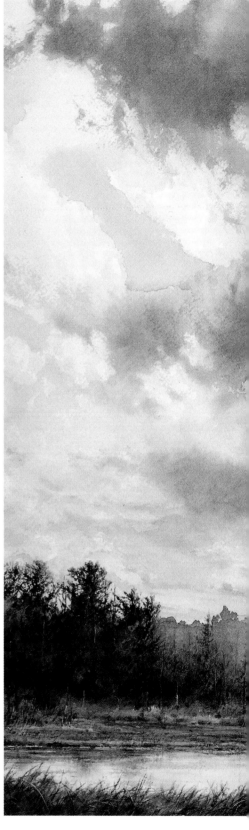

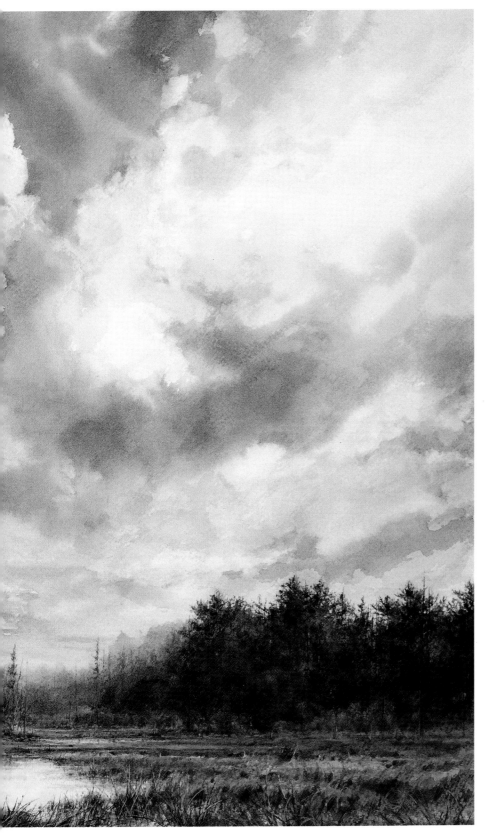

ABOUT THE ARTIST

David M. Band, a native of Portland, Maine, now lives in Texas. He has devoted the majority of his life and talents to art as a painter, printmaker, educator and collector.

David is a member of the Allied Artists of America, the National Watercolor Society (signature member), the National Arts Club (exhibiting artist member), the Watercolor USA Honor Society, the Salmagundi Club, Audubon Artists, Inc., and the Artist's Fellowship.

His work can be found in the collections of the Butler Institute of American Art, the Davis Museum and Cultural Center, Wellesley College Museum of Texas Tech University, the United States Air Force Collection, and the Dunnegan Gallery of Fine Art.

He is the author of *Enrich Your Paintings with Texture.*

He exhibits regularly at the Cole Pratt Gallery in New Orleans.

STORM CLOUDS PASSING,
14 x 13" (36 x 33cm), WATERCOLOR

SIDNEY CARDEW SHARES HIS SECRETS FOR

Creating an atmospheric impression of the sky allows for more spontaneity in fast-changing weather conditions.

In England we can always rely on having ever-changing atmospheric skies from which I find the inspiration for my paintings. As a marine artist, I find painting outdoors and using the rapid and flowing quality of watercolor gives me the opportunity to create an atmospheric impression of the sky, rather than a precise representation.

I start a painting by lightly sketching in the main subject, creating a focal point after considering the light source. I leave the sky area to be developed when painting.

I then proceed to paint the whole sky area wet-in-wet with color, sometimes strengthening or lightening the wash, but keeping the paper wet. I then float in other washes to create sky color and cloud effects, which may require adding further color mixes to get the density and atmosphere required.

I usually complete the sky in one wash and then paint any water areas using the same color and effects as the sky.

The foreshore and any other subject matter are then painted, again using the wet-in-wet method, and then left to dry.

All the finishing touches then are added: people, rigging on boats, clutter on the shore, birds in the sky. These are only a few I consider since the list can be endless.

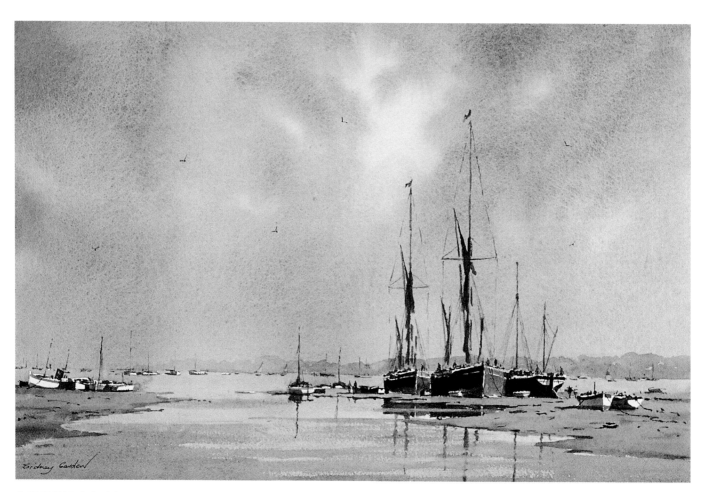

GATHERING CLOUDS, PIN MILL, 15 x 22" (38 x 56cm), WATERCOLOR

SPONTANEOUS SKY WATERCOLORS

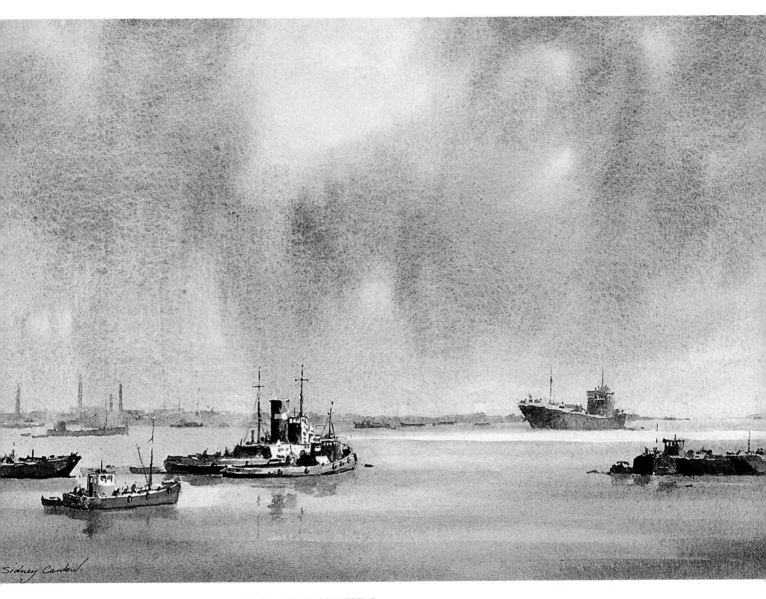

MOORINGS AT GRAVESEND,
15 x 22" (38 x 56cm), WATERCOLOR
This painting is typical of the Thames estuary.
One minute the sky was full of subtle color and then
the next moment, misty clouds floating in pour off
the water. I created this watercolor effect by letting
the washes flow independently.

WHAT THE ARTIST USED

Support

Saunders Waterford, Whatman and Arches cold-pressed
("not") watercolor paper; 200, 300 or 400lb. paper,
depending on the size of the painting.

Support boards to take 7 x 11" (18 x 28cm),
11 x 15" (28 x 38cm), 15 x 22" (38 x 56cm) and
22 x 30" (56 x 76cm) papers, which are secured by
masking tape. Papers are not stretched.

Brushes

Mop brushes
#4, #6, #8 Round brushes

Colours

Raw Sienna
Burnt Umber
Bright Red
Alizarin Crimson
Cerulean Blue
Ultramarine Blue
Burnt Sienna
Winsor Blue (Red Tint)
Winsor Yellow
Indian Yellow
Raw Umber
Winsor Emerald
Winsor Blue (Green Tint)
Magenta
Olive Green

Other materials

Plastic water holder and bottles
Paper towels or tissue
Lightweight tubular sketching easel
Paint box handmade by Craig Young

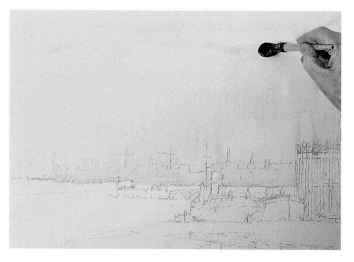

1 BEGIN WITH A LIGHT WASH
I start with a light sketch in pencil. Keeping the paper damp all the time,
my first light wash of raw umber covers the whole paper. ▶

4 CREATE A TONAL EFFECT
Distant sky areas then need a wash of ultramarine blue and alizarin crimson
to create a tonal effect. This can be carried down into the foreground water.
I then carry on with a reverse of the sky colors.

2 START THE SECOND SKY WASH
A further wash is added as I watch to ensure there are no areas that have dried. Otherwise, they can cause nasty "blooms," which can ruin the sky. I use raw sienna and add a small amount of alizarin crimson into the wash now and again to make it interesting.

3 DEVELOP THE BLUE SKY WITH A WASH
With the paper still wet, I introduce Winsor blue with a touch of ultramarine blue for a blue sky and ultramarine blue and burnt umber for the cloud area. As long as the paper is wet, further colors can be added for additional effects. Moving the board can also create some unusual cloud features.

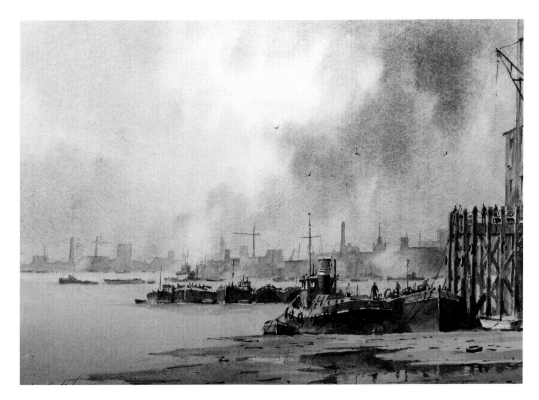

5 DEVELOP THE BOATS AND REFLECTIONS
Further washes are introduced to strengthen the cloud cover while the paper is still wet. Then the foreground is painted to introduce lights and darks into the boats and jetty area and among the reflections on the shore. Other distant boats and buildings are introduced to give a tonal effect.

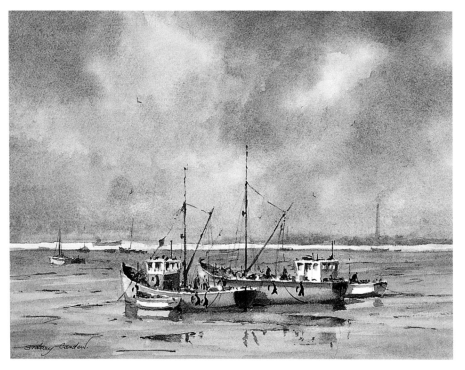

LOW TIDE AT LEIGH, 11 x 15" (28 x 38cm), WATERCOLOR
A very low landscape gives a wonderful sky effect, broken only by the distant landscape and the fishing boats waiting for the tide.

DO'S AND DON'TS

- Find a subject or place that gives you inspiration.

- If possible, work on site from nature.

- Use an easel with your board tilted 15 to 20 degrees from horizontal.

- When painting atmospheric cloud effects, your board can be tilted by hand to allow the watercolor to flow.

- Ultramarine blue, burnt umber, Venetian red, and raw umber are colors which, when mixed, give a granulation effect that is ideal for clouds.

- Always use top-grade artist's colors.

- Mix colors to suit an overall effect.

- Ensure sufficient quantity is mixed to cover the whole sky area.

- For better density, add sufficient pigment to a true value watercolor wash. Color will be lighter after it dries on the paper. Any wash meeting an almost-dry area can cause ugly "blooms," which can ruin a sky.

- When confronting errors, revise small areas by scrubbing carefully with a hard-bristled oil painting brush to remove the watercolor.

- I never use black, white or masking fluid or body color.

TURNING POINT

The initial inspiration when I started to paint came from my first tutor, Tom White, who taught me to see, a very important factor for any artist. It allows one to look for subtle tones and colors, the play of light and shadow, and the distant grays.

My second tutor, John Snelling, was a watercolorist who gave me the inspiration for atmospheric skies with his very fluid and fascinating use of color.

While developing watercolor techniques from these sources and finding inspiration from viewing the paintings of Edward Seago, John Singer Sargent, and Russell Flint (to name a few), I came upon what was to be a turning point in my career.

On a painting weekend I met two professional artists, Trevor Chamberlain and Peter Gilman. They invited me to paint with them and a group of 25 artists known as The Wapping Group of Artists (founded in 1946). They meet once every week along the Thames or other estuaries to paint and enjoy a social drink.

I was very pleased to be accepted as a member. This gave me a wonderful chance to paint with people with the same desire and to further my career.

It also culminated with my exhibiting with the Royal Society of Marine Artists and ultimately becoming a member.

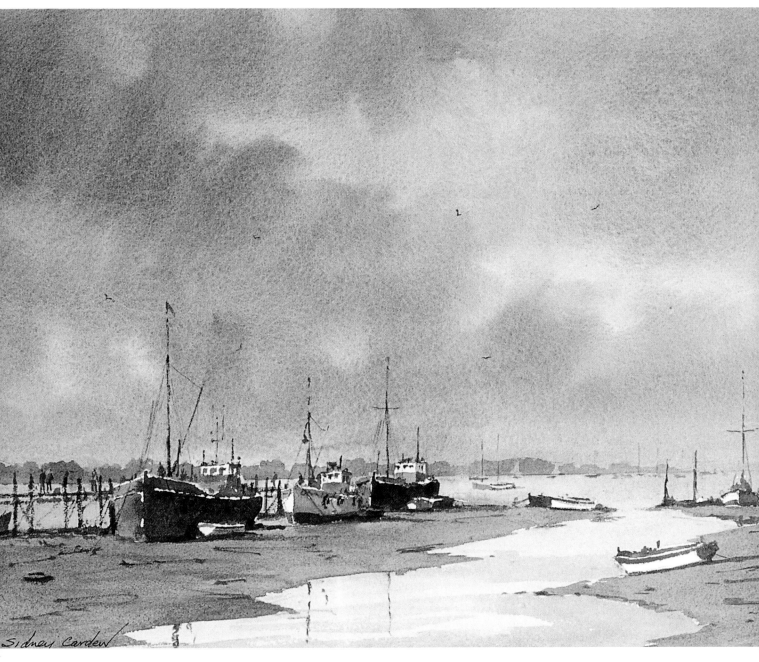

GREY DAY ON THE BACKWATER, 11 x 15" (28 x 38cm), WATERCOLOR
I painted this scene on a typical English cloudy day when the sky very rarely had any brightness, but I made the most of the little I had. Emphasizing the cloud cover gave it a very stormy effect.

ABOUT THE ARTIST

Sidney Cardew was born in London, England, and started painting in 1970 after working as a design engineer for Ford Motor Co.

Working in oils and watercolors, he found that living by the East Coast drew him towards the sight of boats moored on the estuaries with reflections and atmospheric skies.

He became well-known for his marine watercolors and established himself at various galleries in England and abroad. He exhibits his work in the R.I., R.W.S. and R.S.M.A. exhibitions in the Mall Gallery, London, and at the Mystic Gallery in America.

He is a member of the Royal Society of Marine Artists, the Wapping Group of Artists, The London Sketch Club, The Chelsea Art Club and Essex Art Club. He also undertakes private and company commissions.

As an artist, he believes in creating a painting that will give the viewer as much pleasure as he had in painting it.

JOE CIBERE FINDS PAINTING SKIES IS RISK TAKING

Learning to paint skies can teach you how to paint watercolors, Joe Cibere believes. He proves you can't take all the credit when you paint skies in watercolor.

Skies are the perfect subject matter for learning how to paint watercolors. You've probably heard that watercolor is a difficult medium, but I disagree. I think it's one of the easiest because you only have to do part of the painting. You have a painting partner if you just let it have its turn.

I'm always amazed at how interesting and surprising the results are. Every painting you start is not going to be a masterpiece, so get over it and move on. It takes practice and that practice promotes confidence.

Getting over the intimidation that leads to actually putting paint on paper and the creative constipation that soon follows is not that hard. The idea is to have fun expressing ourselves.

The biggest reason people have trouble with watercolor is that they try to do too much. Having said that, one must also understand that drawing is a given and design is

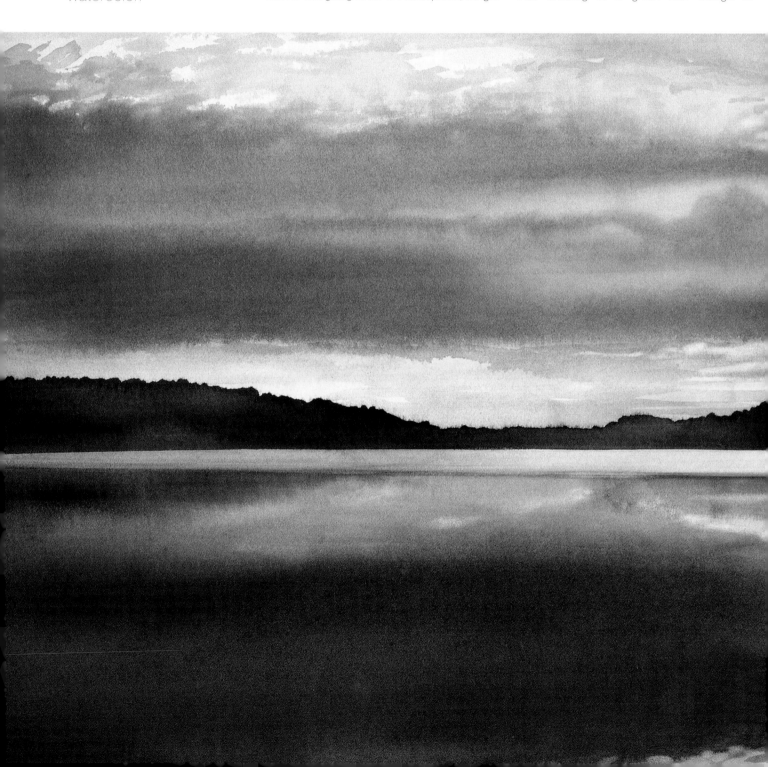

2-3 MINUTES AT A TIME

everything. No medium will make up for a lack of these basics. Skies give you tons of flexibility and will teach you how watercolor reacts to wet-in-wet, wet-in-damp, dry-in-wet, wet-on-dry, and so on. The process will also teach you tonal value.

First, choose the size of your paper. Smaller is better because there just isn't enough time to put paint down fast enough when the light is changing. Use a pad, or block, or watercolor board, but not stretched paper when you're starting out. After you've spent all that time stretching paper, it's hard to be free, because you won't want to mess it up.

Second, use bigger brushes. They will eliminate the fussy overpainting that we know and loathe.

Remember: Only two to three minutes at a time is all you should spend painting a sky. Otherwise, it's not fresh and you didn't give your partner – watercolor – a chance to paint, too.

FIRST LIGHT AT DEER LAKE, 42¼ x 18½" (107 x 47cm), WATERCOLOR
This is one of my earlier paintings, bit still reflects my philosophy of "less is more." Design is everything. Although freely painted, it has a realistic quality because of the reduction in image size and the illusion that watercolor creates. I did use a large brush for almost everything and painted it very quickly, even with the larger paper size. No pastel was used because I wanted a quiet sky for that time of day and this made for a simpler rendering.

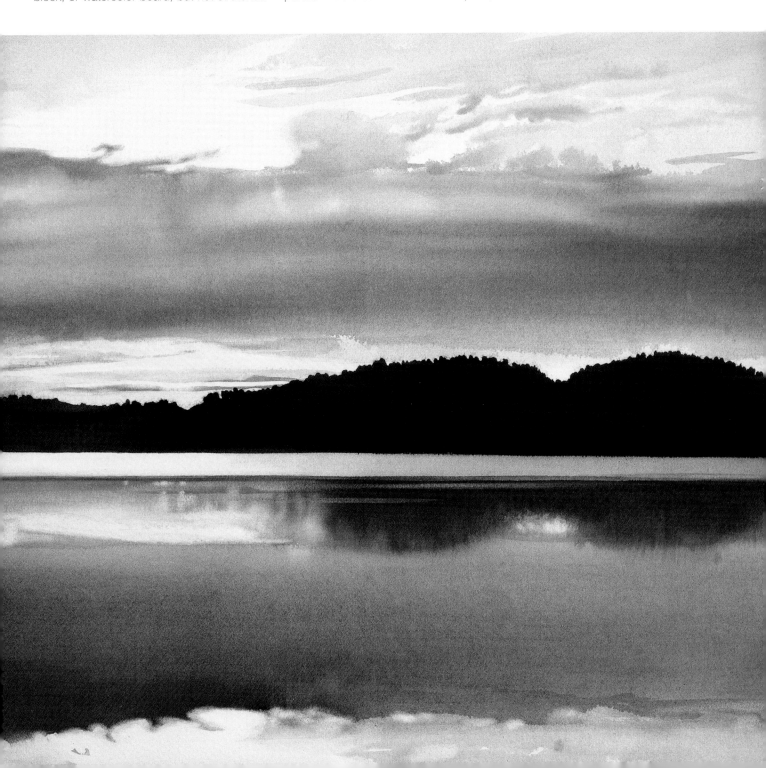

I usually do not start with a pencil for skies. I have a general idea what I want to accomplish.

Skies and watercolors have a mind of their own and lots of great things happen if you let them. I start working on wet paper, painting wet-in-wet.

Depending on what I'm trying to paint, I'll let this dry and glaze over it or re-wet it and add softer shapes. Or leave it alone.

The pastel is painted on completely dry paper, if at all.

The secret is using bigger brushes or smaller paper. This means less detail, letting the watercolor paint itself, especially with skies, when there is much less time to apply paint. Put it down and leave it alone. The biggest cause for failure is trying to do too much.

WHAT THE ARTIST USED

Support
20 x 14" (51 x 36cm) d'Arches
140lb cold press watercolor block

Brushes
2" Flat, 1.5" Oval, #14 Round

Other Materials
Spray bottle
Small towel
Gray masking fluid
Pastels
Hard and soft pastel pencils
Butcher tray

Colors

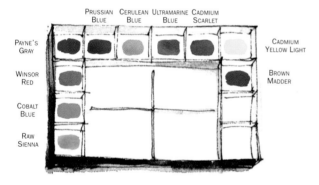

	PRUSSIAN BLUE	CERULEAN BLUE	ULTRAMARINE BLUE	CADMIUM SCARLET	
PAYNE'S GRAY					CADMIUM YELLOW LIGHT
WINSOR RED					BROWN MADDER
COBALT BLUE					
RAW SIENNA					

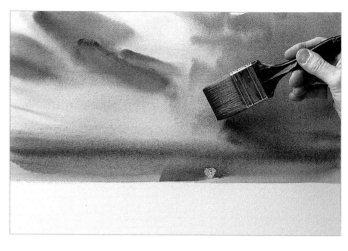

1 APPLY THE FIRST WASH, THEN INTENSIFY THE COLORS
I put a little mask over the sun and then applied the first wash with a 2" flat brush to wet the paper and give it a slight tone, usually raw sienna. I immediately started applying color by using more paint and less water. This takes no more than one to two minutes. Then I let the watercolor paint itself. I keep stressing that less is more. In this case, less time applying paint means more freshness. Do not go back into the first wash to "make it better."

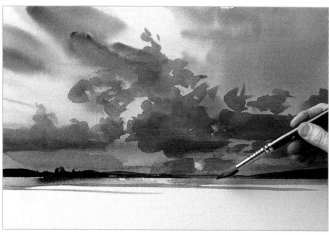

4 DROP IN THE HORIZON
Next, the horizon was added and the sky just lit up. In this painting, the foreground is very simple so as not to take away from the sky and also to create contrast. Then I paint the water with the large flat brush.

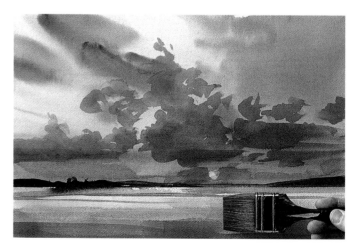

5 DRY-BRUSH THE SEA WATER
Water was added with a dry brush pulled across the paper to make the sea look like it's windswept. Keep this simple in value and detail.

THESE TECHNIQUES

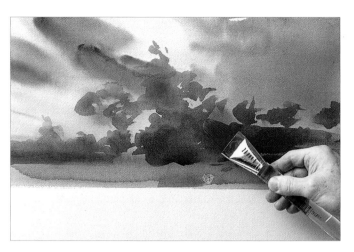

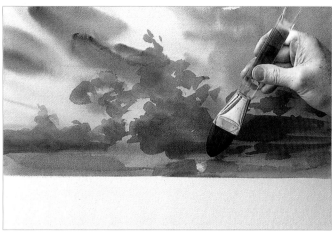

2 BRUSH ON THIN GLAZES
After the first wash dries, I go over it with thin glazes, blocking in some shapes. I use the oval brush and thin paint at this point. Be confident when you do this. Plan ahead and put it down quickly. Then leave it alone.

3 ADD THE SUN'S LIGHT
I took the mask off the sun and then added color to brighten the light source. This also included the reflected light on the surrounding clouds.

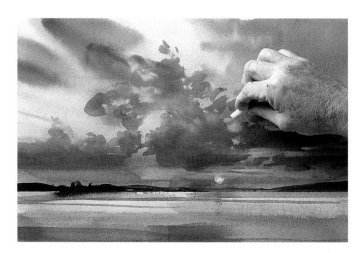

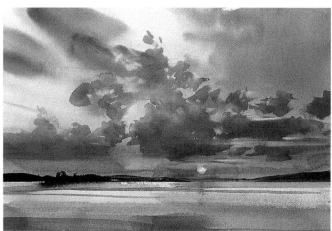

6 USE PASTEL FOR THE FINAL DETAILS
The final touches were added with pastel to light up parts of the sky and to refine some of the shapes. The pastel option at the end gives you the freedom and courage to paint confidently right from the start.

7 THE FINISHED PAINTING

A CONFESSION TO MAKE

The finished "Florida" painting was pretty much what I had in mind, but I have to admit that this is the second one I started. I overworked the first one and didn't give the watercolor a chance to paint. You can tell this right away, so just say no and start a new one. It's only paper. It's so much better if you give the medium its turn because good things will happen that will amaze you.

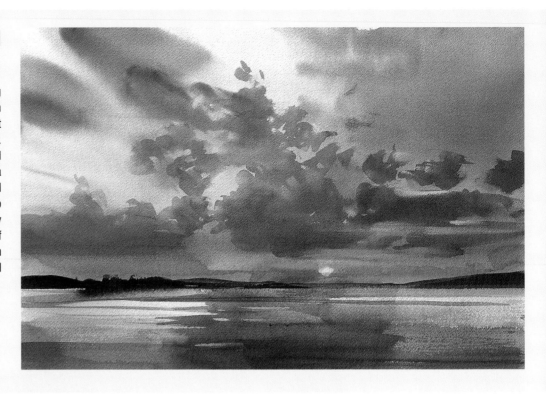

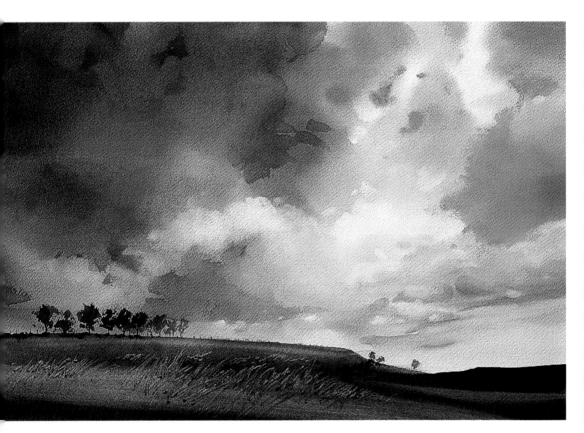

MONTANA, 20 x 14" (50 x 36cm), WATERCOLOR AND PASTEL
After I laid down the initial wash, I used a tissue to blot out some of the wet paint to give the illusion of clouds, although I rarely use this technique because it's not as fresh looking as I would like. I use a spray bottle when re-wetting the paper so that I don't have to touch the paper when I want to soften edges. The foreground horizon gave me the value contrast to light up the sky.

LESSONS I'VE LEARNED...

- Skies are important because they set the mood and usually are the main light source.

- Skies are the perfect subject to paint when learning watercolor and how it acts and reacts.

- Skies don't have a specific symbol to be compared to.

- Risk-taking has its rewards. You're just experimenting.

- A 2-3 minute time limit helps keep your painting fresh. It's only a piece of paper.

- Using pastel, if needed, over watercolor to finish the painting will give you confidence at the start.

COLORADO SKY,
20 x 14" (50 x 36cm),
WATERCOLOR AND PASTEL
This is one of those paintings I like to use as a teaching exercise. The emphasis is on strong design and simple icons. There are no large classic symbols to get into the way. You can create an image that becomes almost an abstract. It's great fun and easy to do if you keep the values and perspective right.

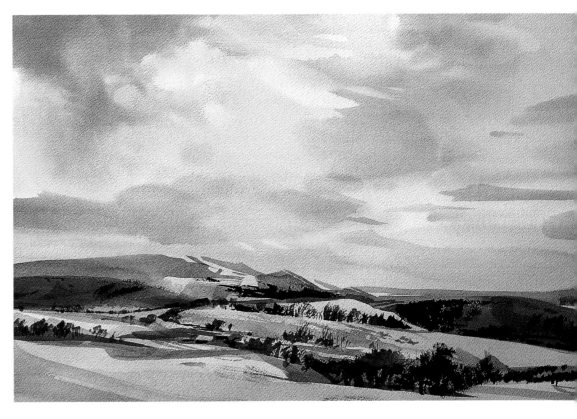

TURNING POINT

I've had several turning points, but the one that stands out started with the cover on a major art magazine. I couldn't figure out how it was done.

I had been a commercial illustrator/designer for over 25 years at that point. I thought I knew all the tricks, secrets and shortcuts for painting an image. I had used gouache and acrylic paints because of my short deadlines. I had never worked in transparent watercolor.

The artist who painted that wonderful image was Nita Engle. I had to take one of her workshops.

I ended up attending three and one of them was in Michigan, very close to her home on Lake Superior. She is a great instructor and communicator. I soon learned how she used her techniques, most of which she invented to make a watercolor paint itself.

In the beginning, I wanted to paint like her so I could learn how she did it. It took a while to develop my own style of expression. Drawing is a given and design is everything, I learned.

ABOUT THE ARTIST

Joe Cibere has spent the past 35 years as a commercial artist, art director, and painter. He has been making the transition from advertising art to the fine art arena his whole life.

He has painted in several mediums, but the one of choice for him is watercolor. His background in the commercial arena has been very beneficial because of the discipline required.

His love of nature and the wilderness is telling in his work. He calls his style representational with a sense of illusion.

Watercolor lets him do that because "it paints itself," he says. "The challenge is to know when to stop and let the medium take over. That's why the most successful paintings seem almost effortless." He is currently represented by Granite Mountain Galleries in Prescott, Arizona. His work is included in corporate and private collections. He has been featured in magazines and has taught several workshops on watercolor technique.

His Web site is www.joecibere.com

ARNO ARRAK SHOWS HOW TO CREATE A WATER

Applying the monotype process to watercolor skies and clouds creates
a feeling of spontaneity and freedom.

I have been using and developing this technique since 1992. I call it *watercolor monotype*. A sky reflects a sense of freedom, and when painting, I am totally spontaneous and have a hard time planning my clouds in advance. They are like thoughts, in constant flow and change. The wet-in-wet method also does not allow much time for planning, so this technique involves a relatively short burst of high concentration.

In my painting, I use a serigraphic screen and pure water-pigments. Although it is a technical method with somewhat unpredictable results, it allows me to achieve blends and a rich smoothness that are unique to this technique.

My advice to the beginner is to start from the top, since the water will flow down and the top will dry sooner.

Use thinner paint for blends and thicker paste-like pigments to hold finer details.

You can lift off pigment from the screen completely by blotting with a paper towel.

Finally, always put the paper underneath the screen when transferring. This seems obvious, but it has happened to me more than once. In the excitement of anticipation, my print has ended up decorating the surface of my printing table.

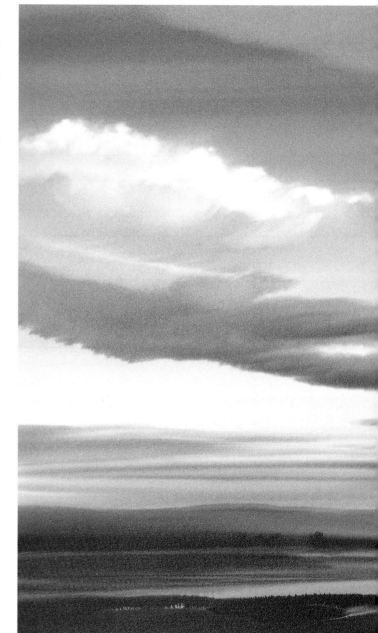

TURNING POINT

While working as a master printer at the Toronto Open Studio, I met Alan Flint. A great print master and artist, Alan has always had a leading edge on innovative and experimental printing techniques. Working with him has had an inspiring influence on my path as an artist and printmaker. I was inspired by the technique that we explored together – creating something so soft in surface while still achieving a hard edge. It created a lot of challenges for me that I liked to tackle as a printmaker. It showed me the possibilities for taking it further and experimenting with my own landscapes and skies. A Toronto-based international art dealer noticed me and took my work to the New York Art Expo. The turning point came after his return. He had sold all my pieces and was asking for more. Since then, I have been professionally painting full time.

COLOR MONOTYPE

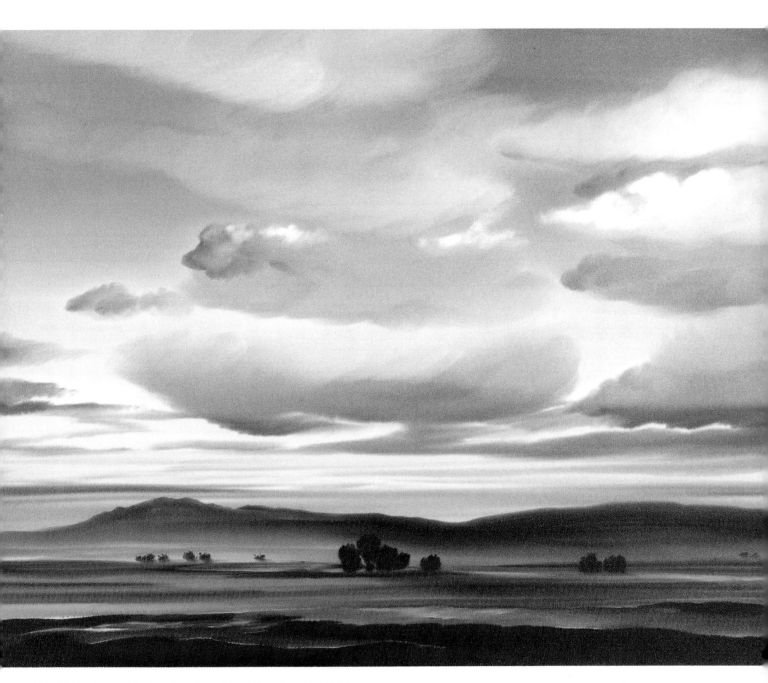

AUTUMN CLOUDS, 19 x 36" (48 x 91cm), WATERCOLOR MONOTYPE

1 PREPARE THE SCREEN
Before starting the painting, I prepare a serigraphic screen. I block off everything except the area for the painting. The "window" will be the work area.

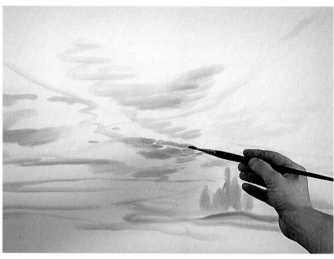

2 BALANCE AND CONTROL ARE KEY
The painting is done wet-in-wet. The critical point here is to balance the amount of water that the screen can hold before water starts running. This technique requires constant control over the water and relatively fast working in order to capture the overall softness and to control the edges uniformly. In a matter of minutes, the water evaporates, so I pay particular attention to controlling the amount of water and pigment in the brush throughout the painting stages.

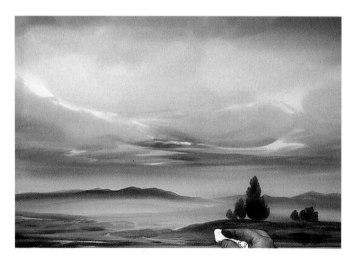

5 LIFT OFF EXCESS PIGMENT
In some areas, where pigment is concentrated too heavily, I lift off the color with a paper towel. Sometimes I also use my finger to blend colors on the screen.

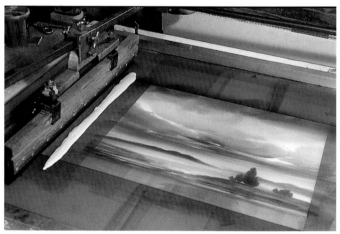

6 TRANSFER THE IMAGE TO THE PAPER
In this stage, the screen is mounted on the print table. Using clear screen-printing base, the image is transferred to the paper underneath. Most of the pigment is transferred to the paper, so only one transfer can be achieved.

TECHNIQUES WITH THE TOOLS OF PRINTMAKING

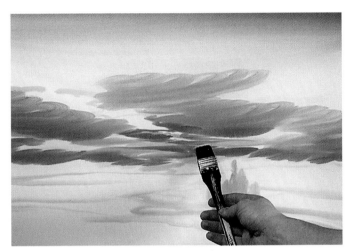

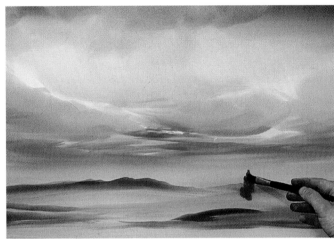

3 & 4 CONCENTRATE ON THE SKY FIRST

In all my paintings I start with the sky. First, I apply the main areas of interest points and start creating the mood from there. In my landscapes, I use trees to balance the sky and to achieve a greater sense of perspective and grounding.

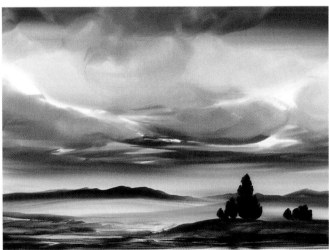

7 REVEAL THE WATERCOLOR MONOTYPE

There is always an element of surprise when I lift the screen and see the original on the paper for the first time. This is the final stage that will decide if the piece is a "keeper." After printing, the screen should be washed off with a power spray to prevent a ghost image from remaining on the screen.

8 THE FINISHED WORK

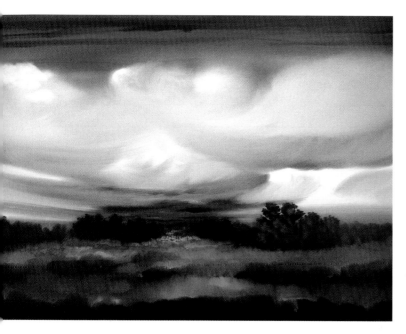

IN THE SOLITUDE, 24 x 36" (61 x 91cm), WATERCOLOR MONOTYPE
This painting was inspired by an empowering dream. In the process of painting, I replaced the ocean with the foreground you see here.

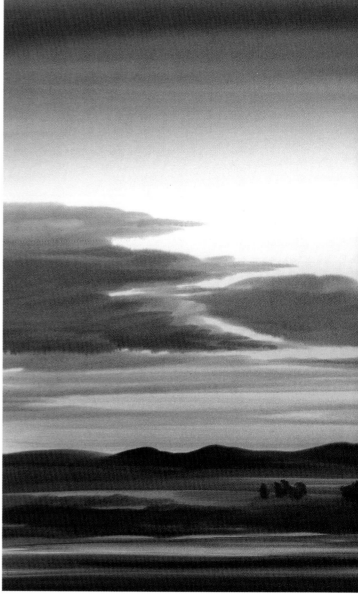

STILL WATERS, 19 x 36" (48 x 91cm), WATERCOLOR MONOTYPE
This is a space for healing, contemplation, and spaciousness. It was painted in a very relaxed mood, after I had been quietly contemplating on the peacefulness of the universe.

HOW TO AVOID THE PITFALLS

Creating watercolor monotypes presents a number of challenges. First, you need to know serigraphy printmaking and have professional-quality printmaking equipment in your studio. I was a master printmaker for a number of years before starting with this technique.

The wet-in-wet method is more difficult to work on screen than on the paper. You have to control the entire painting area at once, moving quickly and constantly re-wetting the screen while controlling the amount of pigment in your brush. A screen does not bounce light in the same way that paper does, and consequently, the image does not appear nearly as intense on the screen as it will

after transferring to the paper. What you see on the screen is like a "ghost image" of what it will become. I consider this to be the most challenging aspect about this painting technique. It takes a while to learn the guesswork.

Lighting can be a problem since it glares off the wet screen and makes it even more difficult to accurately see the color with which you are working.

It is important to work in a clean environment. The wet screen is highly susceptible to attracting debris and dust particles, which will cling to the screen and change the flow of water, not allowing the pigment to flow evenly.

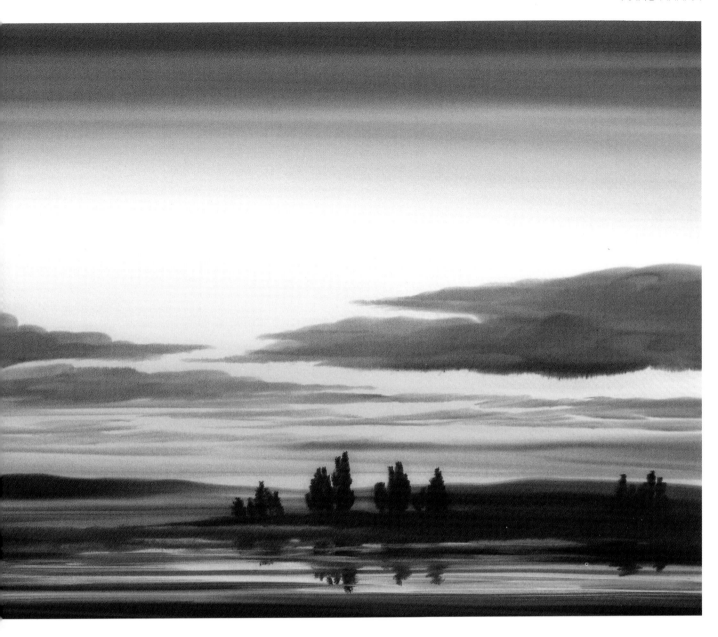

ABOUT THE ARTIST

Arno Arrak was born in 1963 in Tallinn, Estonia, into an artistic family. His father, Juri Arrak, is one of Estonia's most prominent artists, with work in the collections of major museums and galleries throughout Europe and the United States. His mother is a watercolor artist and a leather-craft designer.

Arno's early training in his father's studio first gave him a fundamental base in color and form. He attended the Art University of Estonia, later supplementing his education in St. Petersburg, Russia, and Stockholm, Sweden.

In his early twenties, Arno made several journeys into the mountains of Southern Siberia in search of ancient spiritual traditions. This was where he first experienced the empowering spirit and purity of nature that is so strongly present in his work.

Resisting the oppression of human rights and spiritual freedom of the Soviet occupation in Estonia, Arno escaped to Sweden in 1989. After two years in Stockholm, he relocated to Toronto, Canada. He presently lives in Oregon and makes frequent trips from the United States back to Estonia.

Since 1992, he has been painting the original watercolor monotypes that have attracted widespread international interest among printmakers and art collectors. His work is represented in numerous galleries and in private and public collections worldwide.

ELIZABETH COCHRANE'S CONFIDENCE-BUILDING

Progressive practice steps are the secret for mastering the more difficult sky subjects.

R elax and go with the flow. This is easier said than done. The best watercolor skies always look effortless, but are probably a result of lots of practice. I am always more relaxed when I know my equipment and how to use it. I got to know my colors by starting with a limited palette.

I found a specific paper that works for me. I use Bockingford 140lb watercolor paper. It is durable and the paint lifts off easily, even when it has dried. I also use Saunders Waterford 300lb, which soaks up the color more, but is good for subtle layers and distances. I buy my paper in bulk to save money, but it also makes me less precious about using it.

I can always use failed paintings to practice glazes, sponging out, and so forth. I often continue in acrylics on top of a watercolor painting that I didn't like.

I use good quality brushes and paints. It's worth it. Many beginners in watercolor give up after becoming frustrated with floppy brushes, crinkly paper or poor quality colors.

I practiced many color studies in front of real skies and didn't worry about them, because they were not going to be finished paintings. Before I start, I look hard at what I am painting to analyze the colors and to mix enough of them so that I am prepared.

By learning to do basic washes, tipping the paper to get nice gradations of color, I was able to do my own control experiments and learn from my experiences about the various effects of paint on wet paper.

I do not work to the same formulas every time I paint a sky. Every time I begin to paint, I am working with a spontaneous moving abstract. There are some general characteristics: The blue at the top of the sky is always more intense than at the bottom; the clouds have a sense of perspective similar to the landscape, but upside down.

I started with more simple skies and worked my way up to the more dramatic ones. Beginners can often be too ambitious when choosing a subject. The more paintings I have done, the more confidence I have gained and the more relaxed I am when working today.

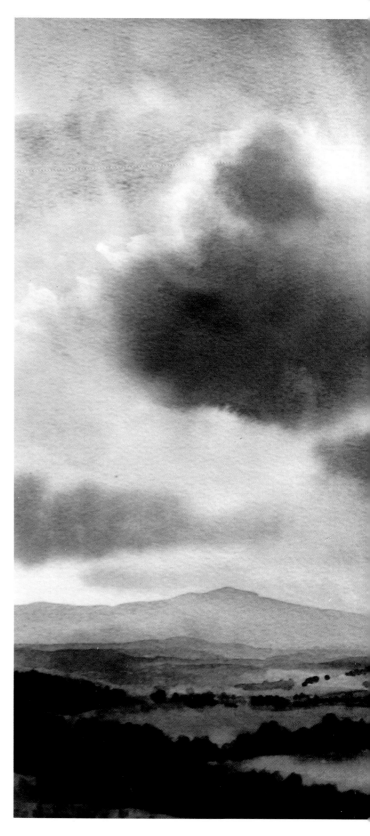

LOOKING TOWARDS BUONCONVENTO,
16 x 21½" (40 x 55cm), WATERCOLOR
The shapes of the clouds, more than the landscape, interested me about this view. The clouds melted into the distant landscape. It was a windy day with big, heavenly clouds. Parts of the landscape were dissolving into the clouds where the rain was falling. The light rays happened while I was painting and were added afterwards by wetting the painting in stripes and lifting off the paint lightly with a tissue.

TIPS ALLOW GREATER SPONTANEITY

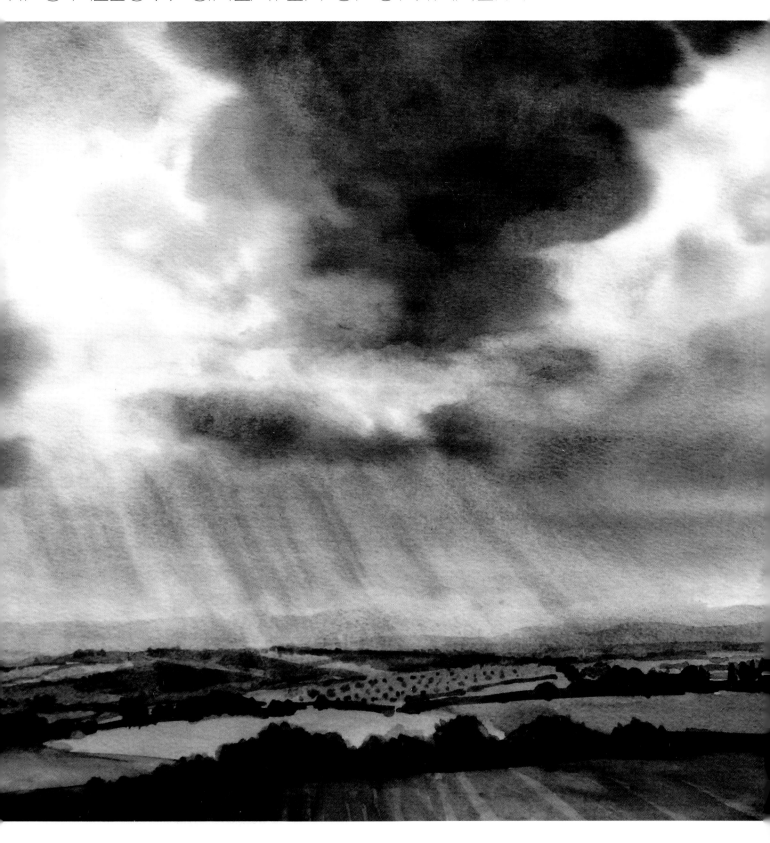

WHAT THE ARTIST USED

Support
Bockingford acid-free, mould-made 140lb watercolor paper

Brushes
Large brush for washes and glazes (squirrel or synthetic bristles)
#9, #12 Round sable brush
#3, #4 Round synthetic brush

Colors

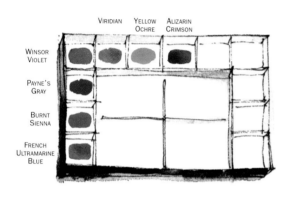

Other Materials
Pencil
Natural sponge (even textured)
Spray bottle

1 SKETCH IN THE COMPOSITION
I start the painting with a basic pencil sketch, describing the main elements of the landscape, such as the horizon and the cloud forms. I may do the sketch also with pale tonal watercolor marks to describe the movement of the clouds or to suggest strong tonal differences. ▶

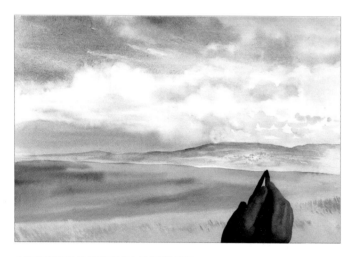

4 CREATE THE DISTANT LANDSCAPE
When the sky is dry, I start with the distant part of the landscape, which in this composition, is very far away. I use pale blues and grays to give a sense of aerial perspective. Very slight texture is introduced after an initial wash of Payne's gray, French ultramarine blue and Winsor violet. Sometimes I add a touch of viridian and a touch of burnt sienna where I see a distant town. All colors are being used very diluted and tonally similar to give the effect of distance.

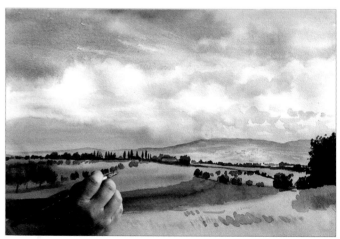

5 USE CONTRAST TO SEPARATE THE BACKGROUND AND FOREGROUND
When the background is dry, I start on the foreground by dampening the paper and adding the general colors, which in this case are yellow ochre and viridian. I add more vivid color into the wash when I am sure of the composition. The contrast of the warm yellow against the distant blue grays helps to separate the foreground from the background. When it is dry, I add darker elements of the trees in the foreground. This helps to describe the form of the land as it follows the edges of the fields. I have used mostly Payne's gray, with some diluted with yellow ochre and viridian.

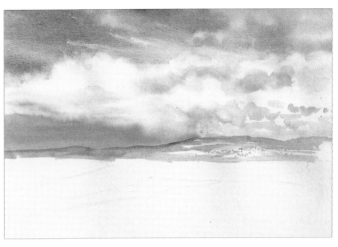

2 PAINT THE BLUE PART OF THE SKY

When that is dry, I dampen the paper with a spray bottle and a piece of natural sponge on the area where I will put the French ultramarine blue for the blue part of the sky, leaving dry the cloud areas. I mix the French ultramarine with water and, using a large enough sable brush, I add to the wet parts of the paper. Where I want soft edges on the clouds, I use a slightly damp sponge around the edges of the white and blue. I can use the sponge to lift out the blue color if I want to rearrange the clouds at this point. I can make finer, more linear streaks of white in the blue by using a damp paper tissue, drawing it across the blue and absorbing the color.

3 BRUSH IN SUBTLE COLORS

At this stage, I add more subtle color variations to the sky. If I see warmth in the clouds, I dampen the white areas and add some diluted burnt sienna. Where the sky is darker, I add touches of Payne's gray and Winsor violet. The tonal differences can be strengthened later. I often use the dirty areas of the palette warmed up with red colors and cooled down with blue colors as required.

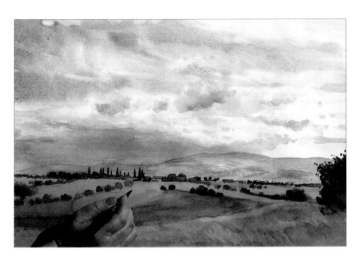

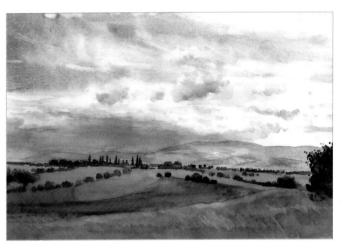

6 GLAZE IN WARMTH

When I have the painting at this stage, with everything described, I add glazes to the foreground of yellow ochre and alizarin crimson to warm it up. I add texture to the grass in the foreground by dragging off some of the paint when it has dried. I may add more depth to the sky by darkening the darker areas with another layer of the same wash. I sponge out any strange drying marks in the sky that bother me, always being careful to blend the sponge mark convincingly into the sky. (If the paper needs flattening afterwards, I dampen the blank side of the paper and leave the painting evenly weighed down underneath a board for a few hours.)

7 THE FINISHED PAINTING

TURNING POINT

My turning point was when I moved from London to Tuscany after seven years in an office job. I had continued to paint after art college, but it was difficult to do with a full-time job. I also was living in a city and not much inspired by the London art scene.

After moaning about my job, a friend asked me what I would do in my ideal life. I promptly replied, "I would like to be painting in Tuscany or Provence." She asked me why I had not tried to do that instead of living in the city. She was the first person who gave me a serious reply to this statement, and I immediately realized that I hadn't even tried to follow the dream.

I started a file on my perfect life and how I was going to acquire it. The following year, I took time off work to organize a painting holiday in Tuscany. The rest is history.

When I went to Tuscany, all I wanted to do was to find a way to stay there, because I just didn't have enough hours in the day to paint the wonderful landscape. Being out of the city environment helped me focus on my own work without being too influenced by others. Once I found myself artistically, I felt that I could communicate in a more natural and personal way through my work. I also realized that I am a landscape painter and this is my inspiration at this point in my life. I am an artist who responds to what is around me as much as what is within me.

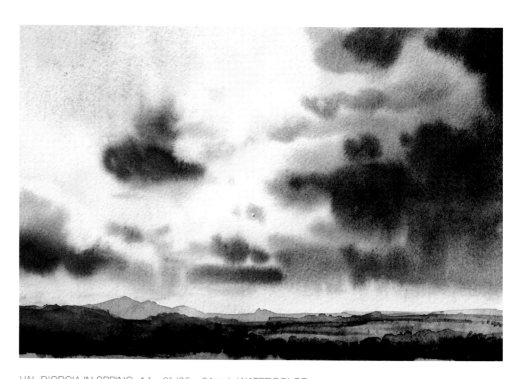

VAL D'ORCIA IN SPRING, 14 x 8" (35 x 21cm), WATERCOLOR
A small, quickly made sketch of the clouds in the evening light after the rain. The rain has made the colors more saturated and the green of the spring fields really vivid. The sky was done all at once with a wash and added color.

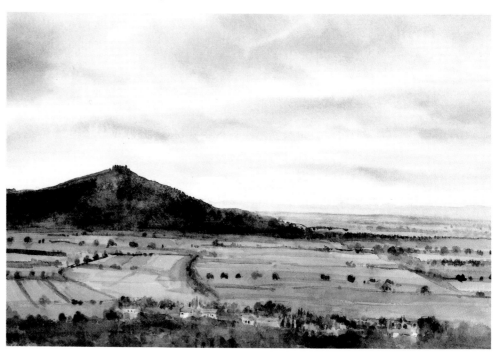

VIEW OVER OSSAIA FROM PERGO, 20 x 12½" (50 x 32cm), WATERCOLOR

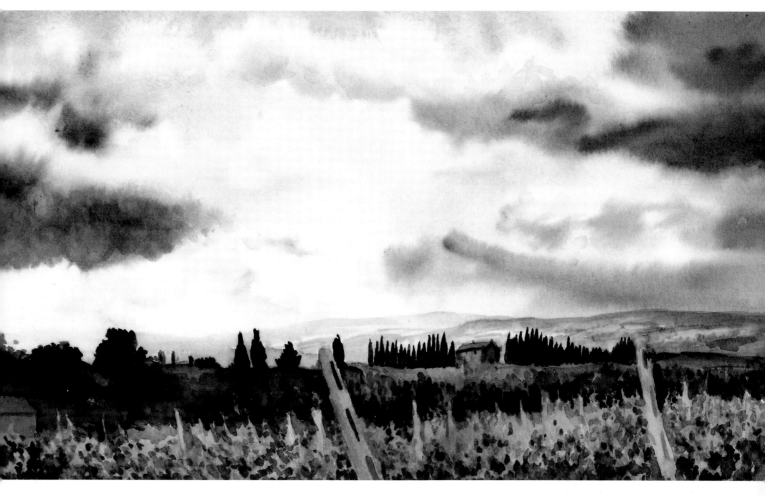

MADONNA DELLA NEVE AND VINEYARD, MONTISI, 20 x 12" (51 x 30cm), WATERCOLOR
The church in my village is named after the miracle of the Madonna of the Snow, a local miracle when it snowed in midsummer. The sky was painted rapidly as I tried to combine the warm light of the clouds with the clear blue of the sky behind. The sky was changing quickly and the landscape was thrown into shadow, so I glazed over the landscape to make the sky seem brighter.

ABOUT THE ARTIST

Elizabeth Cochrane is primarily a landscape painter who works in both watercolor and oils. She studied at Manchester Polytechnic and the University of Newcastle upon Tyne, where she was awarded prizes for painting.

Elizabeth says that when it comes to the medium of watercolor, she is self-taught.

She had been exhibiting her work since her university days, but mainly in do-it-yourself exhibitions she organized.

She took a month off from her office job in London and organized a painting holiday for beginners in watercolor that took her to Tuscany. She has now lived there for seven years and has been exhibiting regularly in gallery spaces in beautiful Tuscan towns. Since she supervises most of her exhibitions, she gets to enjoy meeting the people who buy her work.

Elizabeth teaches groups that come to stay in her village every spring and autumn. The rest of the time she spends painting and exhibiting.

She lives in a Tuscan village called Montisi, where she has been for the past five years. Her web site is www.elizabethcochrane.com.

JON CRAWLEY REVEALS THE CRUCIAL INGREDIENTS

Adding dimension and atmospheric effects to your skies and clouds will help you avoid dull skyscapes.

Light creates atmosphere and the effect of light is usually the main attraction for painting a subject. Successful watercolor skies are the result of a confident approach. That confidence comes from observation, knowledge and practice. First, observe skies and how they are structured. Analyze the colors, shapes and tones by doing small color studies, taking notes, and doing tonal sketches in black and white on mid-value paper. The gathering of this information, which should be done at all times of the day and in all kinds of weather conditions, will help you develop a knowledge base so that you can paint skies with confidence.

Second, develop your watercolor skills in a way that gives you confidence to paint wet-in-wet, because skies have the greatest impact when they look fresh. Soft edges, merging colors, crisp edges and tonal variation, as well as glazed washes, are all required to achieve convincing skies. Many of these effects are best done wet.

The key to this technique is to always be aware of the water and pigment balance in your brush, on the paper and in your palette. You then are able to have greater control of the washes to create soft or hard edges and the strength of colors and tones.

Adding pigment to a wet area is more effective than playing around with watery washes. The aim is to get the tone and color right the first time. It won't happen every time, but confidence grows as you achieve each success.

Skies will invariably have areas where you will need to retain the white of the paper. These areas must be kept dry while washes are added to the rest of the sky.

For a crisp edge, paint up to the dry area. For a soft, fuzzy edge, run a thin line of water along the edge first, then paint up to the edge of the water so that the pigment gently merges into the water.

You will find that this effect will vary with the wetness of the paper, pigment strength and the amount of water in the brush.

Always be aware of these factors and you will develop the confidence to create atmospheric skies.

TURNING POINT

Painting in Europe every day for four weeks in the early 1990s really provided me with a focus on the atmospheric effects of light in the landscape. European light really made me analyze colors and tones, an experience and experimental period that increased my knowledge. The opportunity also enabled me to "use watercolor to the max" by letting pigment and water do their thing with minimum interference from my brush. It was my "Aha!" moment.

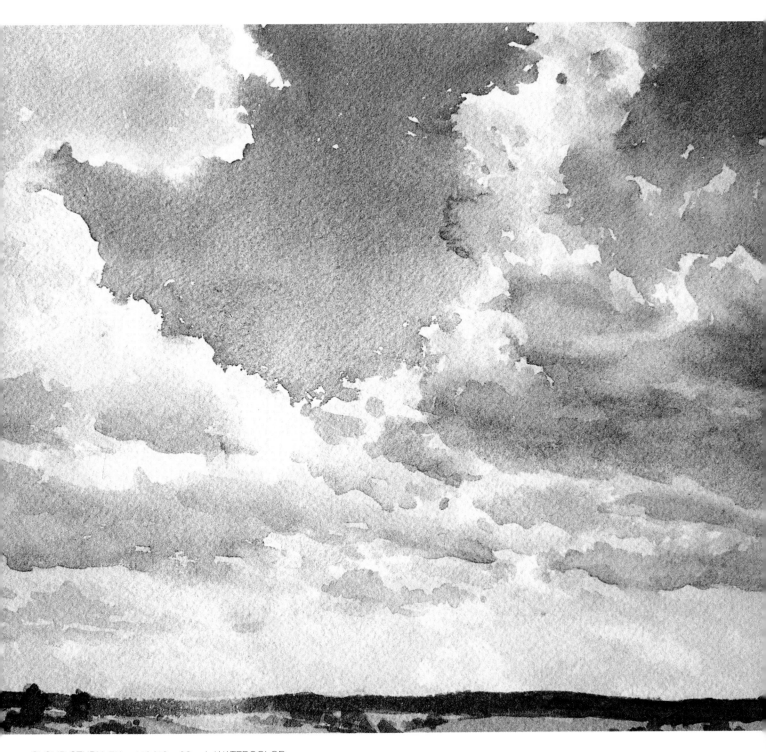

CLOUD STUDY, 7½ x 11" (19 x 28cm), WATERCOLOR

Cloud shapes can be painted to create aerial perspective by using tone and color. Visual perspective is created by making them smaller as they near the horizon. Similarly, depth is created by using stronger blue pigment near the top of the sky and lighter washes toward the horizon.

The gray shadow tones in cloud shapes can be mixed in many ways by using colors that enhance the atmosphere of the painting. Use cool or warm mixes. Also, lightly tint the white areas of the clouds with a warm color to indicate the sun's effect. Be careful not to make the blue areas look like holes. This one could be improved with more soft edges around the blue areas.

ART IN THE MAKING CAPTURING A GOLDEN GLOW

My goal in painting "Tranquil Low" at the Eilean Donan Castle in Scotland was to capture the golden glow created by the sun low in the sky behind the mountain on the left-hand side.

WHAT THE ARTIST USED

Support
22 x 15" (56 x 38cm)
Saunders-Waterford 300gsm
rough watercolor paper

Brushes
1½" Flat, #16, #12 & #6
Sable (Round)

Colors

COBALT BLUE RAW SIENNA RAW UMBER BURNT SIENNA

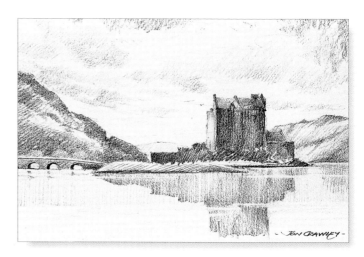

1 START WITH A TONAL SKETCH
The simplified tonal sketch established the composition, light direction and tonal shapes. My sketchbooks are invaluable for recording ideas, feelings and images.

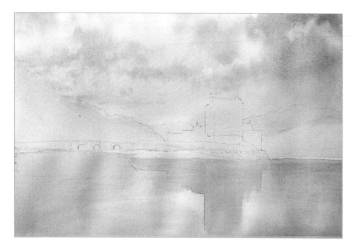

4 TAKE THE SKY COLORS INTO THE WATER BELOW
While the sheet is still wet, the same sky colors are taken down into the water, taking care to retain the thin band of white light between the mountain and water.

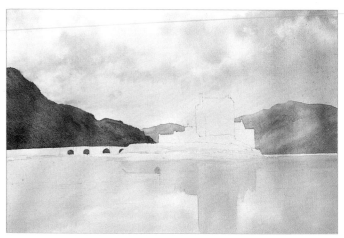

5 START THE MOUNTAINS
The paper then is completely dried. The mountains are painted using cobalt blue with a touch of burnt sienna; raw sienna and raw umber are separately dropped in while wet for the two mountains catching the sun's golden rays. Form can be created using varying tones. The mountain in shadow is established with strong cobalt blue and burnt sienna; raw umber and raw sienna are dropped in wet to create form. As this dries, a misty effect is created by lifting out pigment with a barely damp brush.

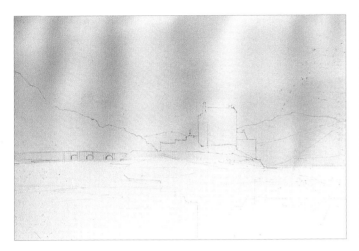

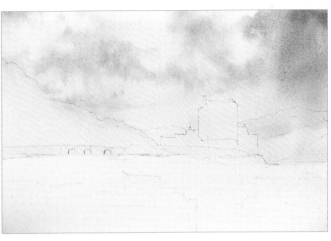

2 TRANSFER THE IMAGE TO THE WATERCOLOR PAPER AND APPLY THE INITIAL WASH

Using a soft graphite pencil, the image is transferred, using simple lines, to the watercolor sheet. An initial wash of watery raw sienna (followed by raw umber) is flooded in to the sky down to the horizon. Variations are achieved by varying the pigment strength.

3 SAVE THE LIGHT AREAS AS EDGES ARE DEVELOPED

The sky must still be shiny wet to enable the cobalt blue and cobalt blue/light red mixture to be brushed in. Light areas need to be saved, soft and hard edges developed and the paper tilted to allow some pigment to merge downwards.

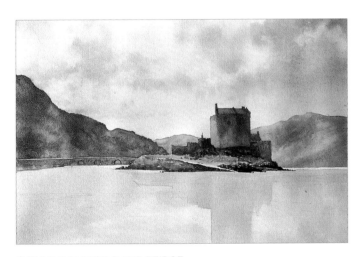

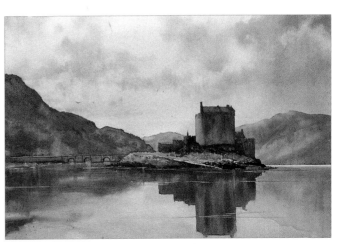

6 PAINT THE CASTLE AND BRIDGE

Dry the work again before painting the castle and bridge with cobalt blue and burnt sienna first. Then, with a brush loaded with strong raw sienna, followed by raw umber pigment, use a single brushstroke to add the areas of golden light. The raw sienna and raw umber will push the dark away, leaving a golden glow. Small areas of white paper are retained to add sparkle. The reflections are painted using the same colors with vertical brushstrokes to create variety of color, tone and edges.

7 ADD THE FINAL DETAILS

After the work is dry, small adjustments are made and minimal details added. The aim was to capture the subtle glow and gentle clouds, and the atmosphere they created. I titled the painting, "Tranquil Glow."

HINTS FOR ATMOSPHERE

CLOUD SHAPES WITH SOFT EDGES

To retain areas of white paper with soft edges, use a tissue gently pressed onto a fresh wet wash to create cloud shapes. Just wait until the wash has lost its shine so that it does not run back into the area. But do not use just water to do this.

CLOUDLESS EVENING SKY

Apply a gradated aureolin wash which is weaker at the top and stronger at the horizon. When this is still wet, apply permanent rose, stopping about one-third of the way above the horizon. Let the wash merge downward. Finally, mix ultramarine blue with a touch of brown madder in a stronger mix. Take a large brush and sweep it at an angle across the top third of the sky with the board tilted at a 15-degree angle. Allow the wash to merge downward.

EARLY MORNING, CLEAR SKY WITH HORIZON HAZE

On dry paper run a gradated wash of cerulean or phthalo blue over two-thirds of the sky. Pick up the bead of water at the base of this wash with a band of light red/raw sienna, then at the horizon add ultramarine blue to the light red to create the haze.

CLOUDS IN A BLUE SKY

After determining the light direction, lightly shade the areas of paper that are to be saved with a pencil. Next, wet the sky using a weak wash of cobalt blue (this is easier to see), leaving the light areas dry. To achieve a mix of soft and hard edges, work quickly and decisively. Use a stronger mix of cobalt blue toward the top of the sky to create patches of blue that leave hard-edge cloud shapes. Watch the edges: pick up over-runs with a damp brush rather than a tissue (which dries the paper too much). Then add the cloud shadows using cobalt blue/light red, creating soft and hard edges. Do not fiddle!

STORMY SKIES

These can be dramatic! Cool dark (cobalt or ultramarine blue with burnt sienna) or warm dark (cobalt or ultramarine blue with Indian red or light red) can be effective depending upon your chosen weather and atmosphere. Mix your dark color and test it first (one-go darks are best) before adding the cloud shapes to wet paper. Because the paper is wet, the mix must contain plenty of pigment to avoid watery washes. Allow edges to blend into the unpainted wet areas, controlling them with a just-damp brush, if needed. For a warm stormy atmosphere, add cadmium red brushstrokes near the horizon (or red plus raw sienna). For a cool stormy effect, just add a weak raw sienna wash to the light areas of the cloud shapes.

FOGGY OR MISTY SKIES

Lovely atmospheric effects can be created by using ultramarine blue and raw umber or burnt sienna brushed onto wet paper for a cool feel. Use ultramarine blue, brown madder and raw sienna for a warm, hazy and misty atmosphere. The key is to vary the direction, size, color and tone of the area being painted. Make sure the paper is very wet so that the pigment can be left to work its magic by mixing and merging.

STORMY EVENING, 7½ x 11" (19 x 28cm), WATERCOLOR

Stormy skies can at times become too dominant. To overcome this, use the cloud shapes as a design element. Create diagonals to introduce a variety of shapes and tones; vary the edges – some soft, some hard.

Ultramarine blue and burnt sienna with a touch of cadmium red make a rich, dark gray that is best when painted strongly onto wet paper and allowed to blend and merge with water.

One brushstroke of strong pigment into a wet area will create a soft-edged shape. It is always more successful to paint strong pigment into water than to play around with weak washes.

The cadmium red glow near the horizon was brushed in before the clouds were added. This makes it imperative that the mix for the clouds is done strongly and with confidence to avoid a muddy look.

KEYS TO 3-DIMENSIONAL SKIES

The color of the sky is strongest overhead, so use stronger mixes of pure color at the top of the sky.

Color becomes less intense, washes need to be weaker, and impurities occur as the sky nears the horizon. Use more water and dulled colors in this area.

Clouds are smaller the further away they are, so to create depth, paint them smaller as they near the horizon. Movement can be created by placing clouds in diagonals across the sky, rather than having them all horizontal. Horizontal clouds can be used to indicate calm.

When mixing colors for clouds, first consider whether you want cool colors or warm colors.

Cool grays can be made from burnt umber with either cobalt blue or ultramarine blue (burnt sienna can be substituted for umber). Other cool grays can be mixed from cadmium orange with

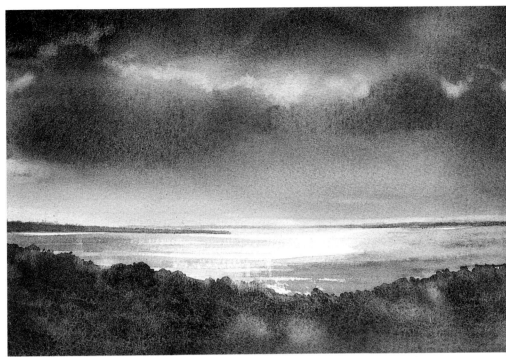

STORM OVER CORIO BAY, 7½ x 11" (19 x 28cm), WATERCOLOR

cobalt blue or ultramarine blue; viridian or phthalo green with cadmium red or quinacridone red or permanent alizarin.

Warm grays can be created from light red with any blue; brown madder and ultramarine blue or cobalt blue; or vermilion added to the blues. The combinations are endless and depend upon which color is dominant and how much water is added.

My best advice is to experiment with all combinations, but remember to only mix two colors so that you avoid making muddy washes. Be aware that clouds are rarely pure white. They will have a cool or warm tint depending upon your chosen atmosphere.

When you place clouds in a blue sky, do not make the blue too dark or create too many hard edges because the blue will look like a hole. Instead, merge part of the cloud edges into the blue to avoid this problem. Keep a few hard edges for impact in the focal point area.

ABOUT THE ARTIST

Born and raised in Ballarat, Australia, Jon Crawley began a career in engineering before following his interest in art and education.

After completing a Diploma Art & Design (Hons.), Diploma of Education (Hons.) and Bachelor of Education (Hons.), Jon lectured in art education and taught secondary college art for almost 25 years before setting up a studio to practice as a professional artist.

Jon works in all media, but has an on-going passion for watercolor that was initiated by meeting Robert Wade in 1986. Bob's friendship and encouragement have been a continuing inspiration.

Sought after as a judge and lecturer, Jon finds his classes, demonstrations and workshops are always popular, as is his best-selling video, "A Prelude to Watercolour." He has written many articles for *Australian Artist* and *International Artist* magazines.

Jon has received over 300 awards, in all mediums, for his painting and drawing. He has held 36 exhibitions in Australia and England, with his artwork in private and public collections worldwide.

He can be contacted by e-mail at: joncrawley@email.com.

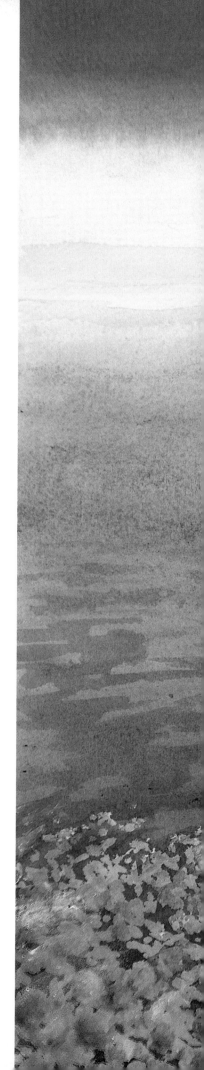

CHAPTER 7

JEANE DUFFEY PAINTS SKIES AND CLOUDS FROM AN AERIAL PERSPECTIVE

Changing the point of perspective brings a whole new vitality to skyscapes.

T he medium of watercolor is ideal for expressing the vast, constantly changing expanse we call the sky. It is interesting to know that the higher you fly, the darker the sky becomes. From a supersonic plane you can see the curvature of the earth, and a sky that deepens from pure cobalt to darkest indigo and black. Monet once said that no one should paint before 11 a.m. and after 4 p.m. I believe that this good advice applies to skies as much as landscapes.

For me, skies must be painted quickly and intuitively as far as possible. One needs a good supply of clean water, plenty of room to make a mess, brushes and mixed paint ready, and a good supply of tissues, rags or paper towels. Once you have an idea in your head, it is best to just do it. Much can be achieved on wet paper by adding, and blotting, color. Any pure white or pale areas must be kept as far as possible. Art masking fluid leaves unwanted hard edges, and I try not to use it. I find wax is a better alternative. This can be left or removed by carefully ironing with several layers of tissues.

A digital image of what I am aiming at is on my computer for reference as I work. Watercolor loses its depth of color as it dries, and this is something one has to bear in mind. It is unlikely that you will want to choose colors that granulate, such as ultramarine blue, for your skies. I hardly ever sketch with a pencil. I prefer to use Caran d'Ache Prismalo watercolor crayons. These dissolve into the paint. Normally, I lightly draw a horizon line, establish my light source, and nothing else. I have my entire picture worked out in my head beforehand. This is a useful thing to do when the boring necessities of life have to be done.

TURNING POINT

I have had many turning points in a long career. The advent of acrylic paints, a commercial success undreamed of, prestigious exhibitions, and mixing with and meeting my peers, and the good and the great. Lately, I have had five years' editorship with International Artist Publishing Inc., which is very rewarding.

After much contemplation, I think my real turning point came when I realized that I was free to be the rebel I am. After a long talk with my art historian brother, I established that the rules surrounding watercolor painting are really nonsense and not based on historical principle. There is absolutely no reason why watercolor has to be transparent. The "purists" are just as free as I am to do as they please. It is the end result that counts. I try not to be influenced by anyone, but I admire the works of Samuel Palmer, Charles Rennie Mackintosh, Rubens, Klimt, and a host of others.

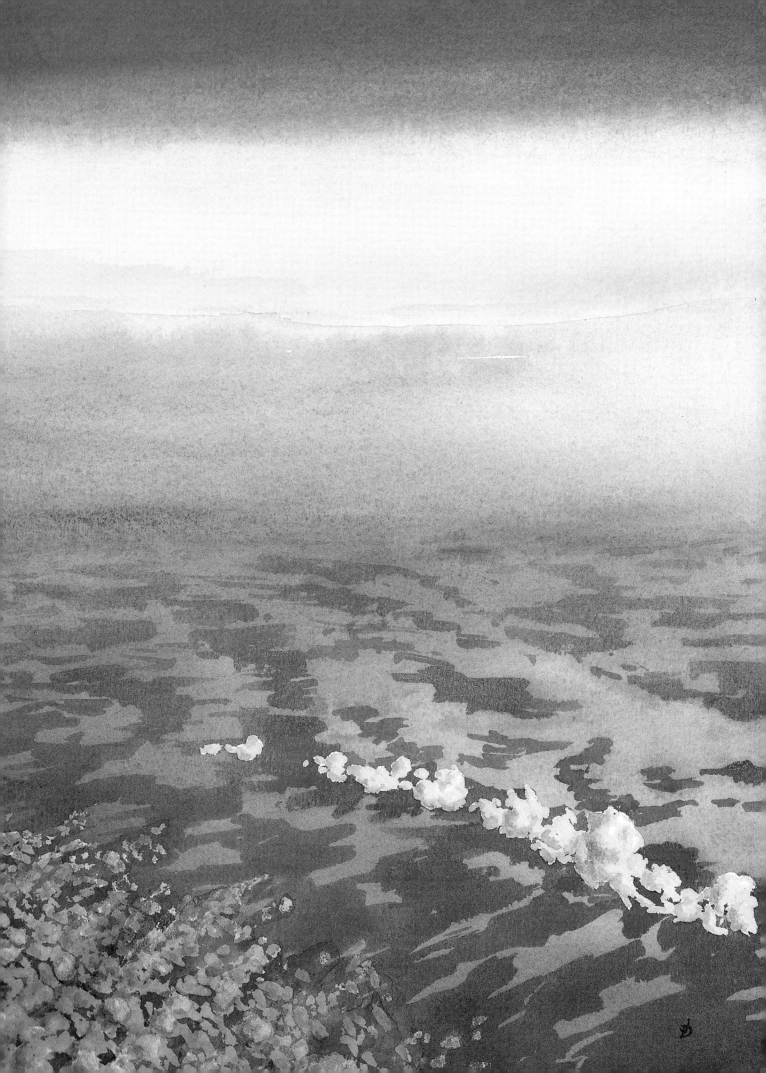

ART IN THE MAKING THE OVERHEAD VIEW

The sky is a fascinating source of inspiration and ever-changing source of material for the artist. It is so fleeting that memory or a camera must be relied on.

Clouds can be a real challenge and I do not believe that there can be any set formula for painting them. Wet on wet? Wet on dry? Dry-brush on dry? Big washes and blotting while wet, or shapes blocked in and lighter passages removed when dry?

I have used a hard-edged approach in "Over Brazil," because anything else would not have expressed the scene as I saw it. In my demonstration here for "Final Approach," I have attempted to merge the sky and the landscape, using many tissues to blot out for swirling clouds.

The whole painting has been worked out, and refined, in my mind before I ever put brush to paper, so value sketches are never used, and were never mentioned at art school. In England, I was encouraged to do many thumbnail sketches to establish the most suitable composition, but watercolor is a subject not generally taught in these schools. We all learn the hard way.

WHAT THE ARTIST USED

Support
T.H. Saunders "not" watercolor 300lb (this means not rough or smooth)
Fabriano Artistico 300gsm
Cold press watercolor paper

Brushes
Large 2" sky wash brush.
The great advantage of my old brush is that the hair is 1½" long, eliminating any danger of scraping the paper with the ferule.
Smaller 1" wash brush, ¾" long
Sceptre #12 watercolor brush.
The excellent shape has a point so fine that nothing else is needed.
A very old #5 brush for dry-brush work.

Other Materials
Casein White
Large box of tissues
Caran d'Ache watercolor pencils
Computer screen to display my own CD of digital photos
Hair dryer

Colors

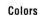

CADMIUM YELLOW DEEP | PHTHALO BLUE | QUINACRIDONE ROSE | PAYNE'S GRAY | QUINACRIDONE SIENNA

1 BLOCK IN THE LAND MASS
I start with the land mass, using cerulean blue and tissues. The sodden tissue on the left shows the extent I have played around here. All my washes are very liquid, as I like to layer them to soften edges and vary the colors. ▶

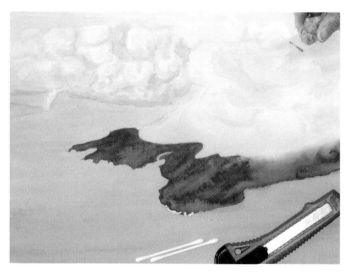

4 ADJUSTING THE COLOR
Oops! I mixed my land color with too much enthusiasm and made two dark blots on the painting. I carefully removed these with damp cotton buds and a malleable eraser. I did not need to use the craft knife to carefully scrape off paint. ▶

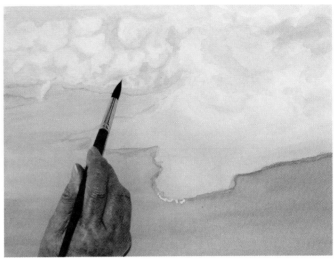

2 ADD THE WASHES FOR THE SEA
Here I have laid down the washes for the sea and have started to define the clouds.

3 APPLY THE FINAL WASH
I brush on the final wash on the sea and do more fiddling about with the clouds. This clearly shows the beautiful point of my #12 brush.

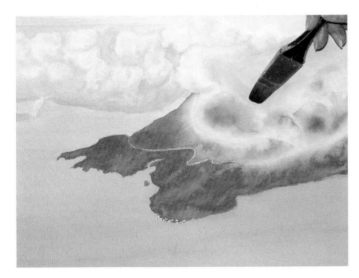

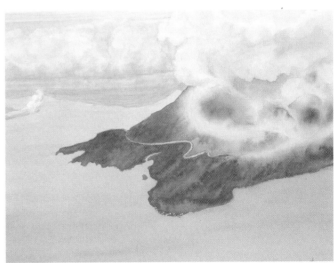

5 KNOCK BACK THE CLOUD BANK
Almost there, I finish the clouds over the mountain and "knock back" the cloud bank on the left with a light coat of titanium white casein. I have used cobalt blue, cerulean blue, quinacridone rose, cadmium yellow deep, and Payne's gray watercolor paints. Hard edges that I did not want have been softened with Prismalo Caran d'Ache watercolor pencil.

6 FINISHED WATERCOLOR
I titled the completed 11 x 15" (28 x 38cm) picture "Final Approach."

CORRECTING MISTAKES

There are many ways of retrieving a painting from an apparent disaster. Much depends on the paper you are using. Fabriano Artistico is not a paper that you can abuse, and therefore care is needed. Arches watercolor paper, 300 gsm, I find best for rough, tough use. You can use fine emery paper, repeated applications of art masking fluid (it removes a little color every time it is applied and removed).

You would be very surprised to know how many top professionals use Caran d'Ache Prismalo watercolor pencils. These can and do obscure many errors. Rub over the area with a damp figure and it becomes part of the watercolor. You are not even cheating.

Careful scraping with a craft knife is an obvious choice. I prefer to do this under a magnifying glass so that I can instantly see signs of damage to the paper. This also is a valid choice. Many artists achieve highlights this way.

Low tack masking tape also can do the trick when it is applied several times. You can use ordinary masking tape by just pressing the sticky side several times on a clean spot on your studio table to get the low tack you need.

Don Farrell once said, "A painting can be labored, it just must not look it."

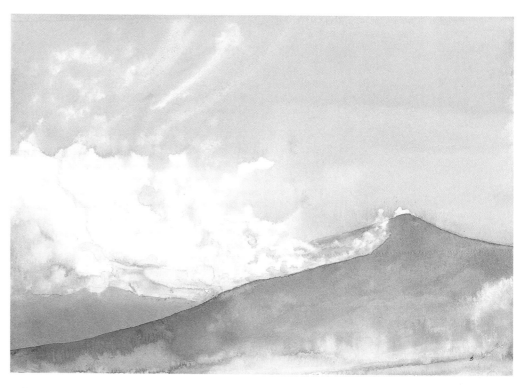

MOUNT ETNA — THE GRAND TOUR, 15 x 22" (38 x 56cm), WATERCOLOR
A simple but majestic view, from the tourist's flight, of the mountain. The clouds quickly build during the day until you can see little else. Early morning, as seen here, or just before sunset, seemed to be the best times to experience this magnificent sight of raw, but seemingly peaceful, nature.

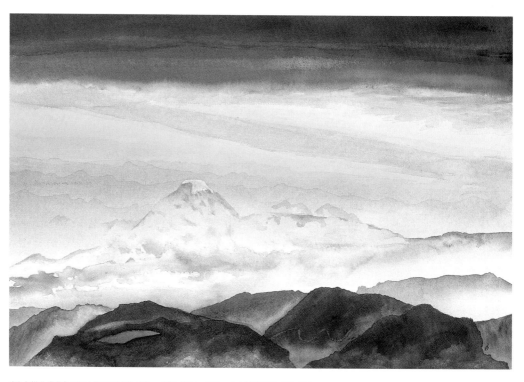

20 MINUTES TO LANDING, 15 x 22" (38 x 56cm), WATERCOLOR
Just before sunset, the diagonal gray cloud gave me the classic Z composition for the central part of the picture, of no consequence except to the artist who has studied the "rules." It was accidental and fortuitous. What I really wanted to show was the awe-inspiring view seen from an aircraft flying low over the mountains.

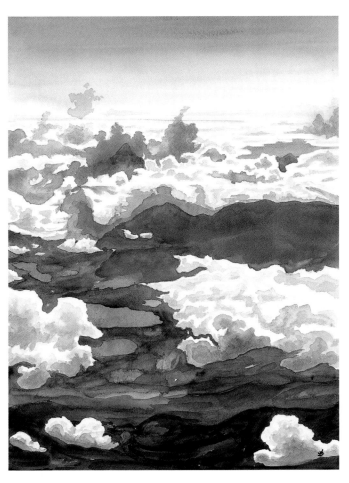

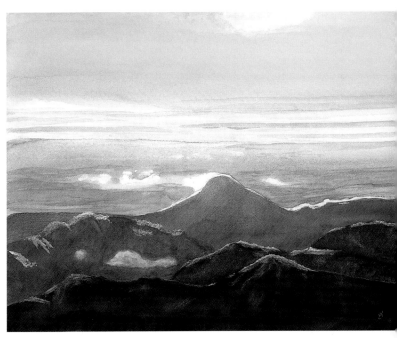

CONTINENTAL BREAKFAST AT 18,000 FEET,
15 x 11", (38 x 28cm) WATERCOLOR
Here I broke the rules and placed the mountain right in the center, where I felt it belonged and where I saw it on waking up after an overnight transcontinental flight. It may seem a simple matter to use a camera, but you have three layers of glass and plastic — the outer one dirty and scratched – to contend with. One must train one's mind to record the moment in terms of atmosphere, lighting, color, and the mood of the moment. As a student, I was trained to understand the vital need for an artist to be observant.

OVER BRAZIL, CLOUDS, LAKES, AND FOOTHILLS,
15 x 11", (38 x 28cm) WATERCOLOR
A deliberately hard-edged and instinctive rendering of my reaction to this exciting glimpse of another country so far from home. The vibrancy and vitality of Brazil seemed to be discernable even at this height.

LESSONS OTHERS HAVE SHARED WITH ME

I have been lucky enough in my life to meet a great many interesting artists. Among them I vividly remember Rowland Hilder. In the course of conversation, he gave me three interesting insights into his methods.

He said that every watercolor artist should have a tube of white casein paint, the artist's "white out" (which, of course, can even be added to watercolor). Rowland liked to apply his darkest darks first in Indian ink. Green often was made by mixing black and yellow, a surprisingly successful combination.

John Blockley admitted to having all his sketches in a drawer on scraps of paper. I immediately identified with that. His darks, he told me, were mixed from yesterday's paint. Why not?

I have forgotten the life drawing lessons from visiting professors, but I will never forget the wonderful female drawing instructor who opened my eyes to an infallible way of drawing. For that, I am forever grateful.

ABOUT THE ARTIST

Jeane Duffey has Canadian and British citizenship. She was born and trained in England. Her family tree contains so many different nationalities that she feels very much at home among the diverse peoples of Canada.

She lives in Tsawwassen, near Vancouver, B.C., Canada.

Many of her works are included in private and corporate collections around the world. Jeane has exhibited widely and her works have been extensively published in the world market. Her work may be found in more than 45 countries. Serigraphs have been published by Christies Contemporary Art Galleries, and also in Canada.

Jeane works in acrylic, watercolor, mixed media, gouache, pastel, and conté crayon. She particularly enjoys portrait commissions and is a founder member of the Canadian Institute of Portrait Artists.

She was Exhibitions Chairperson of the Federation of Canadian Artists for eleven years and has also served as President of the Federation of Canadian Artists.

Her work can be seen at www.jeaneduffey.com. Her e-mail address is duffey@dccnet.com.

GERALD GREEN REVEALS HIS TECHNIQUE FOR

Using warm-colored washes in winter skies provides the ideal contrast to cold snow scenes.

The winter period offers the artist a uniquely refreshing view of the landscape. At this time of the year, the vibrant colors of summer and the richer shades of autumn have been supplanted by much cooler, darker hues. Those colors can often appear extremely intense when seen against the brilliance of a snow-covered landscape.

The key to creating truly atmospheric winter watercolors lies in the treatment of the sky. For example, winter skies can in reality appear quite dark in tone, which can be used in a painting to enhance the contrast of a bright, snowy landscape.

It is very easy to fall into the trap of painting skies in pale washes or predominantly in grays or cooler colors, but this will overstate the cold effect, resulting in subjects appearing dull and uninteresting.

To prevent this, I prefer to incorporate warm colors into my

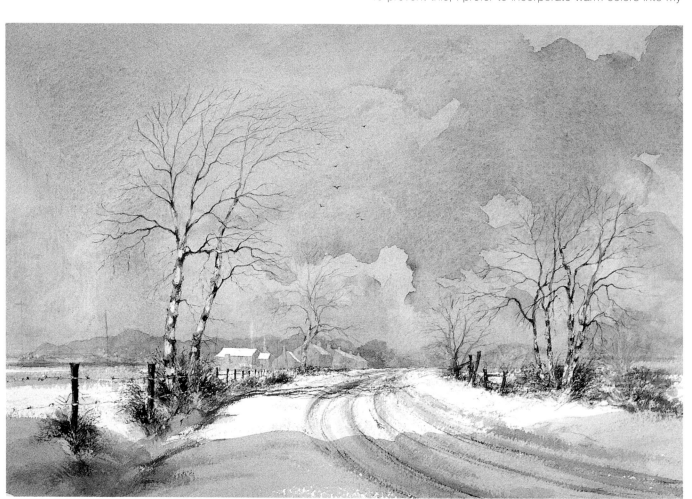

WINTER ROAD, 21 x 13½" (53 x 34cm), WATERCOLOR

CREATING ATMOSPHERIC WINTER SKIES

skies, or at least I begin by putting in a warm-colored under-painting.

The first wash establishes the general mood of a painting, over which I can then build atmospheric cloud patterns by incorporating a variety of additional warm/cool color relationships.

I also introduce extra variety by combining softer-edged gradated color washes with stronger, harder-edged forms.

Essentially, I see my skies as a single element which I then break down into a simplified pattern of larger masses, rather than made up of several individually painted cloud shapes.

I then build these basic shapes in layered washes, while resisting any temptation to get bogged down in overstated detailing or fussiness. I also pay particular attention to the position and direction of lighting in order to produce a cohesive, overall statement.

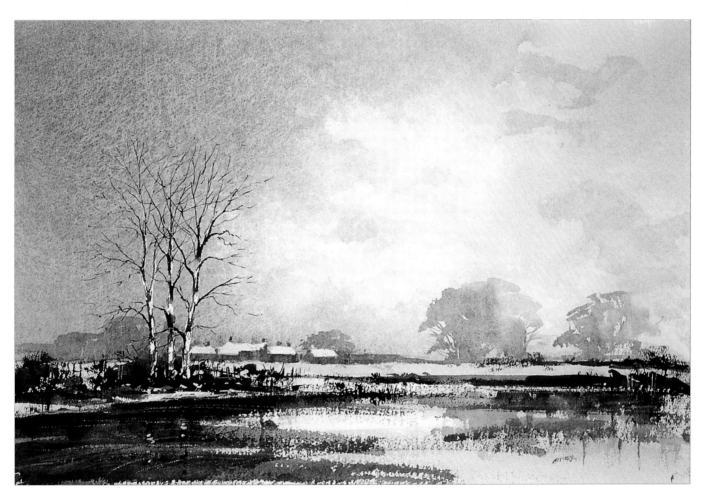

FLOODED FIELDS, 21 x 13½" (53 x 34cm), WATERCOLOR
The inspiration for this painting lay in the way the landscape and sky were linked together by the reflections in the partially-flooded fields. Essentially, I wanted this to be a quiet painting, but the atmospheric sky creates some movement in what might otherwise have remained a static image.

WHAT THE ARTIST USED

Support
21 x 13½" (53 x 34cm)
Arches 640gsm Not (Cold Press)
watercolor paper

Brushes
3/4" Wash Brush, ½" Flat,
#2 Rigger

Other Materials
Masking fluid
Pencil

Colors

CADMIUM
ORANGE

ALIZARIN ULTRAMARINE NEUTRAL LAMP
CRIMSON BLUE TINT BLACK

1 A PENCIL SKETCH DETERMINES THE LANDSCAPE COMPOSITION
My subject for this "Approaching Storm" painting combines a number
of different drawings taken from my sketchbooks. I felt that the group
of buildings in this drawing would work well as a focus in the painting, but
to intensify the scale of the powerful sky, I needed to place them in the
middle distance.

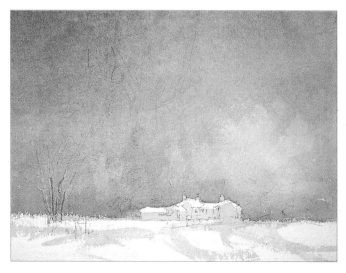

4 BRUSH IN A SECOND WASH OF NEUTRAL TINT
When the previous stage was completely dry, I applied a second well-
diluted wash of neutral tint with a touch of ultramarine blue, gradating it
from the top left-hand corner to the bottom right-hand corner and down to
the horizon line, again carefully cutting around the roofs of the buildings.
The painting was then again allowed to dry.

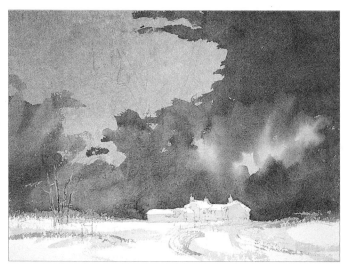

5 CREATE THE CLOUD FORMS
I dampened the lower right-hand area of the sky with clean water and
I established the main cloud forms with my large wash brush, beginning at
the top of the paper with a darker, slightly less-diluted wash of neutral tint
and alizarin crimson. I cooled it with ultramarine blue as I moved down and
to the left. The softer-edged cloud forms were created where this wash ran
into the dampened paper.

COLOR HARMONY

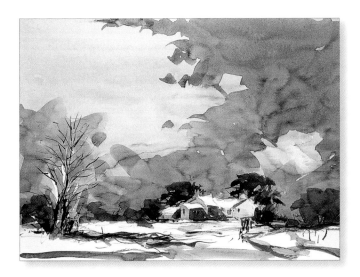

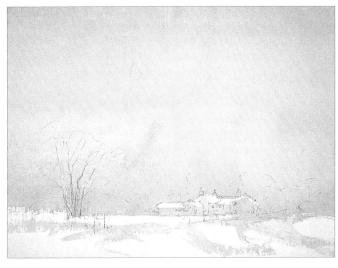

2 CREATE A VALUE SKETCH

This image is my final choice of three preliminary drawings which I made to try out various alternative compositional arrangements and to work out a suitable tonal distribution for the painting. I worked in pencil on cartridge paper, overlaying washes of lamp black watercolor to fix the general tonal masses.

3 SKETCH IN THE MAIN FORMS AND APPLY MASKING FLUID

I began by sketching in the main forms of my composition, which I kept to a minimum. Then I applied masking fluid to the foreground trees so that I could paint the sky washes over them while still retaining them as white paper in the finished image. Using a wash brush and working in horizontal strokes from the top of the paper downwards, I began the painting process by laying in a well-diluted first wash of cadmium orange with a slight touch of lamp black to reduce its intensity a little. I worked on dry paper, painting around the roofs of the buildings down to the horizon line. I added in a blush of alizarin crimson on the left as I worked down the paper. I also pulled in some of the orange color into the foreground.

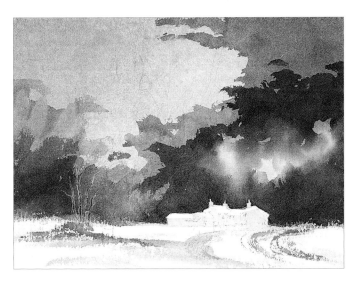

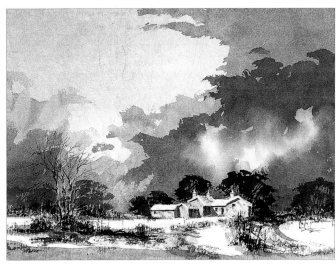

6 STRENGTHEN THE TONE

When the previous stage was thoroughly dry, I laid in another cloud wash in the same color to complete the sky.

7 DETAIL THE LANDSCAPE

I finished off the painting by completing the landscape forms, working from the background to the foreground. I painted in the background trees in dragging strokes with the edge of a ½" flat brush, using darker, thicker versions of the cloud colors. I finally removed the masking fluid from the foreground trees and added the tree detail with a #2 rigger brush. Combinations of all the colors were used to finish the foreground elements.

WINTER FARM TRACK,
21 x 13½" (53 x 34cm),
WATERCOLOR
To create the feeling of a bright day in this painting, I combined warm and cool colors in the sky, which I laid as both wet-into-wet and hard-edged washes. The lightest cloud tops I allowed to remain as white paper, which, together with darker contrasting landscape elements and directional shadow shapes, further enhanced the illusion.

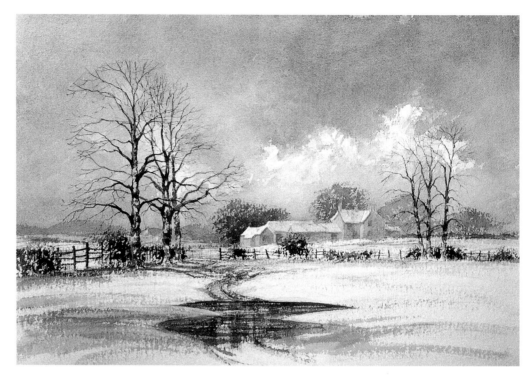

TURNING POINT

I suppose a turning point for me came with the realization that, whatever the subject, what we call successful watercolor paintings are those which essentially catch something of the moment or the essence of the subject.

To do this, they do not need to be exact likenesses or contain lots of detail. In fact, they can be fairly understated, but they must communicate something of the mood or feeling about the subject.

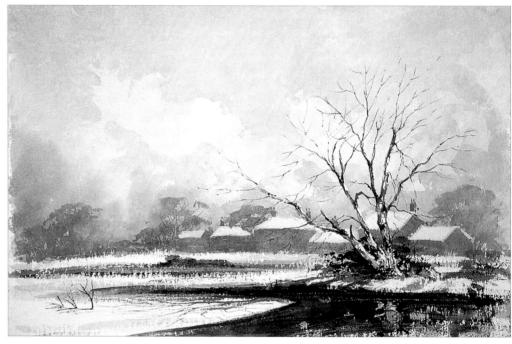

FROZEN POND, 21 x 13½" (53 x 34cm), WATERCOLOR
For this painting, I used an alternative basic palette of secondary colors: orange, violet and green. That provided a more subtle mood to the sky and scene in general. I also created a feeling of misty distance by including hard edges and strong tonal contrasts into the dominant tree group, with softer, diffused edges and more muted tonal contrasts for the background features.

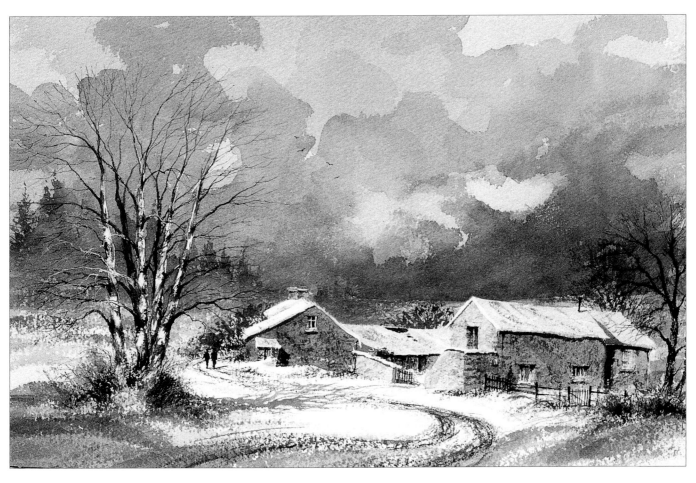

WINTER FARM BUILDINGS, 21 x 13½" (53 x 34cm), WATERCOLOR
I used predominantly cool colors in this painting to emphasize the bleakness of the subject. I included a winding track to lead the eye into the picture and a turbulent sky to give additional movement to the overall image.

ABOUT THE ARTIST

Gerald Green is a British artist who works in both watercolors and oils. He has been a finalist in major U.K. exhibitions, including the Laing Art Exhibition and the Singer and Friedlander/ Sunday Times Watercolour exhibitions. He has had work in both solo and group exhibitions in several public and private galleries, including several of the Federation of British Artists shows at the Mall Galleries in London; Gloucester City Art Gallery; and the Luton Art Gallery, Bedfordshire, U.K.

His watercolor and oil paintings currently can be found at such U.K. galleries as The Wykeham Gallery, Stockbridge, Hampshire; John Noott Gallery, Broadway, Worcestershire; Angel Gallery, Lavenham, Suffolk; Fossee Gallery, Stow-on-theWold, Oxfordshire; Peter Hedley Gallery, Wareham, Dorset; and the

Granby Gallery, Bakewell, Derbyshire.

Since 1989 he has contributed articles on the techniques of drawing and painting to numerous art magazines, including *International Artist* magazine. His work also has been featured in six books, the latest being, *The Artist's Watercolour Problem Solver.*

Gerald has undertaken numerous commissions for many of the major property development and architectural companies, both in the U.K. and abroad.

He also serves as a visiting lecturer at various art colleges and universities in the U.K. and frequently runs painting workshops.

His Web site is www.ggarts.demon.co.uk.

PAUL JACKSON DISCUSSES HOW TO USE CHANGING SKIES AS A PLIABLE COMPOSITIONAL TOOL

The more dramatic the sky, the more it becomes the focal point of the painting.

T he sky is the most magical element that enlivens any landscape. Its endless capacity for change makes it also the most "pliable" compositional tool in your painting.

Because the sky is more exciting at different times, I frequently recall interesting skies from previous experiences to combine with the landscape that needs energizing. Generally, when the sky is dramatic, it becomes the focal point of your painting and all other landscape elements must support and reflect it. The sky sets the mood for everything else in the composition.

I am constantly striving for "flawless" and exciting skies that don't look overly-painted. Brushstrokes and watermarks are not part of my plan, but occasionally happen in ways that make the painting more interesting. Sometimes you just have to let nature take over and let the paint do its own thing without a heavy-handed painter messing it up.

YUKON GOLD, 26 x 40" (66 x 102cm), WATERCOLOR
The color of the landscape and sky working in harmony make for a more believable painting, even when the color choices seem extreme. Masking fluid was required to save the "silver lining" while painting the delicate gradations required for the sky. High contrast between the sky and landscape elements focuses attention on the clouds.

(RIGHT) SEA STACKS, 26 x 40" (66 x 102cm), WATERCOLOR

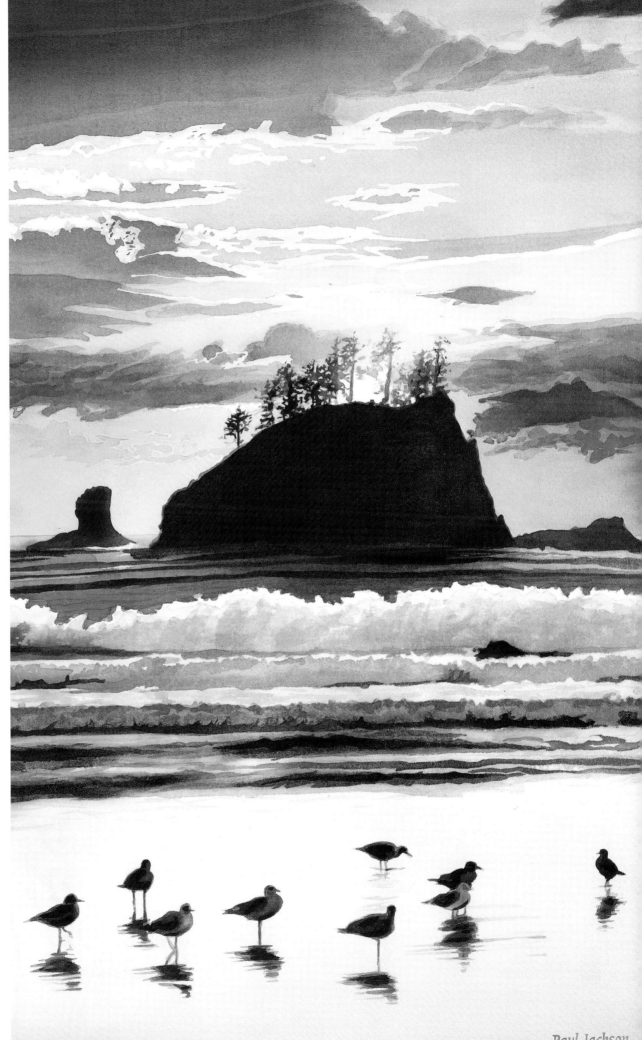

Paul Jackson

WHAT THE ARTIST USED

Support
260lb cold press
watercolor paper

Brushes
Kolinsky sable rounds,
even sizes #2-14
1", 3" flat synthetic brushes

Colors

Cadmium Yellow
Naples Yellow
Lemon Yellow
Cadmium Red
Alizarin Crimson

Purple Lake
Dioxazine Violet
Indigo
Ultramarine Blue
Turquoise

1 POUR ON PRE-MIXED PIGMENT
For the boldest, stroke-free skies, pouring pre-mixed paint onto your just-stretched paper can provide a great starting point. The paint blends smoothly on the wet paper as gravity pulls it down the steep angle of my painting board. I generally have some idea in mind about what I want, but sometimes I let the initial pour determine the subject and direction of my painting. In this piece, I leave the lower right corner of my composition white so that I can draw and paint back into it later.

2 ADD REFLECTIONS TO WATER
Once I determine how to best use the poured composition, I draw in details and a framework for the subject. I then layer over the lower left corner with strokes in the opposite direction to suggest the reflection of the sky in the water.

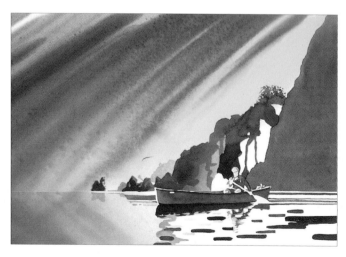

3 BLOCK IN FIGURE AND LANDSCAPE
Using mixes of my original sky colors, I block in the central figure and the surrounding landscape. Once these layers are dry, I add darker details with Violet and Indigo.

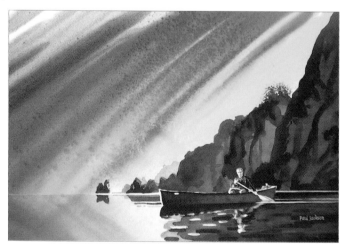

4 FINISH WITH DARKER DETAILS
Resolving the figure with darker details and high contrast makes it come forward from the dark landscape. Final washes and dark shadows complete the value scheme and make this dramatic sky come to life.

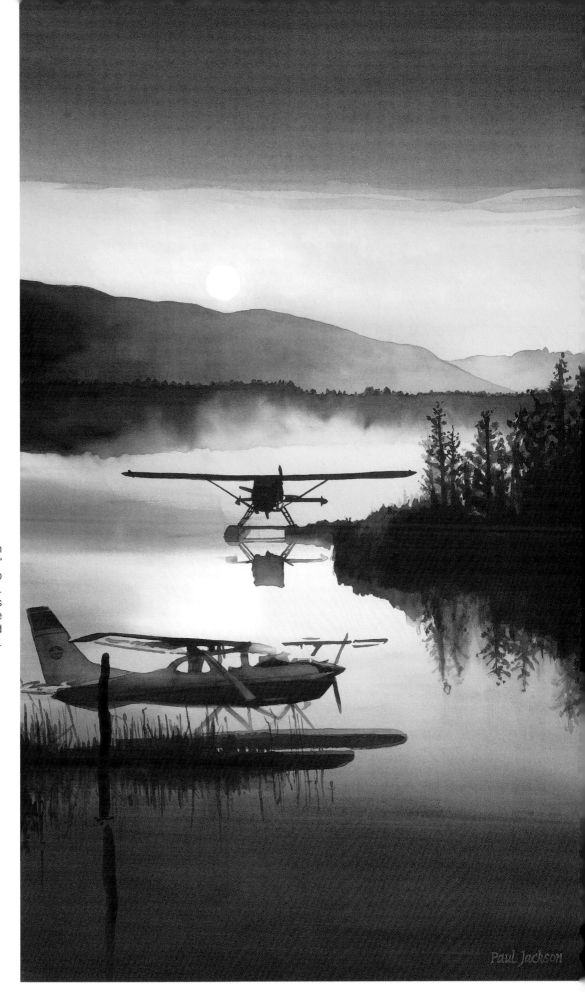

SKY HARBOR, 26 x 40"
(66 x 102cm), WATERCOLOR
All of the sky and sky reflections in
this painting were handled with a 3"
flat brush. The sun was masked to
preserve the perfect circle of white.
The sky, clouds and mountains
were built in a series of successive
layers from light to dark. Foreground
details were added as a final layer.

TURNING POINT

When writing my instructional book, *Painting Spectacular Light Effects in Watercolor,* I was compelled to more closely examine every facet of my own painting experience. I came to truly appreciate the value of a finely stretched piece of watercolor paper and how it can dramatically affect the outcome of your painting. So much more control can be obtained on stretched paper, as much of the buckling issue has been eliminated in advance.

PONT NEUF PARIS,
22 x 30" (56 x 76cm), WATERCOLOR
Lots of water and pre-mixed paint at the ready are required to paint a color-shifting sky like this one. Painting gradations around the clouds can be tricky, but if worked quickly with large brushes, can be done without obvious brushstrokes in the sky.

RACING THE SUN,
26 x 40" (66 x 102cm), WATERCOLOR
The "silver lining" created when the sun is behind a cloud makes an exciting visual element to paint. No silver paint is required, only strong contrast in value. Simple wet-on-dry layers and gradations toward the light source make this bold and dramatic image rather uncomplicated to paint.

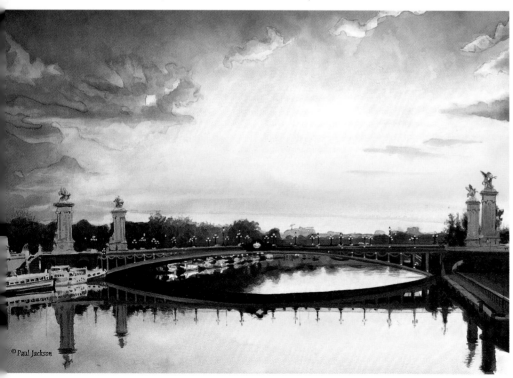

ABOUT THE ARTIST

Paul Jackson began his career in watercolor at the age of 15, and received his first award from the American Watercolor Society at the age of 23. Now 30 years old, Jackson has accumulated nearly 300 awards for his watercolors, including: Best of Show from the Rocky Mountain National Watermedia Exhibition and the Kansas Watercolor Society, First Place in National Watercolor Oklahoma, and the Award for Creative Watercolor from Allied Artists of America.

Paul received his B.F.A. in Painting from Mississippi State University in 1989 and his M.F.A. in Painting/Illustration from the University of Missouri, Columbia in 1992.

Jackson is the author of *Painting Spectacular Light Effects in Watercolor,* and the designer of Missouri's commemorative state quarter.

His work is represented by Illumia, a Paul Jackson Gallery in Columbia, Missouri.

TONY LEWIS SHOWS HOW TO CAPTURE THE POWER

The state of the sky dictates the landscape.

The state of the sky dictates the colours and tones found in the entire landscape. For instance, if you want to portray a cool, stormy sky, to give your painting unity, the cool grays and blues that you will use in the sky will need to be reflected back in some way into the earth. Become a student of the sky. It can be a cloudless, featureless backdrop or it can be the drama of the play itself. The light in the sky and clouds can state your message more effectively than anything else.

Don't just paint the top one-third of the paper blue because something has to go there. Use the sky as your ally. Manipulate the shape, size and colour of the clouds to exaggerate what you want to convey.

Think carefully about where you will place the lost and found edges on your clouds. Consider using rimlight and corona effects. Make clouds benign or malevolent with impending violence; send them scudding across the sky in gathering legions or sit them still, like the happy, fluffy tufts in storybooks. It's up to you.

While you are developing your skies, think about the dividing line between sky and land. You don't have to make every painting one-third sky to two-thirds land. Why not make it two-thirds sky and one-third land? Or even half and half – which is where you use clouds to spectacular effect.

Over the years I have learned many lessons. One of them is – less is more. When you paint, try to understate. What you leave out is so important because it leaves the interpretation of the painted scene up to the viewer.

I also have found that while I may be thoroughly familiar with the street where I live, one morning the light may be so different and beautiful that there will be a feeling of newness to it. In the excitement of that fleeting effect, I will be immediately inspired to reach for my watercolours.

SUMMER SHOWERS, WEST COUNTRY, ENGLAND,
14 x 21" (35 x 53cm), WATERCOLOR
Here I was inspired by the shifting light created by the rain clouds.

First, I applied a light wash of magenta and raw sienna, lightening from top to bottom. When that was dry, I wet the paper again in certain areas with clear water. With a mix of ultramarine blue, indigo and magenta, I painted the clouds.

The waterway is my device to lead the viewer into this painting.

I feel the best feature here is one of dramatic movement in the sky.

ART IN THE MAKING VISUALIZING MORNING LIGHT

For my watercolor, "Tranquil Morning," I visualized a morning light with a moored boat. My goal was to create a feeling of tranquility and stillness.

The scene I envisioned uses a low horizon line in order to reinforce the mood of the sky. The absence of waves on the water's surface adds to the stillness in the scene. Tying it altogether would be a color harmony throughout the painting.

WHAT THE ARTIST USED

Support
Arches 300gsm rough watercolor paper

Brushes
Da Vinci Rounds #12, #8, #4
Da Vinci Large Mop
Long-hair Flat
Fine Rigger

Colors
Ultramarine Blue
Cobalt Blue
Cerulean Blue
Turquoise
Peacock Blue
Indigo
Raw Umber
Burnt Umber
Raw Sienna
Burnt Sienna
Lemon Yellow
Cadmium Yellow Pale
Aureolin
Permanent Rose
Cadmium Rose
Magenta
Alizarin Crimson
Cadmium Orange

1 BEGIN WITH A MONOCHROME SKETCH
Quite frequently before I start painting, I will prepare a monochrome sketch to establish my tonal values. ▶

4 ADD THE DISTANT HILLS
With the paper now dry, I prepared a mix of ultramarine blue and magenta for the distant hills, still holding my board at a 20-degree angle. The colors were kept at a creamy consistency. Working rapidly from left to right, I added raw umber, then raw sienna to the waterline. When almost dry, I came in with a creamy mix of ultramarine blue and raw umber for the trees and reflections.

5 DEVELOP THE BOAT AND REFLECTIONS SIMULTANEOUSLY
It is important to put in the reflections at the same time as the boat. To obtain the feeling of the boat sitting in the water, I ran a wash of clear water above and below the waterline. While the paper was still wet, I used a creamy mix of raw umber and ultramarine blue. The color spreads to give you the required reflection. The general rule for reflections is: the lights are darker and the darks are lighter. I then came in strong with ultramarine blue and burnt umber to strengthen some parts of the water line.

2 DRAW IN AS FEW LINES AS POSSIBLE AND APPLY THE FIRST WASH

I keep my drawing to as few lines as possible. Here I use a soft pencil, which enables one to get a line without pressing too hard.

I applied a wash of raw sienna in a weak mix, while holding the board at a 20-degree angle. As I work down toward the skyline, I weaken the wash to almost clear water. I then proceed to the foreground, strengthening the wash rapidly as I come down.

3 CREATE THE CLOUD EFFECT

I put a wash of clear water on parts of the sky. While this was still wet, I came in with a mixture of ultramarine blue and burnt umber. I applied this mix in varying degrees for the cloud effect, continuing into the foreground.

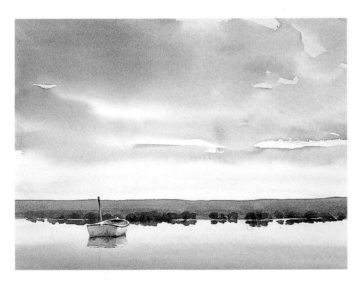

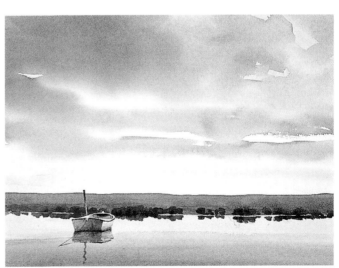

6 LIFT OUT BACKGROUND TREES

I made a mask by placing two pieces of paper on each side of the pile, to which the boat is moored. With a damp sponge, I lifted out the color of the background trees.

7 Finally, I put in the line and reflection coming away from the stern of the boat. The result is "Tranquil Morning", 10 x 14" (25 x 35cm).

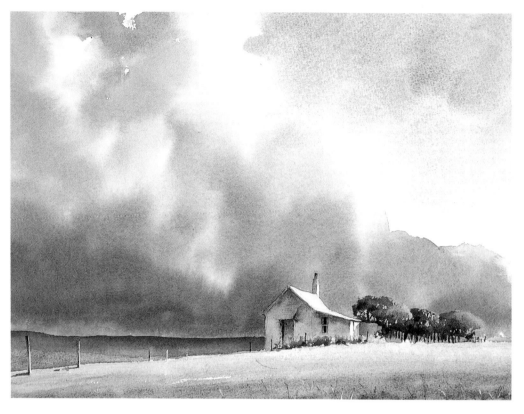

MT. MEE COTTAGE, 10 x 14"
(25 x 35cm), WATERCOLOR
My inspiration for "Mt. Mee Cottage" was the power and grandeur of nature contrasting with the cottage. The impressions of fast-moving clouds and impending storm are its best features.

I started with cobalt blue with cerulean blue on dry paper. I then worked quickly while the blue was still wet and added a weak mixture of raw sienna and permanent rose, working from top to bottom. While the paper was still wet, I applied permanent rose and indigo by using these colors in varying degrees of strength, cutting around the roof and chimney.

Other colors in painting were ultramarine blue and raw umber.

My low line of sight emphasizes the light on the roof for added impact.

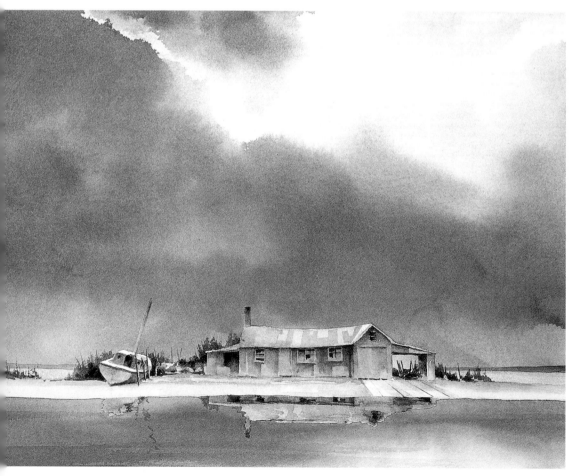

APPROACHING STORM, 10 x 14"
(25 x 35cm), WATERCOLOR
Being in the southern-most part of New Zealand a few years ago, I was inspired by the foreboding feeling of a storm about to break. I also found the old boat builder's yard in this area appealing. The imminent feeling of a deluge on a building exposed to the elements makes for a dramatic scene to paint.

My colors were raw umber with magenta in the sky; and indigo and magenta for the clouds. I also used raw sienna in this work.

I tend to use raw sienna, rather than yellow ochre, which is very opaque.

The compelling feature of the resulting painting is the dramatic color of the sky against the light roof and foreground.

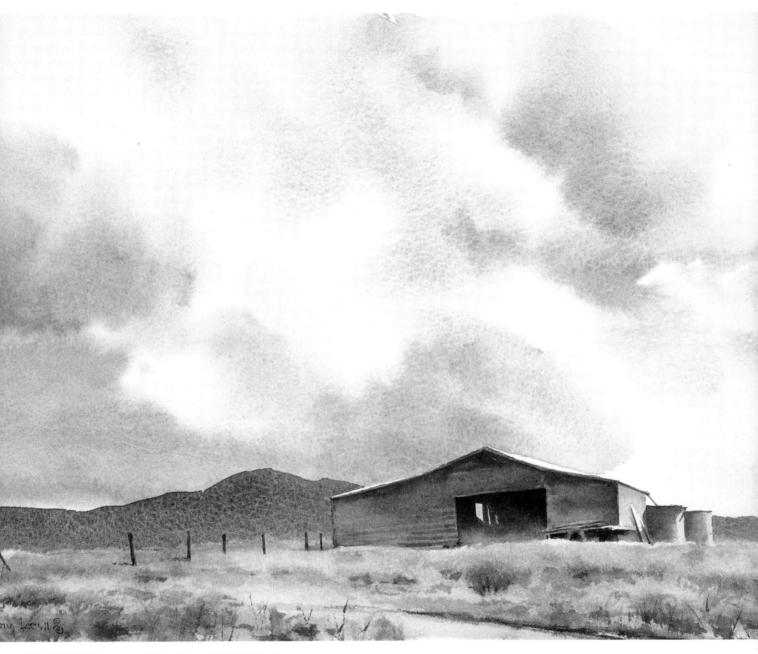

TAYLOR'S BARN, 10 x 14" (25 x 35cm), WATERCOLOR

This work has a timeless quality about it.

Its best features include using the barn roof to break the skyline at a low line of sight, and the feeling of shifting light across the water tanks.

I like to show human involvement. In this instance, it's the pieces of timber against the building.

The sky was achieved in the same way as "Mt. Mee Cottage." In the foreground of this work, I used peacock blue, raw sienna, burnt umber and cobalt blue.

ABOUT THE ARTIST

Tony Lewis was born in the UK and moved to New Zealand in 1963.

He has been painting professionally for approximately 30 years. Prior to this, his business was in advertising in England and New Zealand.

Tony has judged various art awards and was invited to participate in the Asian Pacific Watercolour Exhibition in Taiwan in 1997. His works hang in private collections, the USA, Canada, Australia, Japan, New Zealand and England.

His artworks are currently exhibited in galleries in New Zealand and in Brisbane and Sunshine Coast, Australia, where he and his wife, also a watercolorist, have lived for the past six years.

MARTIN LUTZ USES WET PAPER TO EXPRESS THE

This German artist shows that painting bold and controlled must not be a contradiction.

In landscape painting, nature is the best model. But I don't always paint a sky as I see it. I don't copy a sky. As an artist, I visualize or imagine a certain mood or atmosphere which I want to express. After that, I take the liberty to invent some cloud formations.

The best way to tackle a sky, free and bold, is to use wet paper. The nature of wet paper creates fluid runs and exciting mixtures of color. Above all, soft gradations and edges emerge, which express the softness of clouds particularly well.

However, those soft edges are not always easy to achieve. How is it possible to control your colors on wet paper? On the one hand, I have to evaluate the humidity of my paper correctly. If the paper is too wet, I easily lose control over my color. If the paper is too dry, my colors can't spread out.

Likewise, it is just as important to carry the right amount of water in my brush. Too much water can cause unexpected runs. Using too little pigment and water in my brush prevents fluid color application. As the humidity of the paper changes, evaporation makes it drier in some spots, while new brush strokes make it wetter in other spots. I constantly have to adjust the consistency of the pigments in my brush. In general, I use a lighter and more liquid mixture in the beginning, and a darker and more concentrated mixture towards the end. When the paper becomes almost dry, I use a creamy mixture with little water in my brush.

It is similar to the application used in oil painting. There is a rule in oil painting: "Fat over lean." Oil painters thin their colors with mineral spirits in the beginning and paint with a more creamy mixture at the end. As a watercolorist, I change from a wet-on-wet technique to a creamy-on-wet technique during the painting process. This guarantees the most control over my brush strokes and edges.

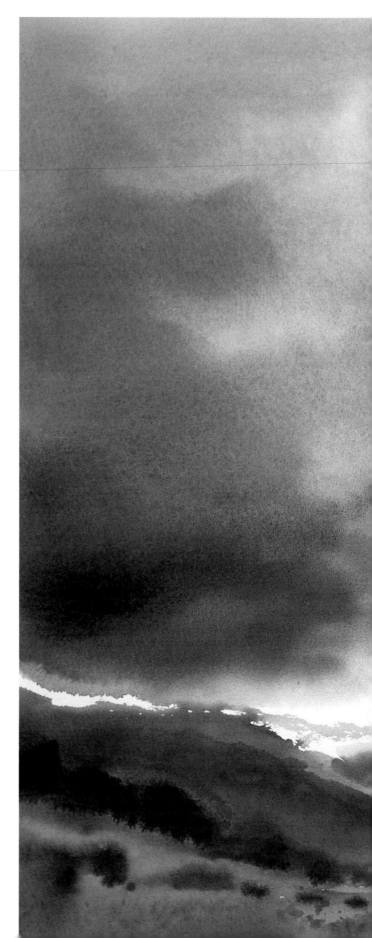

BLACK FOREST, 22 x 30" (56 x 76cm), WATERCOLOR

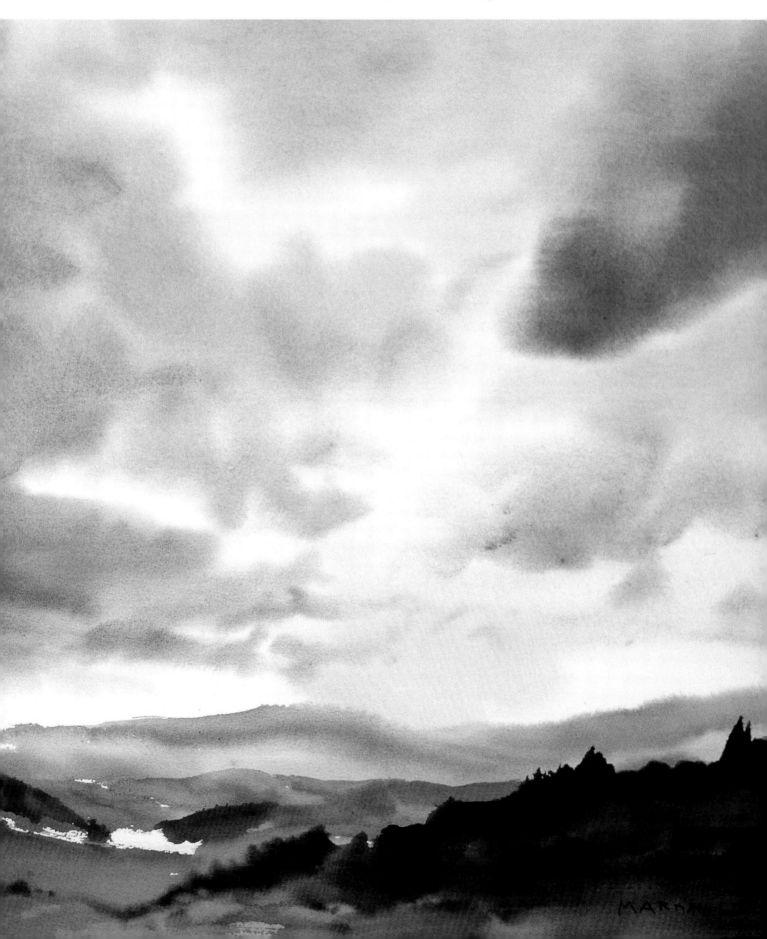

ART IN THE MAKING PLANNING AHEAD ALLOWS GREATER FREEDOM

Working with wet paper makes watercolor a fast medium. This means that there is little time to make considerations during the act of painting. Therefore, it is wise to do some kind of planning beforehand. A good way to prepare myself is by making a value sketch. Seeing my value plan before me helps me to make fast decisions and to paint the right brushstroke on the right spot.

Before I start painting, I thoroughly wet my paper with a sponge. Then I normally begin with a light under-painting over the whole sheet. In order to paint fast and bold I need big brushes. As long as the paper is very wet, I use large, flat bristle brushes. They hold a lot of pigment and cover the paper quickly.

Once I've done a stroke on the paper, I don't go back into it. For instance, I don't "repair" a cloud. This would only lead to unwanted water marks and muddy colors.

At the end of the painting process, when the paper becomes drier, I switch to nylon-haired brushes. They absorb less water, form sharp edges, and give me more control over my brushstrokes.

WHAT THE ARTIST USED

Support
140lb (300gsm), 22 x 30"
(56 x 76cm) rough
watercolor paper

Brushes
2.5" Flat bristle
1", 1½", 2" flat nylon-haired
brushes

Colors

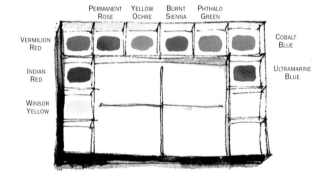

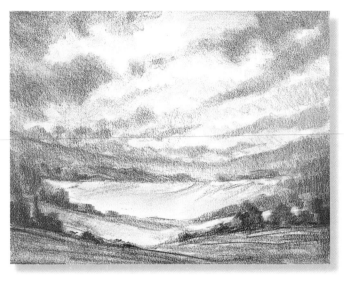

1 CREATE A VALUE SKETCH
All the visual information I need for my watercolor is in this value sketch. Dark clouds and tree shapes on the left and the right of this composition form a kind of frame for the light fields in the middle. The 6B graphite stick marks were partially smeared with a finger to produce soft edges.

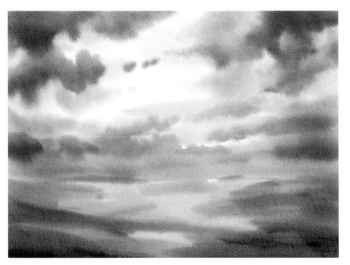

4 PAINT THE CLOUDS DRY-ON-WET
This is the most crucial stage of the whole painting. As the sky area has different degrees of humidity – the unpainted white parts are a bit drier than the yellow parts – I paint the clouds in a dry-on-wet technique. Now there is more pigment but less water in my brush. I paint the clouds in one go with a cool mixture of ultramarine blue, cobalt blue, burnt sienna and permanent rose. I further darken the area of the land.

TO BE BOLD

2 START WITH A PENCIL DRAWING

After the light pencil drawing, I wet my paper thoroughly. I put my board at an angle of about 15 degrees to avoid puddles and start with a very light under-painting. My colors are a warm mixture of Winsor yellow, Indian yellow, yellow ochre with a little cobalt blue and permanent rose at the foreground. In the beginning stage, I use large bristle brushes between 1" and 2".

3 USE LARGE BRUSHES

In order to get soft edges, I directly paint my next strokes on the wet paper. I'm still painting fast with my large brushes. I strengthen the sky and the foreground with the same colors and add a bit of vermilion red, phthalo green and ultramarine blue in the foreground. I keep the values very light, except at the bottom of the sheet. Note that I still leave a lot of white paper in the sky area.

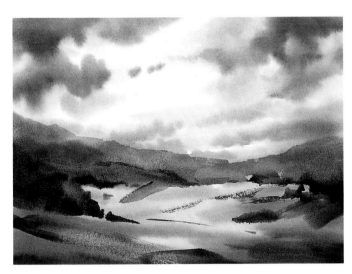

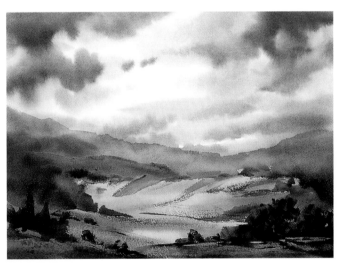

5 ADD THE MOUNTAIN

I wait until the sky is dry. Then I paint the mountain at the horizon on top of the lower clouds. Since the mountain has a similar color and almost the same value as the sky, there is a smooth transition between the sky and earth. Next, with smaller nylon-haired brushes, I put the green hills into the mountain and the dark forest shapes on the left and the right middle ground. Those dark trees make the fields in the middle look even more brilliant.

6 PAINT THE TREES AND SHRUBS

With a dark and creamy mixture of ultramarine blue, burnt sienna and phthalo green, I paint the trees and the shrubs in the foreground. With a few dry brushstrokes on the yellow fields, I finish my "Sunlit Fields" painting.

RAIN IN BRITTANY, 22 x 30" (56 x 76cm), WATERCOLOR

Storm clouds change quickly. I tried to emphasize their movement by giving the band of clouds a diagonal direction. Different kinds of grays for the clouds, with light and dark values, express variety and drama. With a steel brush and the tip of a pocketknife, I scratched striations into the wet paper to symbolize rain. The wet technique was used in the upper part of the land, too. Notice the soft edges of the trees and how they fuse with the sky.

(RIGHT) SUMMER IN BAVARIA, 22 x 30" (56 x 76cm), WATERCOLOR

This is a sunny day with a cheerful mood. The big cloud spreads out like a blanket. I painted the clouds in the dry-on-wet technique. This gave me control over their edges. The clouds are three-dimensional, lighter on top, darker on the bottom. This gives them volume and weight. I put a lot of earth colors on the underside of the clouds. Reflected light is coming up from the ground, giving the composition harmony of color.

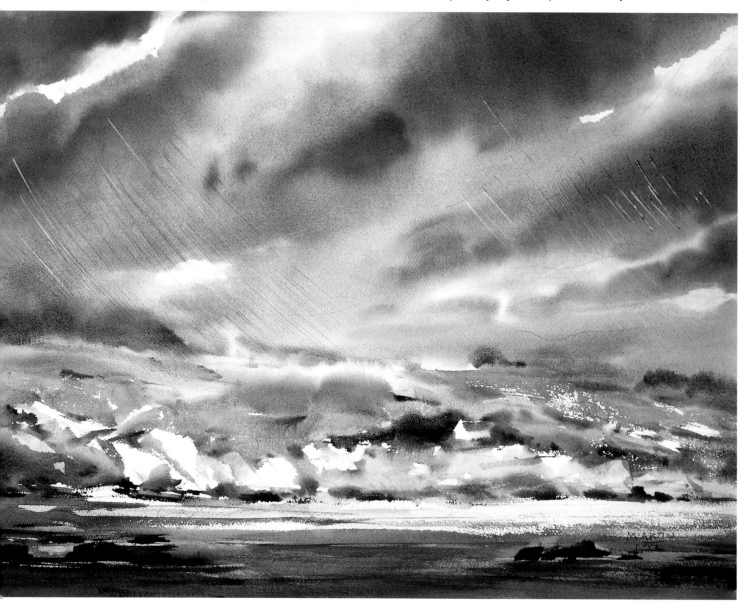

TURNING POINT

The most important turning point in my career as an artist was the founding of my own painting school a few years ago. Since then, I have been working full time and concentrating primarily in the medium of watercolor.

I am also working and associating with a lot of interesting people who share the same interests. The communication and interchange with other artists prepares the ground for new ideas and motivation.

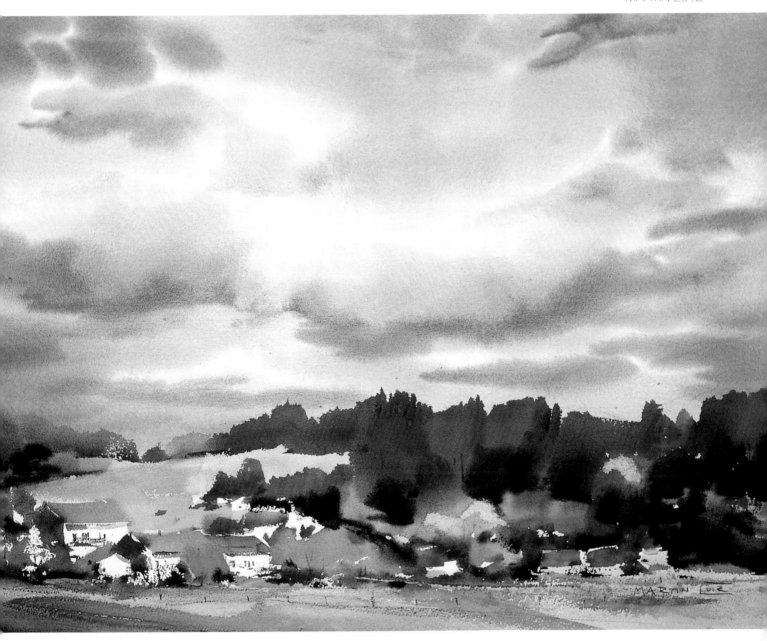

ABOUT THE ARTIST

Martin Lutz has been trained as an art teacher at the Pädagogische Hochschule in Kiel and continued his artist education at the Academy of Art in Karlsruhe, Germany.

His watercolor paintings have been shown in international exhibitions in Europe, USA and Australia, and have won several prizes, such as the President's Award of the Louisiana Watercolor Society, the Walter Foster Publication Award, and the Grumbacher Gold Medallion Award. His work is represented in private and public collections, including the Federal Republic of Germany and the State of Rhineland-Palatinate.

He is a member of the San Diego Watercolor Society and a life member of the Louisiana Watercolor Society.

Martin, with his wife, runs his own watercolor school. The school attracts artists from all over Europe.He is the author of the book, Meisterschule Aquarellmalerei ("Master Class in Watercolor").

His work can be seen on his Web site gallery at www.aquarellschule.de.

ANGUS McEWAN DEMONSTRATES HOW OPTICAL MIXING CAN CREATE RICHER COLORS

Layering pure color washes on the paper, rather than mixing colors on the palette, provides a greater range of color choices.

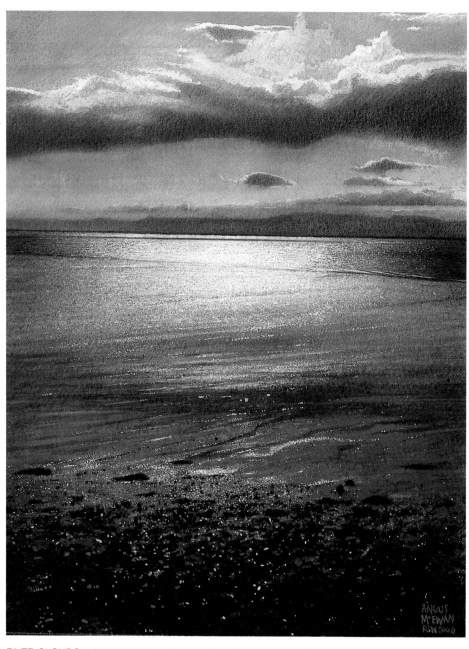

I tend as a rule to use my colors pure, straight from the tube, although that does not mean I don't mix. I prefer to place a layer of pure color on the paper and apply a veil of color on the top of that. This can create a very rich and powerful combination, usually quite different from the qualities gained from the traditional mixing of colors. I call this type of mixing "optical" mixing.

For example, putting blue over orange contrasts starkly with orange over blue. The intensity and color created (warm or cool) is usually dominated by the color overlaid, but the role of the color underneath, though subservient, cannot be underestimated.

It is this layering effect that I have applied to my advantage, producing a wide variety of choices from a limited selection of colors. With three alternatives from two colors, the range of possibilities at our disposal can influence our options and our choices are reflected in our painting's final outcome.

RIVER CLOUDS, 10½ x 8" (26.5 x 20cm), WATERCOLOR AND PENCIL
This is a view of the river Tay at Wormit Bay, Fife, Scotland, looking towards Perthshire. At this point, the river is tidal and frequently leaves large sand bars which seals use to sun themselves on.

The painting looks very monochromatic. Although it includes yellows, oranges and umbers, it most definitely belongs to the cool blue range.

I used the "Golden Section" to guide me in placing the horizon line as I knew this would provide me with a pleasing composition. The foreground has the most extreme use of tonal contrast (the difference between dark and light). This tends to command the most attention, thus producing the illusion of being closer to us.

The painting is an example of aerial perspective, whereby the tonal contrast reduces the further back into the landscape we recede. As we recede into the distance, the atmosphere interferes with the transmission of color to our eyes and, as a result, everything becomes bluer. Using this knowledge, we can manipulate the viewer into believing the painting has depth.

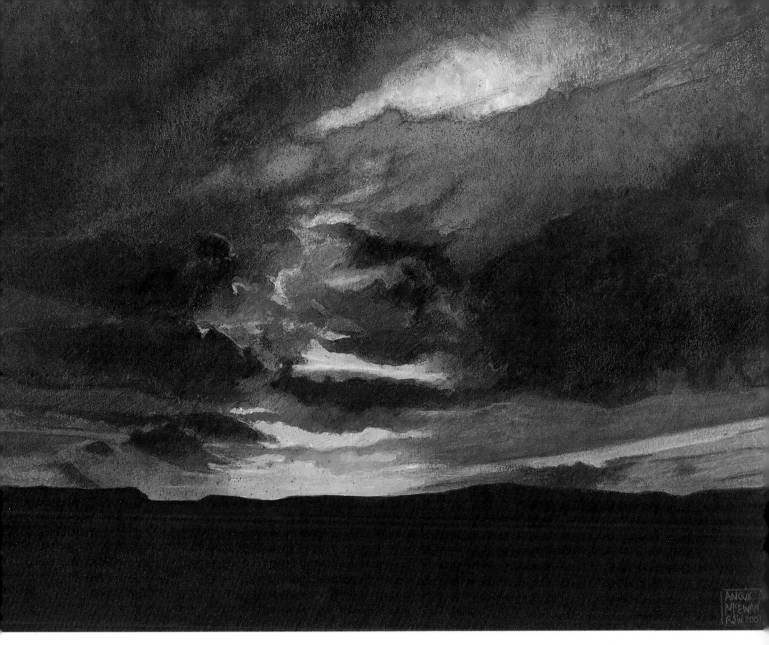

FIRE IN THE SKY OVER PEACE HILL,
18 x 20" (45.5 x 51cm),
WATERCOLOR AND PENCIL

This painting depicts the sun setting in November in Scotland, behind a farm situated on Peace Hill. Visually, from my position, the sun set at around 3:30 p.m. and was exceptionally dramatic. The sky seemed to be on fire. I enjoyed the intense blues playing off of the reds and yellows.

The painting was initially worked wet-on-wet fairly rapidly in an effort to establish the main shapes, colors and tones. I tried to allow the shapes to blur at the edges, while at the same time trying to maintain each discrete profile. The challenge was to have the bright yellows, oranges and reds alongside the deep blue and not let the painting descend into an incomprehensible mess. It was an exercise in making the astonishing convincing.

CREATE A TONAL STUDY

Half closing your eyes has the effect of reducing the amount of information your eyes take in. This simplifies the image for you. If you have problems seeing tone (or values), look through a piece of colored acetate, which gives you the equivalent of a monochromatic version of your view.

As the black-and-white illustration at right shows, I feel it is important to see how an extremely colorful picture like my "Fire in the Sky over Peace Hill" reads tonally. If the tones are accurate, it almost doesn't matter what colors you use.

Digital cameras often have a black and white setting, so you can view your image without color, too.

WHAT THE ARTIST USED

Support
Fabriano Artistico 300gsm cold press watercolor paper stretched with gum strip onto ply board

Brushes
#000, #00, #0, #1, #2, #4, #6, #8, #10 Round
¼", ⅜", ¾", ½", 1", 2" Square-headed One Stroke Synthetic #000, #00, #0, #1, #2, #3, #4, #5
Kazan Squirrel Quill Mop

Other Materials
Plant sprayer
Watercolor pencils
Worn brushes

Colors
Violet Gray
Prussian Blue
Chinese Orange
Olive Green
Raw Sepia
Cobalt Blue Turquoise Light
Cinereous Blue
Cadmium Yellow Orange
Indian Yellow
Bright Violet
Venetian Red
French Vermilion
Chrome Gray

1 THE INSPIRATION
I always carry my digital camera with me for occasions like this and I captured the moment as the landscape quickly changed. ▶

4 BLOCK-IN WITH THIN WASHES
I start by using thin washes of cadmium yellow orange watercolor. I lightly wash in areas which have yellow/green hue to them. I then block in the landscape with a mixture of Prussian blue and raw sepia with a flat one-stroke brush. I work cinereous blue over the cadmium yellow/orange especially at the horizon. I then work on the sky with a #6 round. I start working into the clear cloudless areas with cobalt blue, leaving the white areas of the cloud as paper to start with. I add pure Prussian blue on top of the yellow and cobalt to darken the shapes. I then work into the cloudless areas, deepening the strength of color.

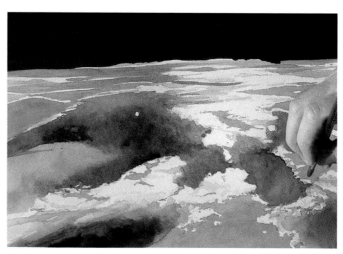

5 DEVELOP THE SHAPES
I mask off the bottom area and use a plant sprayer to spray clean water onto the rest of the sky in order to soften the paint. The reason for doing this is to be able to work into the mass of the shadow using strong Prussian blue and to soften the edges with clean water. This allows the paint to run and to lessen the amount of hard edges in areas I don't want them. At this moment, I am thinking about big shapes and large areas of color. I won't address details until much later. I then break into the larger masses of white paper with diluted Prussian blue to break up the size and whiteness of these areas. Then I work over the large areas of dark cloud with Prussian blue to deepen and strengthen them, while making sure that the paper is damp. When I want crisp detail, I always work wet-on-dry; when I am after diffusion and softness, I use the wet-on-wet technique. I work back over the large tonal masses with Chinese orange to deepen the tone and to cancel out the blueness of the Prussian blue. That adds a bit of warmth to the sky.

REFINE AND TONE EARLY MORNING CLOUDS

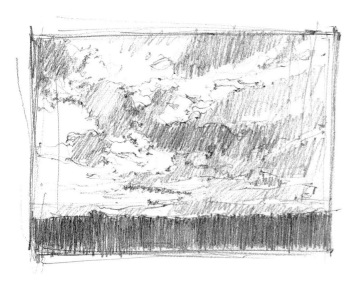

2 CREATING A TONAL SKETCH

I worked on the pencil sketch for this painting while waiting for a train early one morning at Leuchars (near St. Andrews, Scotland). The sunrise was very dramatic and I enjoyed watching the play of light changing as the sun slowly raised itself from the horizon on a very crisp November morning.

I further developed the sketch from memory while I was on the train The painting then becomes part memory, part knowledge, part sketch, part digital image. I drew upon my experience to develop the sketch to the final conclusion.

3 CREATE AN INITIAL DRAWING

Holding my 3B pencil loosely, I meander around the edges of the shapes, trying not to be too crisp or hard, but trying to capture the complexity and elusiveness of the cloud shapes. I changed the format of the painting from the initial sketch, as I felt that the original idea was too static with the foreground gaining too much importance.

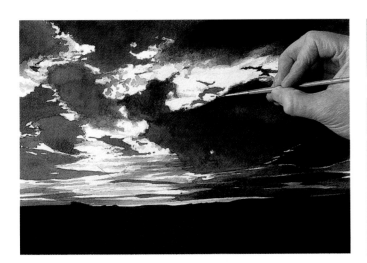

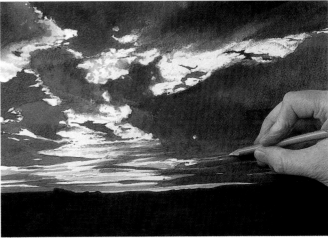

6 ADJUST THE TONES

I use a large brush to apply the Prussian blue over the mass of dark cloud, glazing and bringing down the tone to help unify disparate areas. I start working into clouds with chrome gray (more purple than gray), using a #4 round brush. Chrome gray is very versatile. It is opaque, but when used thinly, it provides a nice gray on paper; used thickly, it gives a lighter quality pale purple color. I use cobalt blue turquoise light in some areas of the cloudless sky near the horizon as it has a green quality that is similar to the way the sky at the horizon is when it is altered by the rising sun. I always work on an easel with the board vertical. I only lie the board flat to work on areas with lots of water or for spraying with a plant sprayer. I decide to put the board flat and work into the areas of shadow with a #3 and #00 Kazan squirrel quill mop (a soft-haired watercolor brush). This holds a tremendous amount of watercolor, but at the same time keeps a point and therefore can allow for fine detail. I use Prussian blue and warm sepia to create my dark. I then put in another layer of Prussian blue over the cloudless sky, deepening the tone and strengthening the color while working flat. I dry the picture with a hair dryer.

7 USE WATERCOLOR PENCIL TO RE-ESTABLISH FORM

Using a watercolor pencil, I decide to work into some of the clouds to re-establish form and tone. Working with a graphic medium helps me focus back into the shapes and tones, rather than getting overwhelmed by color. I sometimes work into a painting with watercolor pencils if I want a particular result or want to boost the color and tone. This is extremely useful if you want to preserve a certain textural effect when adding another layer of watercolor would agitate and alter the surface irrevocably. I do whatever is necessary to make a picture work, as long as it is conservation-friendly. Next, I work back in with yellow and cobalt blue to soften and alter tone in some areas, and to refine the white parts. Refinement is critical at this stage. Otherwise, the picture looks crude and unrealized. I then work back into some pencil work with chrome and gray watercolor. Next, I work into some of the white cloud areas and soften them with an old worn square brush and clean water to quiet down and soften the edges that were too harsh.

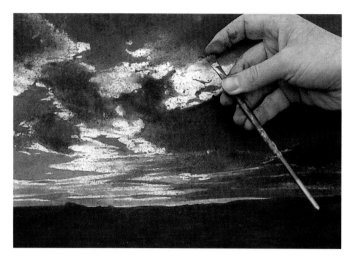

8 USE THE SPLATTER TECHNIQUE

After working back and forward with watercolor and watercolor pencils, I then start splattering in some areas to build up the tone. Splattering with a worn-down brush produces irregular dots of tone and color. I use Prussian blue in the darkest cloud shapes, while taking care to mask with card or my hands some of the areas I wanted to be free from splashes. After a while, I decide that the white areas were far too "edgy." I soak the entire painting with clean water from my plant sprayer, then splatter into the picture with Prussian blue, yellow and cobalt blue. I did not use any reference, but instead went with my gut feelings. This helped to kill the white in the process. By wiping excess water off the brush, you can control the size of the splatter spots, as the splatter effect is managed by the amount of liquid on the brush. I then stipple the bottom landscape part to give it more solidity. I do not want to see paper showing through in this area. I work back into the picture with watercolor pencils to refine, enhance, and lighten areas. Next, I begin to work back into the lighter areas with Chinese white. Using a gray/sepia watercolor pencil and Chinese white watercolor, I work into the details to refine shapes and to lighten areas that had become dirty or splattered with spots of paint. There is always remedial work involved in tidying up the chaos created by uncontrolled splatter, but I enjoy pulling the picture back. I have now lost a lot of the edginess which surrounded the white and dark areas. The mass of dark in the clouds has a suggestion of form from the yellow light catching the underside of the clouds, as well as the tops, which are lit by a stronger white light. The dark of the blue creates a sense of extreme brightness you sometimes see with early morning light. I finish by dry-brushing with white to create small, wispier clouds to help play off the crisper and more realized shapes.

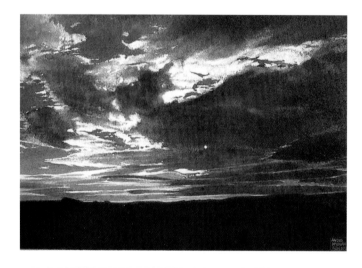

9 FINISHED PICTURE

My "Early Morning, St. Andrews" picture is now finished. Subtlety in the painting process has been the key. I want the picture to have impact, but I also want it to stand up to closer scrutiny.

TURNING POINT

When I decided to return to college in 1995 to study a post Graduate Certificate in Secondary Education, I had already been painting and exhibiting, as well as working full-time for eight years. It was during this period while at college that I applied for a number of scholarships, one of which I was fortunate enough to win: the Alastair Salvesen Travel Scholarship.

I chose to visit China. I spent three months traveling and painting, almost as soon as I had graduated that June in 1986. I traveled from Beijing to Xian, Chongching to Nanjing, down the Yangtze River, and then on to Guilin and Yangshou in the South of China.

As part of winning the scholarship, it was necessary for me to produce a number of paintings documenting my experiences. These were then to be exhibited in the Royal Scottish Academy, Edinburgh, on my return to Scotland. In the end I produced a total of 51 pieces.

I worked mainly from life and began to establish a rapport with watercolor, a medium I hadn't really explored properly up until that point. Since the material was light and convenient to carry, I found I could climb the hills, produce a painting at the top, return to the hotel and finish the work from memory. This versatility gave me confidence to really start enjoying watercolor and I began to experiment with it.

This was the turning point when I established my interest and association with the medium of watercolor. The year before, I had been elected a member of the Royal Scottish Society of Painters in Watercolours, but it was mainly because of my acrylic work. I really didn't start using the medium in earnest until the China trip in '96.

For the past 18 months I have concentrated on watercolor and I have discovered and investigated a number of techniques which can describe a multitude of surfaces (which I think are particularly unique). I owe it all to winning the scholarship, because it forced me to confront a medium I had considered at one point too difficult to contemplate trying.

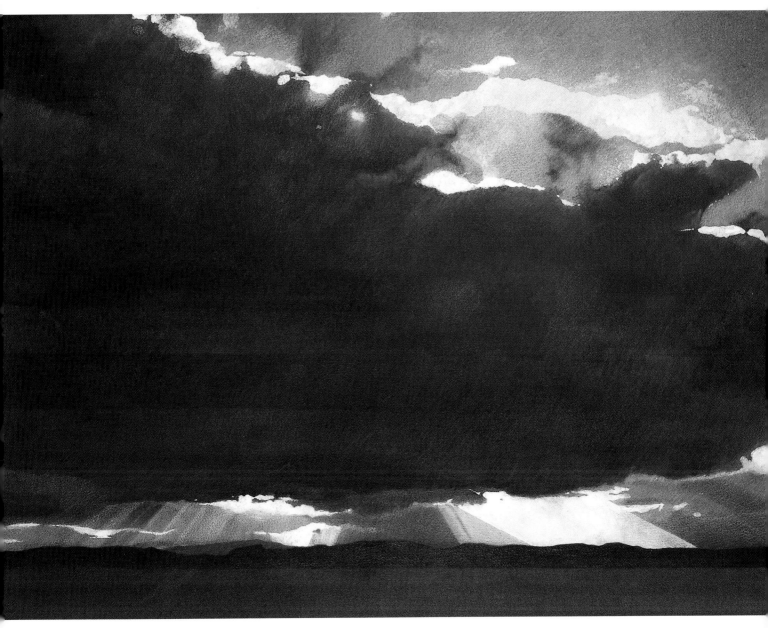

NATURE'S MAJESTY, 27½ x 36" (70 x 92cm), WATERCOLOR AND PENCIL

ABOUT THE ARTIST

Angus McEwan was born in Dundee, Scotland, in 1963. He graduated from Duncan of Jordanstone College of Art, Dundee, in 1988 with a degree and a post Graduate Diploma in Fine Art. Since then he has exhibited mainly in Scotland with the Open Eye Gallery, Edinburgh; Blythswood Gallery, Glasgow; Queens Gallery, Dundee; and the Jerdan Gallery, Crail. He also exhibits in England with the Thompson group – Marylebone, London; The City, London; Aldeburgh, Stow-on-the-Wold; as well as the Shire Pottery Gallery and Studio, Alnwick.

Angus regularly participates in the annual exhibitions with the Royal Scottish Academy; the Royal Scottish Society of Painters in Watercolours; and the Royal Glasgow Institute.

He has won a number of awards, including the Elizabeth Greenshields Award, Canada, (1987 and 1990); the Latimer Award (1995); and the Diana King/Scottish Gallery Award (2002) at the Royal Scottish Academy; The Alastair Salvesen Art Scholarship (1996); The Alexander Graham Munro Award (1999);

and the Glasgow Arts Club Fellowship (2001) at the RSW.

He was elected a professional member of Visual Arts Scotland (2002) and has been a member of the Royal Scottish Society of Painters in Watercolours since 1996 and a Council member since 2002. In 2003 he received two "finalist" awards from *International Artist* magazine.

Angus has been a part-time lecturer at Dundee College since 1997 and gives lectures and demonstrations all over Scotland. He has work in many private and public collections throughout the U.K., Norway, Holland, Australia, and North America. Angus' Web site is www.angusmcewan.com.

TERRY McKIVRAGAN SEES SKIES IN TERMS OF TEXTURES TO ACHIEVE MOOD AND MOVEMENT

By using acrylics as both watercolor-like washes and as luscious pigment, cloud formations can have a textural interpretation.

I paint in acrylics because I like their versatility. They enable me to use them diluted, with all the natural fluidity of watercolor, or straight out of the tube for a luscious, buttery spread of pigment. It is in exploring the combination of the two treatments in a painting that I find so exciting.

The contrasting textures of thick over thin not only display the natural qualities of the paint, which I think should be an integral part of a painting, but the technique contributes toward creating mood, atmosphere and movement.

I think I discovered the potential of acrylics when, while painting with pure watercolors, I found the urge to add body color to the later stages of the painting where I wanted to emphasize some particular aspect or simply to have a change of mind. I liked the contrasting marks they made, and from what I had heard and seen of acrylics, thought that this must be a medium which would allow me to develop this two-tier treatment.

The more I used the medium, the more I discovered how flexible it was. That encouraged me to explore the visual effects that might be achieved. This suited my approach to painting: an impressionistic style where the content remains recognizable but not detailed.

Textural effects and visible brushstrokes painted in carefully considered colors and tonal values contributed to creating the emotive images I was striving to achieve.

This applies particularly to skies, where the abstract nature of cloud formations lends them naturally to this textural interpretation.

THE GATEWAY, ZANZIBAR, 9½ x 10" (24 x 25cm), ACRYLIC
At sometime during the day, the normally blue Zanzibar skies can be dramatically transformed by heavy storm clouds. This creates an exciting backdrop that I attempted to capture here by relying on the natural effects of loosely applied washes with textural knife work overlaid.

WHAT THE ARTIST USED

Support
3mm mount board

Brushes
1" and 2" sable or synthetic flats for washes
Up to 1" sable or synthetic flats for opaque work
Painting knife for fine textural work

Other Materials
Stay-wet palette

Glass with a white card backing for mixing

Colours
Ultramarine Blue
Yellow Ochre
Cadmium Red
Raw Umber
Middle Gray
Titanium White
Magenta
Azure Blue

2 START WITH THE INITIAL DRAWING

Although much of the initial drawing will be painted over at a later stage, I like to make sure that the basic shapes and proportions are correct. Some of the drawing will show through. After drawing in pencil on a 3mm mount board, I overdraw with a pen and diluted acrylic paint, so that the drawing will show through overlaid washes.

1 VISUALIZE THE COMPOSITIONAL ELEMENTS

I start with the necessary preliminaries: photographic references of the Palace of Westminster, mini line sketches and a 5 x 6" (13 x 15cm) color sketch that is about half the size of the painting I will begin.

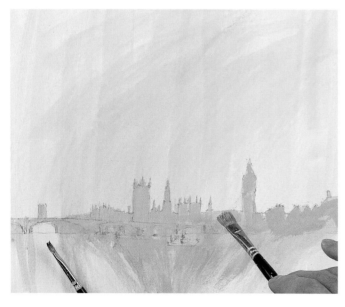

5 SWITCH TO THICKER PIGMENT

Using a thicker, creamy paint, the areas of tone are over-painted with a variety of sizes of square-edge brushes, depending on the size and intricacy of the area to be covered. More than one coat is probable at a later stage, with slight variations of color allowing previous colors to show through. It's nice if brushstrokes are visible. Smaller areas can be picked out, such as the boats.

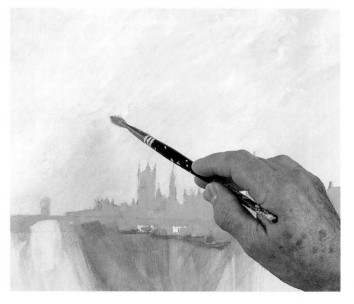

6 ADD COLOR TO THE SKY AND WATER

Now, using the paint straight out of the tube, and still using square-edge brushes, I paint the sky and water quite loosely. I over-paint with variations of the color as I start to create textures with the paint. All the stages so far have been laying down the foundations for the final development stage, where the painting takes off by refining all the painterly ingredients that will hopefully accomplish the aims of that original concept.

KNIFE CREATE UNIQUE TEXTURE MARKS

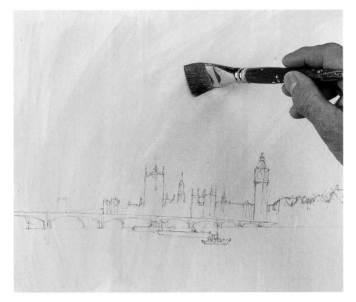

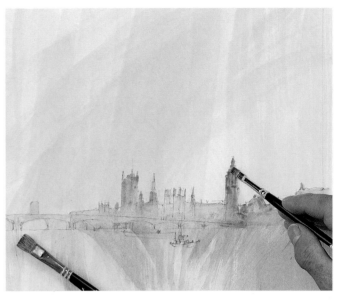

3 APPLY THE INITIAL WASHES

With a wide, square-edge brush, and the board dry, an overall wash of diluted acrylic is loosely applied. When dry, a second coat can be overlaid in a slightly different color to create brush marks which may be over-painted later, but may be left to show through in the end result. The color is chosen to complement the warmth of the final image.

4 DEVELOP THE TONAL VALUES

To help establish tonal values, washes are laid. In this case, it is a simple area. In more complicated compositions, where foreground and distance have to be established, different tones would be laid. I don't always keep to the defined areas; I let the wash drift into the river area in this case.

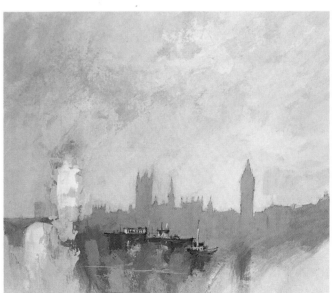

7 A PALETTE KNIFE ADDS TEXTURE FOR MOOD AND MOVEMENT

The more dramatic textural effects are created with the palette knife as I use the paint at its thickest. By sliding the knife over the board, one can create some very exciting textures. Now it's a case of refining the colors and textures, clarifying details where necessary.

8 THE FINISHED PAINTING

TURNING POINT

The move from a long career in the world of advertising design, working alongside other people, to working on my own as a painter necessitated a significant change in life style, but there was a link between the two worlds in the use of watercolors.

As a designer with a particular interest in illustration, in those days, felt tip markers and gouache were my tools of trade. In the later years, however, I became aware of what could be done with watercolors and began using the medium for my illustrations. I also became aware of the interesting work that contemporary watercolor artists were producing.

I began to think how nice it would be to be able to paint subjects that inspired you, rather than painting to order. I made the jump gradually by keeping up my commercial illustration work while exploring the art galleries until eventually I could devote all my time to painting.

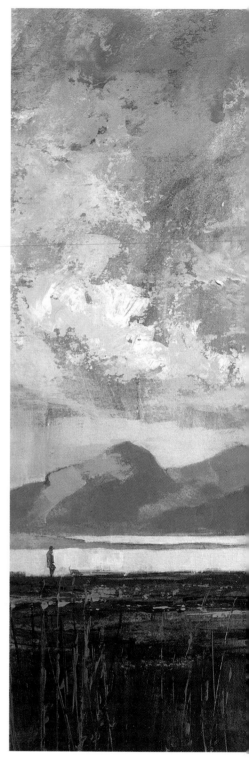

TOURISTS ON PARADE, PIENZA, TUSCANY, 10½ x 10½", ACRYLIC

Here the sky is not the prime interest, but its role is important to setting off the activity and bustle in the lower half of the painting. The colors are subdued, echoing the color theme of the painting. It is made interesting with subtle textures and color variables. There are no sweeping brushstrokes in this sky. The effect is achieved by scumbling, with the addition of some knife work.

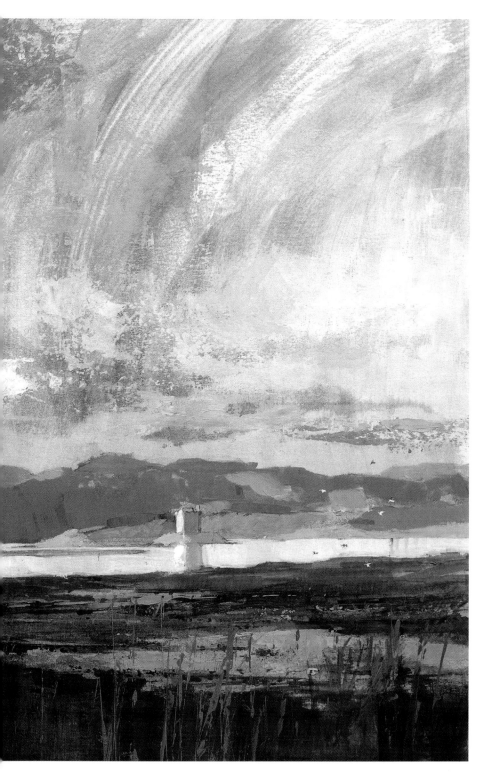

CASTLE STALKER, LOCH LINNHE, 14½ x 24¾", (37 x 62cm) ACRYLIC
Inspired by a view from my Scottish hotel, the strong horizontal composition and the stillness of the loch and distant hills are brought to life by a dominant sky of swirling brushstrokes and knife-applied cloud textures in bright and breezy colors.

ABOUT THE ARTIST

Terry McKivragan trained at the Wimbledon School of Art, where he gained the National Diploma in Design and Illustration. After a career in advertising design, he chose to concentrate on painting. He now exhibits with a number of galleries in London and around the U.K., including a number of the Society exhibitions at the Mall Galleries in London.

He won the Royal Institute of Painters in Watercolours Gold Medal and in 1997 was elected a member. He has successfully exhibited with the Hunting Prize, the Laing Art Competition, the Royal Academy Summer Exhibition, and in 2003 had four paintings chosen for the Discerning Eye Exhibition at the Mall Galleries.

Many of his paintings are to be found in corporate collections and his watercolors are published as limited editions and greeting cards.

Work currently being shown by galleries and publishers can be seen on the Internet by searching under "Terry McKivaragan." His e-mail address is terry@mckivragan.freeserve.com.uk.

BEN MANCHIPP EMPHASIZES DRAMA, SCALE, LIGHT AND COLOR

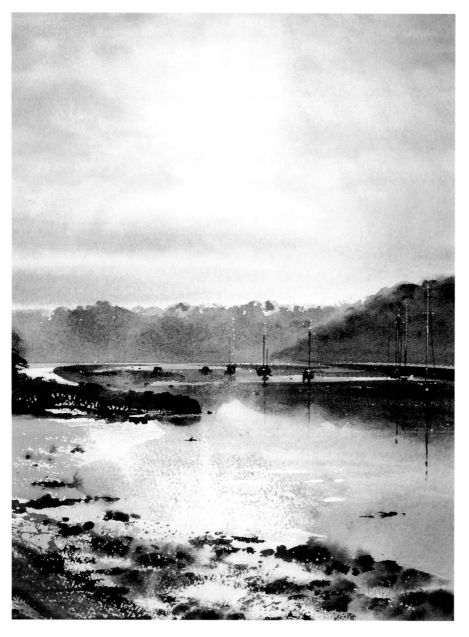

Learn the Manchipp way of creating a "wow factor" with scale and perspective.

Very often the sky can be a small supporting element in a landscape or secondary to a major architectural subject. In this series, the sky dominates the picture. Drama, scale, light and color are the most important elements, in my opinion.

With an extensive coastline never far away, the impact of our weather is considerable.

The choice of a marine subject for most of these paintings provides all the elements I find most stimulating. When a sky is reflected in water or on a wet surface, it increases the light and the impact of the scene on the viewer. The light, contrast and sparkle are very challenging to paint and are a positive stimulus to my work.

The "wow factor" of scale and perspective I find particularly exciting. I also look for a dramatic moment. Often a monochromatic or limited palette, with just small touches of color, enhances the mood or the drama. Two good examples of this are the paintings of "Pett Level Sussex" and "Dramatic Sky South Downs" on the following pages.

BAR CREEK CORNWALL 7 A.M.,
15 x 11½" (38 x 29cm), WATERCOLOR
My concept called for a very simple sky with soft colors, calm and quiet: A new day dawns. The painting required flawless washes and a carefully planned approach. Most of the sky colors are reflected in the water, thereby doubling the effect of light and color. I enjoyed what in effect was painting the sky twice. The foreground is by contrast sharp and contains the all-important "sparkle" effects.

WHISTABLE KENT – END OF THE DAY,
19 x 16" (48 x 40cm), WATERCOLOR
A lovely moment with the sailing finished for the day and a sunset over the bay. It provides a good contrast between the sky and the mast of the boats.

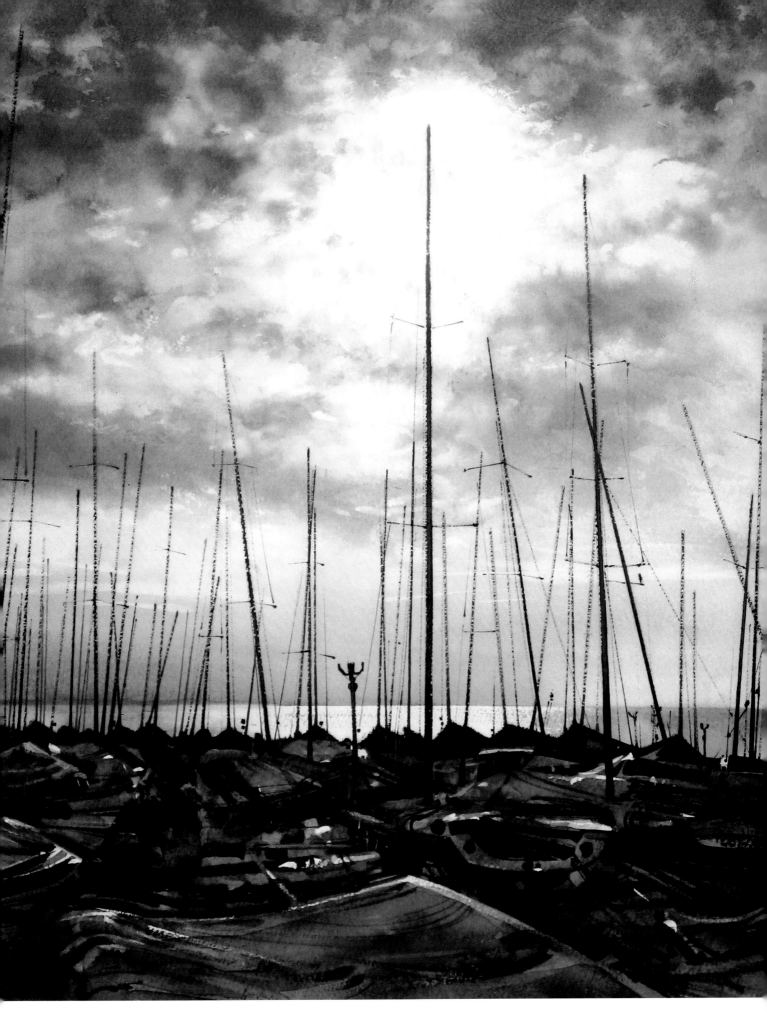

ART IN THE MAKING CREATING THE ILLUSION OF BACKLIT CLOUDS

The appeal of this subject was the scale of the sky compared to the landscape and the intriguing shape of the meanders of the river. I also was inspired by the reflections and the deep tones of the landscape as a contrast to the sky.

WHAT THE ARTIST USED

Support
310 x 415mm Arches Rough
640gsm watercolor paper

Brushes
#12, #24 Round Red Sable
#2, #4 Riggers

Other Materials
Natural sponge
Masking fluid
4B pencil

Colours

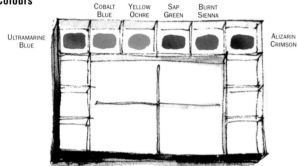

ULTRAMARINE
BLUE
COBALT
BLUE
YELLOW
OCHRE
SAP
GREEN
BURNT
SIENNA
ALIZARIN
CRIMSON

1 DRAW A TONE STUDY TO EXPLORE THE COMPOSITION
I begin with a tone study to explore the subject. This concentrates on composition as I add or remove details to create more interest, for example, in the foreground, the middle distance and, of course, the general tones. Fresh ideas for the painting will often occur at this stage.

4 SPONGE OUT THE SUN AREA
When the first wash is dry, the masking for the sun is removed and sponged out to create a white area with soft edges. I dampen the first wash with a large sable brush and the clouds are painted into the damp area, using a mix of ultramarine blue and burnt sienna. As this dries, it creates interesting edges.

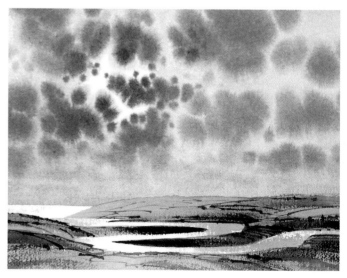

5 BUILD UP THE FOREGROUND
The foreground is blocked in using a mix of sap green and ultramarine blue for the two green tones. The masking then was removed. Simple large drybrush strokes of burnt sienna and sap green were used to indicate where some of the forms appear on the landscape. The sparkle on the surface of the river reflects the color of the sky.

AND WATER REFLECTIONS

2 CREATE A DRAWING AS A GUIDE
I drew a loose pencil drawing directly onto the stretched paper. I wanted just guidelines for the painting, not a lot of details.

3 MASK THE AREAS YOU WANT TO PRESERVE
The river and the area for the sea and the sun are masked out and a simple gradated wash mixed with ultramarine blue and cobalt blue is put in.

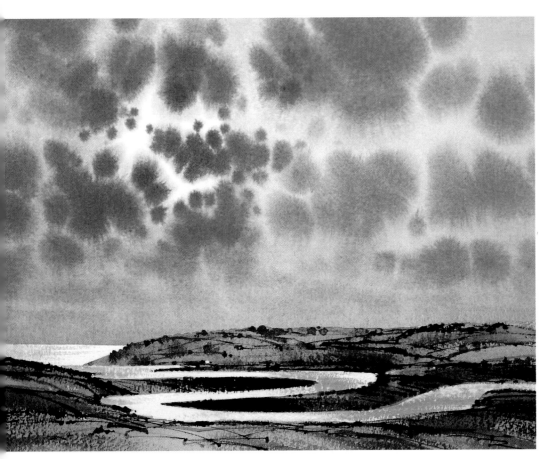

6 ADD THE FIELDS AND HILLS
Using a mix of ultramarine blue and burnt sienna to create a dark brown, I drew in a few details in the fields and hills. The tone on the central banks of the meanders was increased to create more contrast with the water. Finally, a very pale gradated wash of alizarin crimson was put in at the top edge, fading out half way down the sky area. The painting, titled "The Meanders Cuckmere," is now finished.

GOOD REFERENCE MATERIAL IS ESSENTIAL IN FAST-CHANGING LIGHT

All of these subjects are of rapidly changing light and color essential to the mood of the paintings.

Good photographic reference material is needed to capture some of these moments. Some drawn and written notes were made as an aid to memory. However, my photographs were an essential part of the process and proved inspiring when looked at back in the studio.

When working from photographs, I feel free to change, improve or produce something entirely different. The reference for me is part of the process to create something personal and original.

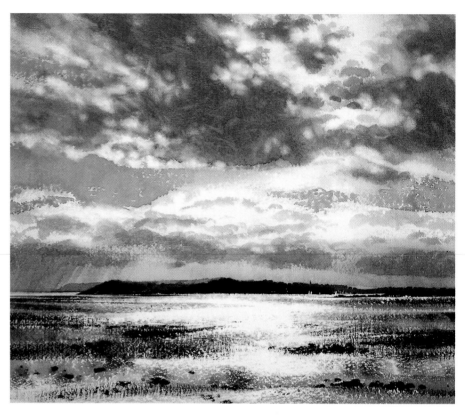

PETT LEVEL SUSSEX, 16½ x 19" (42 x 49cm), WATERCOLOR
A wonderful unspoiled beach, a dramatic sky with high contrast, and the all-important "sparkle" in the foreground. The sky was painted quickly and directly with all the chosen colors in one sequence as a wet-in-wet method. The washes were flooded in, leaving white areas that were softened or lifted out later when the paper was dry. The foreground was painted in one quick sequence, again with a limited palette, and left to dry. The whites were again softened and lifted out in the foreground. The dry-brush and darker details in the foreground needed to be placed cleanly to create the sparkle.

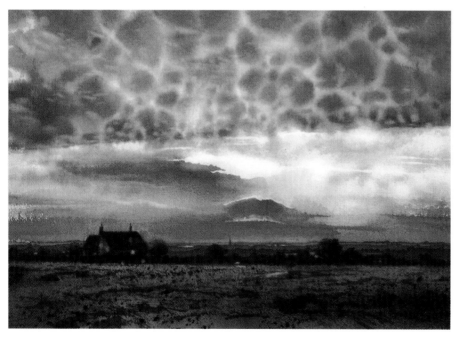

SOFT SURREY SUNSET, 12 x 18" (31 x 45cm), WATERCOLOR
This moment with stunning color lasted less than ten minutes. It was very challenging to paint because it was all soft edges, mostly out of focus, with lots of movement and continual changes. The color palette for me was very different and bordered on the theatrical. But it was hard to resist. I used alizarin crimson, rose doré, cobalt violet and new gamboge with my #24 round sable brush on Arches Rough paper.

TURNING POINT

I have painted and been absorbed with the world of painting throughout my life. I have a passion for landscape and architecture, which is difficult to satisfy when busy with commercial work and other responsibilities.

The turning point came after I reached the top job as head of a much-loved art school. I decided to leave and concentrate fully on painting, which was made easier with the encouragement of my wife. Winning prizes, selling work and exhibiting with prestigious societies is a privilege and enormously encouraging, but like most painters, I carry on painting and try to improve because I am driven by art. I have to do it. I love it.

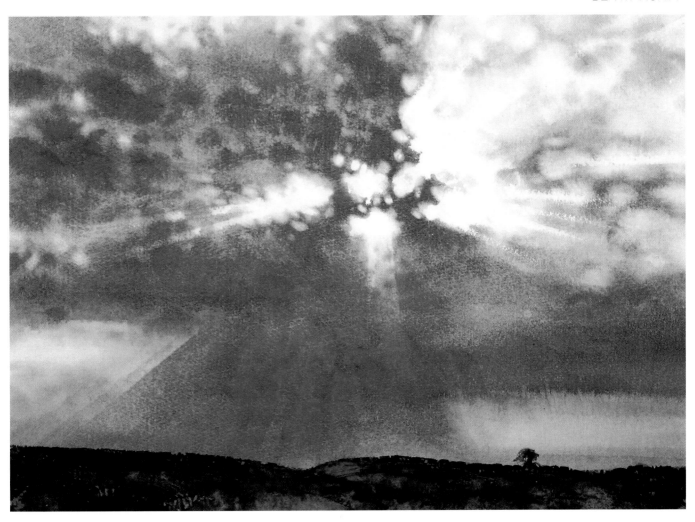

DRAMATIC SKY SOUTH DOWNS, 14 x 20" (36 x 51cm), WATERCOLOR

ABOUT THE ARTIST

Ben Manchipp was trained at Reigate and Guilford School of Art. Following this, he worked in London as a graphic designer.

Ben left London to set up a freelance practice as an illustrator with his wife, Stephanie, also an illustrator. Over twenty years of a busy, successful practice, followed with a period of teaching, led to becoming the head of the Reigate School of Art. Moving away from the commercial art world led to an even busier life of painting, including exhibiting with leading societies and regional galleries.

Ben won the Classic Boat Award from the Royal Society of Marine Artists, and the Rowland Hilder Award from the Royal Institute of Painters in Watercolor. Ben says he has been very fortunate to show his work with both societies for the past six years.

Features in magazines, filming for instructional work, commissions and further exhibitions fill his hours.

Ben's paintings can be seen on his Web site at www.manchipp.com.

BRUCE ALLAN NEVILLE COMBINES WET-INTO-WET SKIES WITH AN EXPRESSIVE THOUGHT PROCESS

Drawing is fundamental for Bruce Allan Neville's emotionally felt watercolor moods.

Watercolor has become a passion and very much a part of my everyday life. First I have to be inspired. It helps that I often have my pad and pencils with me in my daily travels. With my architectural background, the fundamental visual skill of drawing is a beginning for my paintings. Drawing and painting clouds is a somewhat difficult task because they are in constant change.

I draw my subject, whether it is landscape or cityscape, and then combining imagination, all the design elements, and most importantly, rational thought (my private thought process), I then determine the mood I want and the amount of movement I want in my skies.

I also express a great deal of emotion to create the mood. I feel my subject, know it well, and I have gone beyond expressing technique to expressing the passion I have for watercolor.

Each of the paintings in this chapter I hope conveys my thought process, drawing the viewer into a new experience of seeing what I see and understanding my process.

SUMMER DAY, 15 x 19" (38 x 48cm), WATERCOLOR

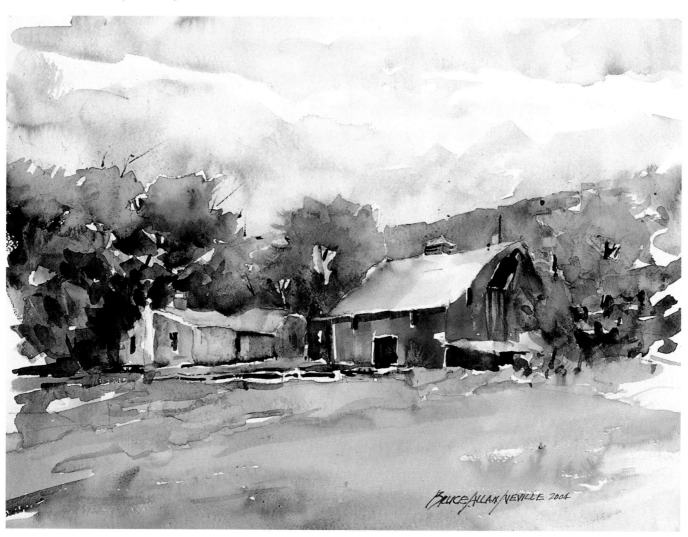

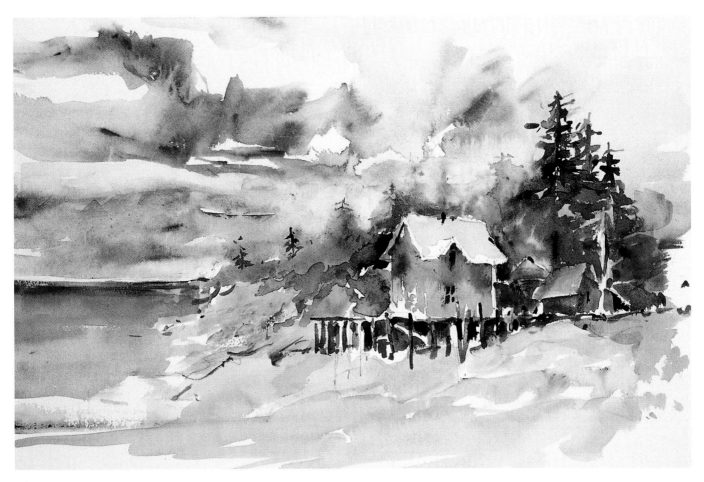

MICHIGAN SKY,
15 x 20" (38 x 51cm),
WATERCOLOR
I painted this from my memories of last summer. It is painted on my favorite cold press paper. The sky is painted wet-into-wet and in all areas I did the color mixing directly on the paper.

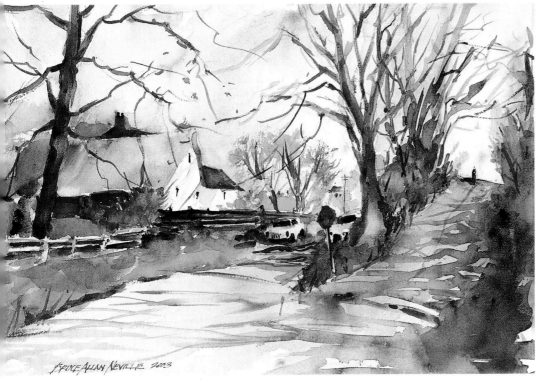

TWO ROADS IN BATESVILLE,
13 x 19", (33 x 49cm)
WATERCOLOR
The color in the sky works throughout the painting as a mother color. I put more intense color in the road and the shadows on the high road.

ART IN THE MAKING PUTTING FEELING INTO A BEACH SCENE

I start with the fundamental visual skill of a drawing. By combining imagination with rational thought, my private thought process enables me to process my paintings. This is just a beginning to explore and develop my thinking process and to be able to convey that sensibility. My goal is to develop not a way of painting, but a way to think, interpret and create.

WHAT THE ARTIST USED

Support
English cold press watercolor
paper, 140lb

Brushes
#8, #10, #12, #38 sables

Colors
Cadmium Yellow
New Gamboge
Leaf Green
Olive Green
Cobalt Blue
Cerulean Blue
Manganese Blue
Phthalo Blue
Phthalo Green
Viridian Green
Cadmium Orange
Cadmium Red
Permanent Rose
Burnt Sienna
Raw Sienna
Cobalt Violet
Cobalt Turquoise
Alizarin Crimson
French Ultramarine Blue
Burnt Umber

1 IDENTIFY THE VALUES
I start by creating the sketch with values where my lightest lights and darkest darks will be placed. Then I put just a few lines on my watercolor paper.

4 TURN THE PAPER UPSIDE DOWN
The bay I put in after turning the paper upside down. Also, I create a rough edge where the sand meets the water.

2 BLOCK IN THE SHAPES
Working light to dark on some areas of the paper, I work wet-into-wet. On this particular subject I do not have a lot of mid-tones; I go into the darkest of the pine trees.

3 DEVELOP THE PINES
I swiftly lay in the different shades of greens and distant blues and I wet only portions of the sky. The blue and greens of the pines seem to mix at the left side of the painting.

5 INTENSIFY THE BEACH SAND COLOR
I add more local color to the beach sand. My final touches are on the trunks of the trees and scraping.

TURNING POINT

Starting back into art at age 60 was my turning point. Now at age 65 I have accomplished some of my goals, with many to follow!

I am basically self-taught, with the ability to see my subject, sketch quickly and create value studies that are tools to guide me through the painting process.

Also, I have benefited from having a very accomplished painter wife, Nancy Nordloh Neville, who encourages me and has given me the strength to move ahead. We do top outdoor shows and have competed for many awards. Competition is healthy. And understanding and respecting each other as artists is important to us. Nancy gives workshops locally and in Michigan, and I hope to do the same in the coming years. Our best times are when we have the time together to paint on location.

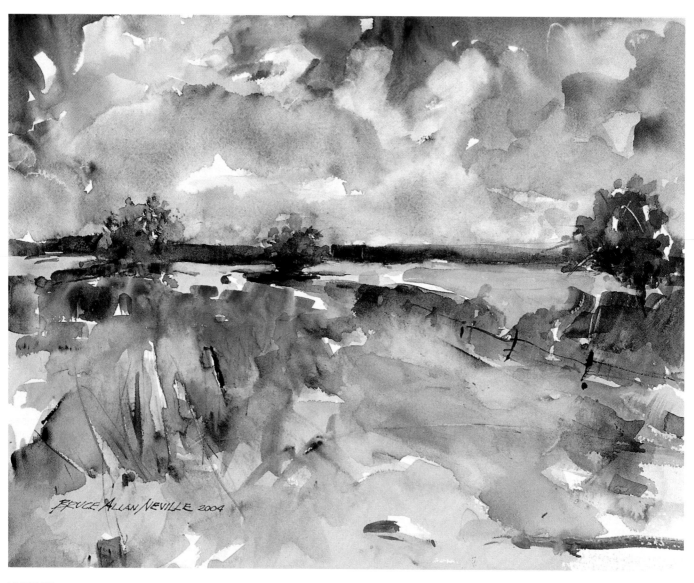

UNTITLED

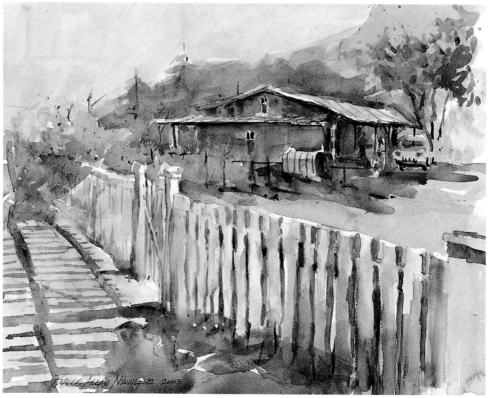

STUDY OF HOUSE WITH FENCE,
14 x 19" (35.5 x 48cm),
WATERCOLOR
This was a demo painting for my
class. I used burnt sienna and
cobalt turquoise for my mix for the
sky and the ground around the
building. The pines were created
wet-into-wet. I put lots of shadow
on the structure and the fence.

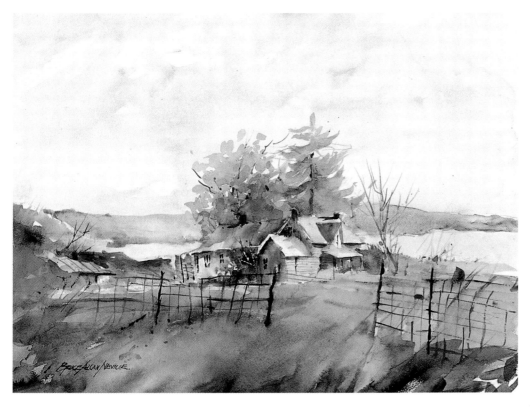

THE JOY OF LITTLE TRAVERSE BAY, 18 x 23", (46 x 58.5cm) WATERCOLOR
A pale blue sky with openings of white was painted on English cold press watercolor paper. This piece has a soft sky and background hills to bring out the farm building on the hilly terrain of Goodheart, Michigan. The trees in the center are so transparent, the viewer can almost see through them.

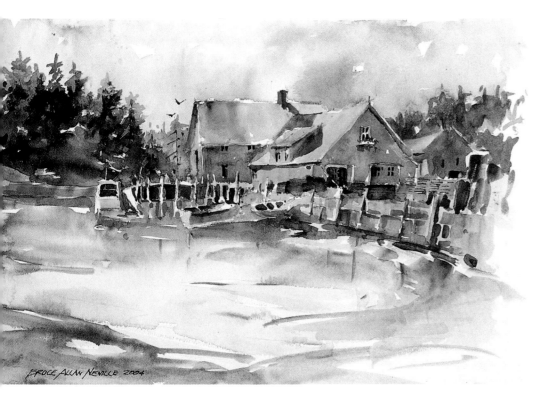

BAY IN NEW ENGLAND, 14 x 18" (35.5 x 46cm), WATERCOLOR
Here is an example of using warm and cool colors to create a scene. I repeated the color in the sky throughout the painting, especially in the foreground.

ABOUT THE ARTIST

Since Bruce Neville's major thrust back into painting five years ago, he has had a major career in a short time. There have been many awards for him. For two years now he has won the Frank Duveneck award for historic subject in Covington, Kentucky. Other awards have been received in Chicago; Lexington, Kentucky; and northern Ohio.

He also has been represented in the Ohio Watercolor Society traveling show for 2003/04.

Bruce holds a B.S. degree in architecture and is a self-taught artist. He has taught watercolor with the Baker-Hunt Foundation and the Cincinnati Art Academy.

He is represented at the Pendleton Art Center, Cincinnati, Ohio, and in Saugatuck, Michigan.

HERMAN PEKEL USES CLOUD SHAPE AS A

At all costs avoid doing lots of different colored washes on top of one another.

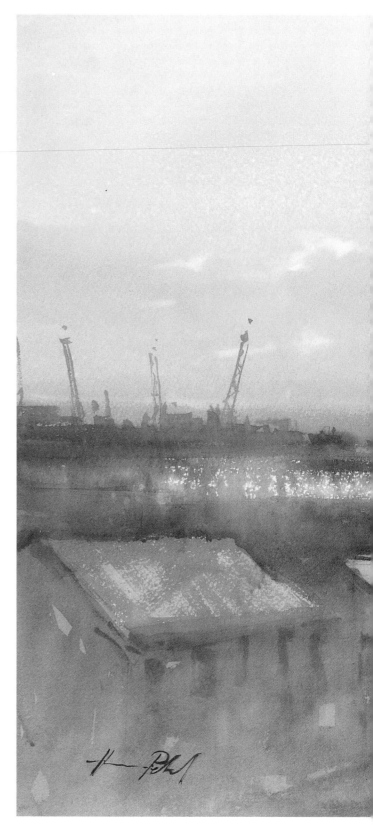

The biggest mistake you can make when attempting skies is to paint lots of washes on top of one another. Students often apply one wash and as it's drying they put another wash on top. Because that looks horrible before anything is dry they make it even worse by adding another wash. That is not how to make a luminous sky. The secret is to make one wash and blend in your colors as you go. In effect, you make a gradated wash. The way to do this is to keep your paper wet so you have longer working time. Once you have achieved the gradated wash, you can let the whole thing dry. Before I start painting I often wet the back of the paper (140lb/300gsm weight) because this keeps the paper and the paint wet a little longer.

Clouds

A good way for inexperienced artists to start is to paint an initial sky wash as described above. Let it dry 110%. Re-wet it by brushing on clear water, then put the clouds in over the top.

As you gain more experience, you can try to do the sky in one wash, preserving some lovely white bits for the clouds.

Very RARELY do I make hard edges on clouds.

Rimlight

For rimlight effects, I suggest you paint in the shape of the clouds first on damp paper so the paint bleeds. At this stage there is NO background. LET IT DRY. Onto the white paper which is the background sky, you paint pale blue. The secret is that the background has to be at least two tones lighter than the clouds or you won't get the rimlight effect. Paint the blue around the clouds and leave a white, halo gap. Don't make this too regular — you can even smudge it a bit with your fingertips.

Cloud color

Never, ever, put too much bright color in the sky if the sky is not your focal point because you will totally kill the light in your landscape.

The exception to this rule is when you are painting a dark or silhouette type landscape. In these cases you can paint brighter colours in the sky.

If I am painting a large watercolour landscape, I usually work on a design that has two-thirds sky and one-third landscape. I will keep painting the sky until I am happy with it, because in a large

EVENING — NEWCASTLE, AUSTRALIA

Anywhere you leave white will immediately attract the eye — and that's the tactic I used to emphasize the focal point in this panting.

I was happy with the soft sky, clouds and suggestion of shapes in this one because it does have a lot of mood. The background was all done wet-into-wet, the only hard bits — the hard edges — are the buildings in the foreground and the dark shapes that cut into and contrast with the focal point.

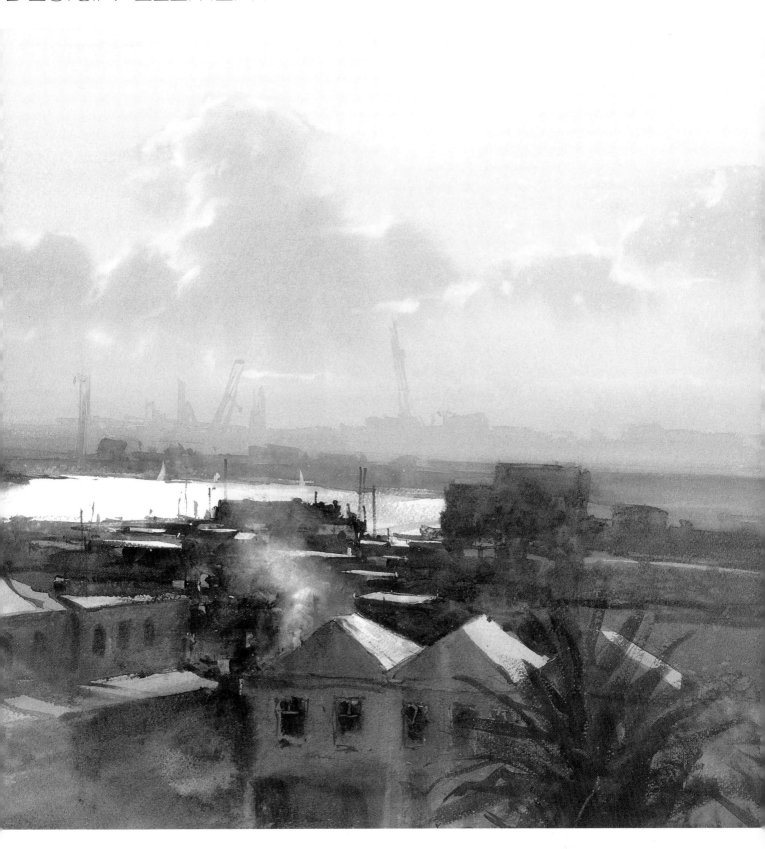

ART IN THE MAKING MOUNTAIN RANGE

WHAT THE ARTIST USED

Colors

ALIZARIN CRIMSON PERMANENT	CERULEAN BLUE	ULTRAMARINE BLUE	VIRIDIAN	RAW SIENNA	BURNT SIENNA

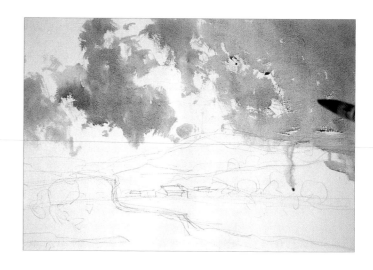

1 THE IMPORTANT START

I made a loose pencil drawing of the composition as my guide. I always begin by painting the sky, because the sky sets the mood for the entire painting. If the sky doesn't work I start again. (Remember, never let the sky dry until it's finished). See how I drop in the color and let it merge while the paint is wet. Also notice how I paint around important areas of white. The vertically-inclined shapes of these clouds will counterbalance the wide, horizontal vista, and add a great sense of depth to the landscape.

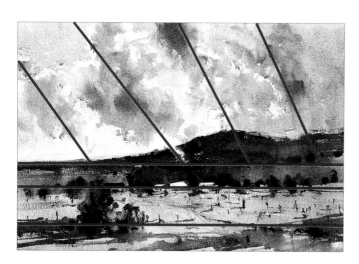

DESIGN PLAN

The vertically-inclined shapes of these clouds will counterbalance the wide, horizontal vista, and add a great sense of depth to the landscape.

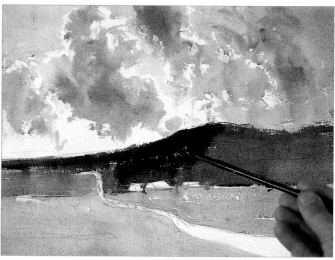

4 STRENGTHENING AND BUILDING UP

I make sure my first mountain wash is totally dry, then I apply a second wash of 70 percent ultramarine blue and 30 per cent alizarin crimson permanent. This sets the tonal range.

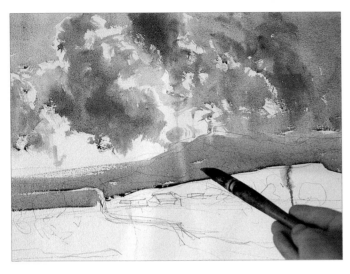

2 INTRODUCING COLOR
A viridian wash goes on. Remember that watercolor dries lighter than it looks when it is wet.

3 MERGING AND BLENDING COLOR
While the first wash is still wet I introduce raw sienna into the mix so the colors merge and mingle. I avoid painting over the road and rooftops and use much more raw sienna as I work into the foreground. You can see how quickly I am working because the paint is still wet in earlier washes.

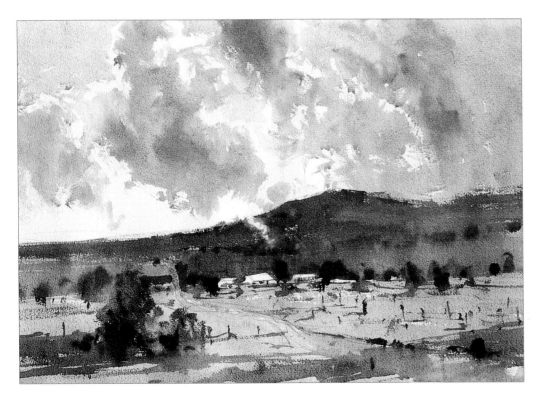

5 FINISHING WITH DARKS AND DETAILS
I complete the painting by adding foreground trees using raw sienna and ultramarine and placing details using rich, dark pigment. Next, I introduce a transparent shadow across road.

The clouds float serenely across the sky adding to the mood of this painting.

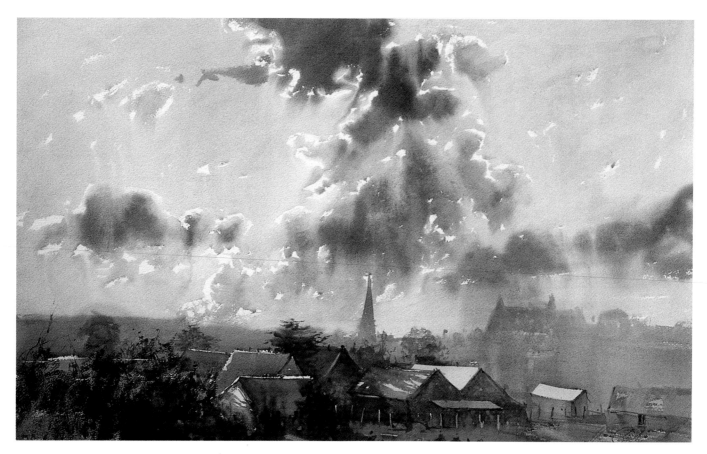

CLOUD STUDY — DAYLESFORD

Basically this is a cloud study with just a minimal foreground. I have one rule with clouds and skies — never let your sky dry until it's finished. In other words, do your sky in one go. To prevent the sky drying out, I usually use an atomiser spray bottle and spray water on the sky area to keep it wet. Either that or work very fast.

landscape you must do the sky very quickly, it shouldn't take more than ten minutes. A labored sky will not work.

If my sky does not work first time, I don't worry. I simply turn the paper over and start again until I get the sky I want.

Reflections

An accepted truth and general rule for artists to observe is that when the sky reflects in clear water it looks a bit darker because it loses the light a little bit. In the same way, in nature reflected darks become a little bit lighter. Reflections from pure white objects will be marginally darker. Black will look lighter.

The exception to these general rules is when the sky reflects in muddy water, or if there are ripples on the water.

Aerial perspective

Many students ask me if they should make it a rule to paint big clouds overhead and little clouds in the distance to suggest the effects of distance.

I believe it's always better to OBSERVE. Sometimes you think you should put the big clouds overhead, but when you look at the sky that's not what you see. Nature doesn't obey our rules.

• Observe, Study, Sketch, Draw

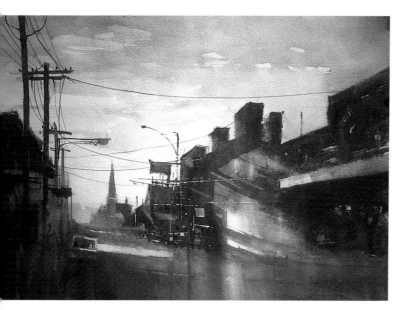

MIDDLE OF WINTER — FOOTSCRAY

I think one of the wonderful things about watercolor is it's ability to capture atmosphere and mood — in fact, I think it's the best medium for doing that. This painting doesn't have a lot of detail and perhaps it fails in some areas but even with its shortcomings I do believe it has an exceptional sense of light that is supported by a simple sky.

Fantastic skies

What about those skies that look so surreal you are afraid to put them in your painting because you don't think people will believe them — they just don't look "realistic"? You have to accept that it is far better to put something in that is real. It will look great provided it is done with confidence. Sometimes I would prefer students to include skies that look really unusual rather than put in a "regulation" sky or a sky done the way they think it should be painted.

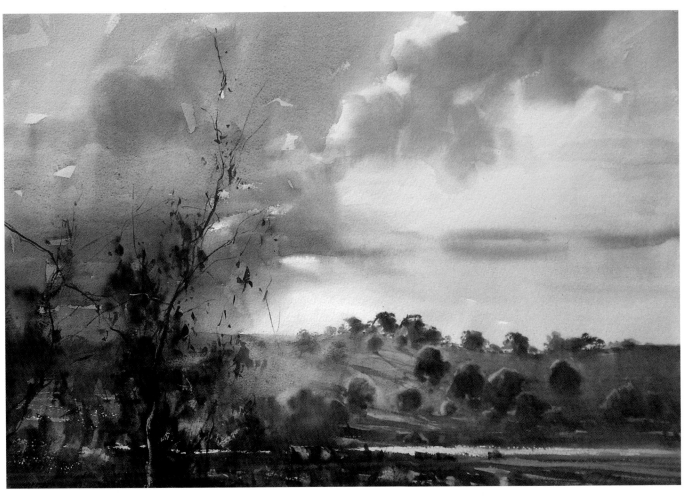

LAST LIGHT — YEA
There was a time several years ago when I painted lots of watercolors with the ambition
of capturing that last light and making it look convincing. You be the judge.

ABOUT THE ARTIST

Herman Pekel was born in Melbourne, Australia in 1956 to Dutch parents.

At age 13, he knew he wanted to be an artist. "The smell and feel of my first set of oil
paints was one of the most exciting moments of my childhood, and then to paint on location
in early spring was beyond anything."

Herman showed a prodigious talent, winning his first major award in 1973 at the age of 17.
Among his 90 awards to date, Herman has won the much coveted Camberwell Rotary
Watercolor Prize in 1995, 1993 and 1989, and the Oil Prize in 2004. In 1989 Herman won
the Camberwell Travel Study Scholarship. In 1981 he obtained a Fine Arts Degree from the
Philip Institute of Technology.

Herman's work has frequently appeared in *Australian Artist* and *International Artist*
magazines, and he contributed a chapter to "The Watercolor Landscape Techniques of
23 International Artists", which is available through International Artist Publishing's website
www.artinthemaking.com

Today, Herman's works are represented in many private and corporate collections
throughout the world.

VIVIENNE POOLEY SAYS THE SKY IS INTEGRAL TO HER MOUNTAIN PAINTINGS

Putting a mountain view in contrast to vivid skies adds power and depth to a landscape scene.

My major paintings shown in this chapter all illustrate different ways in which the sky is a key factor in their interest and success. As I am mostly a mountain painter, I am keenly aware of the weather and the effect that the sky has on landscapes below or, in the case of mountains, as they reach up into the clouds or into a clear void of blue.

It also is important to remember that the sun is our source of light in the sky and, therefore, the time of day is a big factor as well. It can give us side-light, high or low light, or have us view the scene against the light. All these factors allow an artist endless interest and challenges.

Clouds (water vapor) can be seen and portrayed in endless forms, from lacy veils to solid-looking masses with light and shade casting deep shadows onto each other and onto the landscape below.

It gives me unlimited pleasure to portray such variety of form, color and mood in my watercolors.

AFTER THE STORM, 23½ x 23½" (60 x 60cm), WATERCOLOR
When the sun shines out as a storm passes, there is always a feeling of revelation which I love to depict in watercolor. In this sky, the stormy action is captured in the giant-like clouds blotting out all light to the distant mountains.

ART IN THE MAKING
CONNECTING THE SKYSCAPE DIRECTLY TO THE LANDSCAPE

When I first saw the scene I chose for this demonstration, I was attracted by the warm light of the sunset and the reflection of that light into the shadows on the snow-covered mountain. The reflective qualities of snow have always intrigued me and, in this instance, the link between sky and mountain was so wonderful that I felt it would show to good effect the passion I have in relating skies to mountains successfully.

WHAT THE ARTIST USED

Support
Stretched Two Rivers Rough watercolor paper

Brushes
#12, #8 Sable Round
#4 Nylon Round

Other Materials
Blotting paper
10 large mixing pots
3" shallow pans

Colors

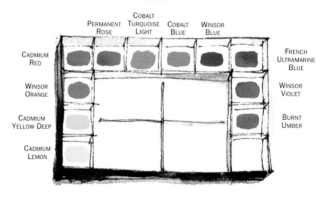

PERMANENT ROSE · COBALT TURQUOISE LIGHT · COBALT BLUE · WINSOR BLUE
CADMIUM RED
WINSOR ORANGE
CADMIUM YELLOW DEEP
CADMIUM LEMON
FRENCH ULTRAMARINE BLUE
WINSOR VIOLET
BURNT UMBER

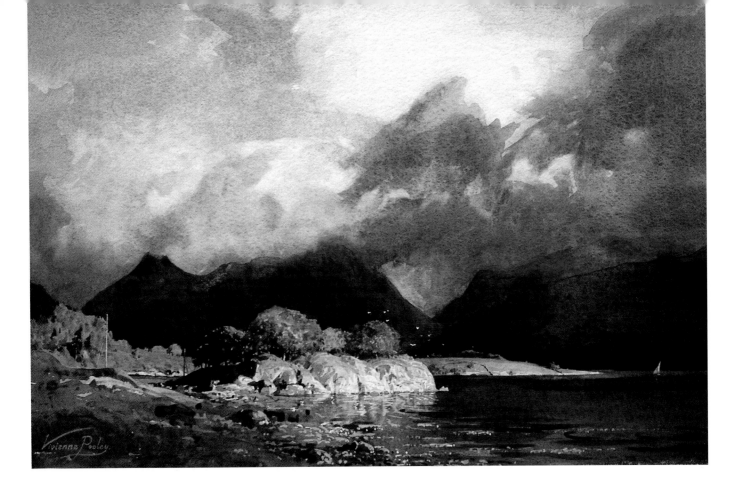

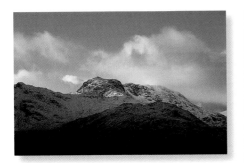
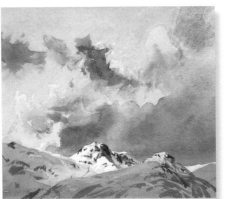
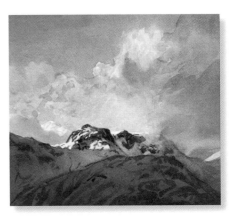

1, 2 & 3 DEVELOPING THE COMPOSITION ▶

As you can see from my reference photo, I alter the scene as I develop my composition and color scheme in two small watercolor sketches. I decide to use ideas from both to create my larger 20 x 23¹/₂" (50 x 60cm) painting, "Sunset Glory." I created a large drawing and traced the major outlines onto the stretched rough watercolor paper.

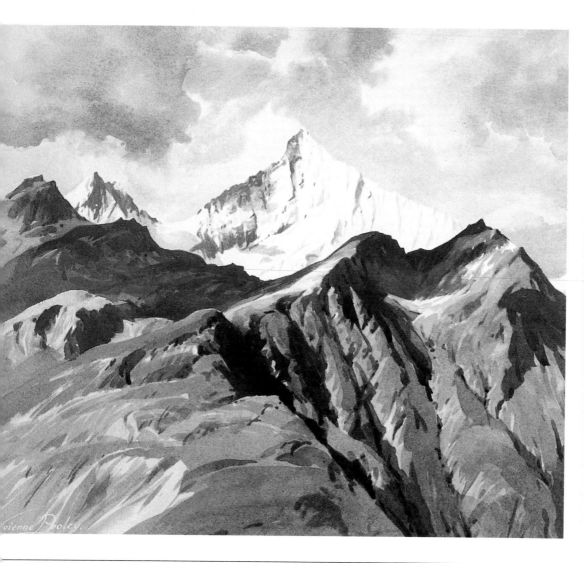

TURNING POINT

After having had an ambition to paint in the Alps for 25 years, I went to Chamonix in 1999 to walk the "Tour De Mt. Blanc" for two weeks with the idea of sketching on route. I planned to paint inspired works when I went back home. I found this to be a turning point for me.

After selling well, I have been able to return on two trips.

The inspiration I found in the magic of the Alps has given me a new quality in my painting.

4 START WITH THE BLUES IN THE SKY

I begin by mixing the blues for the sky in large pans. I try the colors first on scraps of watercolor paper. I mainly use cobalt turquoise light with Winsor blue added while that is still wet at the top of the sky. A little Winsor lemon is added with water as the brush reaches for the distant light seen just above the mountain. The paper is slightly inclined and the colors very diluted, especially in the lower sky. As the color runs down, there is usually excess gathering at the bottom edge. This can be mopped up carefully with a dry sable brush before leaving it to dry. The cloud colors are mixed next. Again, trials are made on a swatch of scrap paper with fairly diluted cadmium yellow deep, cadmium red, permanent rose, along with violet and cobalt all ready in separate pans. Using my #12 sable brush, I begin to paint in the cloud shapes, being careful not to overlap the edges of the previous washes of blue. This is then left to dry.

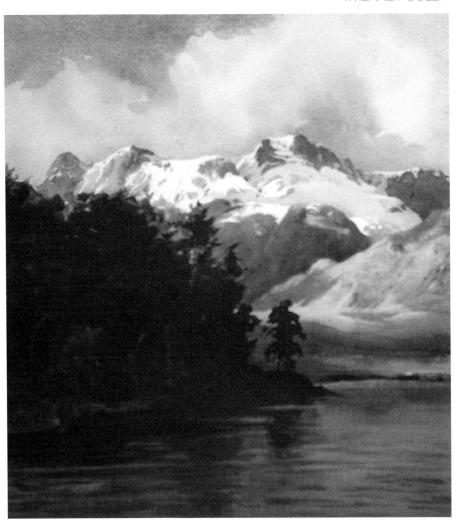

LANGDALE PIKES AND BLEA TARN,
16 x 17" (40 x 43cm), WATERCOLOR
This rich little painting is one of my best examples that shows how a sky was designed to integrate with the rest of the subject matter.

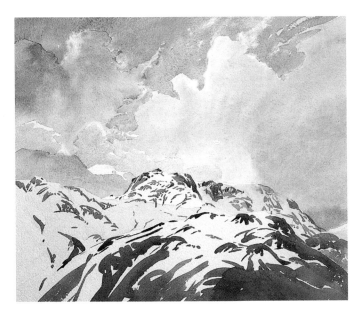

5 CREATE DIMENSION FOR THE MOUNTAIN
The mountain area needs painting at this stage to cover all but the sunlit snow. I begin with the rock outcrops and areas without snow using a mix of colors ranging from orange and cadmium red to burnt umber and violet. I am using a #8 sable brush at this point.

6 BRUSH ON THE MOUNTAIN SHADOWS
When this is dry, the shadow colors for the mountains are made up of three mixes, one similar to the clouds (rose/cadmium red going to rose/violet and a mix of violet/Winsor blue). This very large wash is done with the large #12 sable brush. I allow them to flow softly together while working downwards. This is allowed to dry at the same gentle angle as it was painted.

This is almost a monochrome painting, because the subject is against the light. It is the middle of the day, so the sunlight is high in the sky. I have had fun with the bright sunlit clouds surrounding the forbiddingly dark mountain ridge, which creates more drama, suitable for this rather dramatic place.

SKY OVER SANNA BEACH,
16 x 17" (40 x 43cm), WATERCOLOR

This painting was done because I love the relationship between the rain drifting down in the distance and the peacefully sunny dry beach. I also liked the design, with the angle of the rain almost connecting to the stream across the sand.

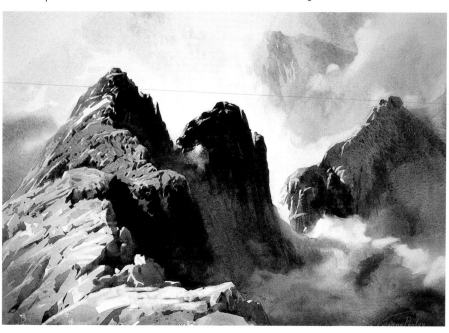

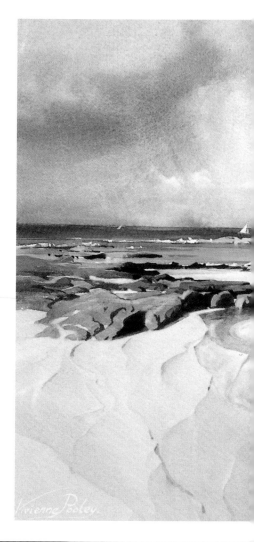

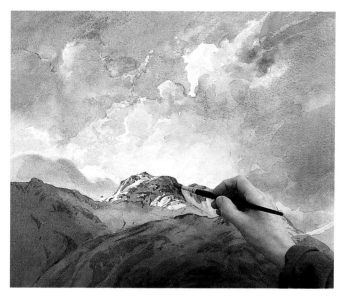

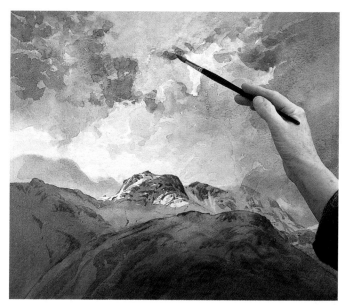

7 INCREASE THE RICHNESS OF THE SKY COLORS

Now that the paper is covered with a diluted version of what I want, I proceed with the sky once more. Using the same colors as before, but painting in slightly richer colors and tones, I give more shape to the clouds. At the same time, I keep some of the lights and transparency, which is coming from the sun. Notice that the sunlight is coming from below the clouds and, where the cloud is in shadow, it is a cooler color (a dark mix of violet/cobalt blue). The small washes of color are placed, sometimes with soft edges faded out with water on the brush and some left with hard edges.

8 ADD THE DARKER TOP CLOUDS

Before painting the small dark top clouds, I wash out the light cloud high in the sky to improve its shape. This is achieved by using a harder nylon bristle brush with clean water and then blotting paper. (This is very easy when using Two Rivers paper, unlike some papers which are more difficult.) Any unwanted hard edges can be removed in the same way with a smaller brush. I always let the area dry well before adding color again after washing out.

ABOUT THE ARTIST

Vivienne Pooley grew up in Cumbria, where she became a keen mountaineer as well as developing her skills in watercolor painting.

In 1972 she attained a degree in printed textile design in Manchester, and has since brought up her family of three children while living in Cheshire.

Vivienne now has her studio near Kirkby Lonsdale, on the edge of the Lake District. She is a member of the prestigious Lake Artists Society.

As well as painting the Lake District, Vivienne makes frequent visits to paint the Scottish wilderness and the French and Swiss Alps.

Each year Vivienne exhibits with the Royal Institute of Watercolorists in the Mall Galleries in London.

Her watercolors have been featured in the *International Artist* magazine, as well as in several books on watercolor technique, including *Landscapes in Watercolour.*

In addition to several gallery exhibitions around the U.K., Vivienne shows her paintings in her own gallery in Cumbria. Her Web site is www.viviennepooley.co.uk.

9 DARKEN THE TONAL STRENGTH

Work is continued on all aspects of the painting, deepening the colors to make richer, darker tones where needed until every part has the desired tone and color. This stage cannot be rushed and sometimes needs much thought. A useful tip at this stage is to view it through a mirror. One could also place a mount around it while thinking and planning the next move. At this point, I need to reinforce the tonal strength of some rocks on the mountain with more concentrated burnt umber and ultramarine blue. Another richer, deeper wash is applied over the large shadows on the mountains. I use just water in the brush over the areas I want to keep light and warm in color, and add much deeper mixes of those already used (Winsor blue) with the addition of ultramarine blue and almost none of the violet.

JACK REID RELIES ON A LIMITED PALETTE TO PAINT

Working spontaneously helps capture winter skies quickly.

Many students ask, "How do I paint skies in watercolor?" I jokingly reply, "Very quickly," something like painting ducks. I prefer to paint skies "plein air" using 300lb. rough watercolor paper cut to 11 x 15" (28 x 38cm) or 7½ x 11" (19 x 28cm) sizes and taped to coropast.

I love the challenge of painting skies, drawing only with a brush, using a very limited palette of cobalt blue and burnt sienna. I start by applying the cobalt blue to indicate the sky and leaving white paper for the clouds; then I render the underside of the clouds with a gray mixed with cobalt blue and burnt sienna. (I use more burnt sienna for warm gray and more cobalt blue for cool gray.)

Painting this way forces me to work spontaneously. However, in this chapter, I have chosen different types of moody skies, rather than those I have just described.

WINTER DAWN,
18 x 20" (46 x 51cm), WATERCOLOR

This painting was done from a photograph taken by my friend Peter Trueman on Amherst Island, near Kingston, Ontario. What moved me was the first hazy light of a colorful dawn contrasting sharply with the pans of ice in the foreground and open water in the middle distance.

I wet the entire sky area with a sponge and applied a soft wet-on-wet technique to the sky, combining permanent rose, aureolin yellow and cobalt blue. I followed that with a wash of ultramarine blue and burnt sienna on the dark tree line.

I then applied a graded wash on the open water, leaving white paper to indicate the light path. On the rest, I used a square-tip 1" wash brush to paint the sharp edges of the jutting ice using cobalt blue softened with light additions of aureolin yellow and permanent rose. I glazed areas of the ice pans with cobalt blue several times, combining all three colors to increase the value and dimension and to reflect the warm light on the edges of the pans.

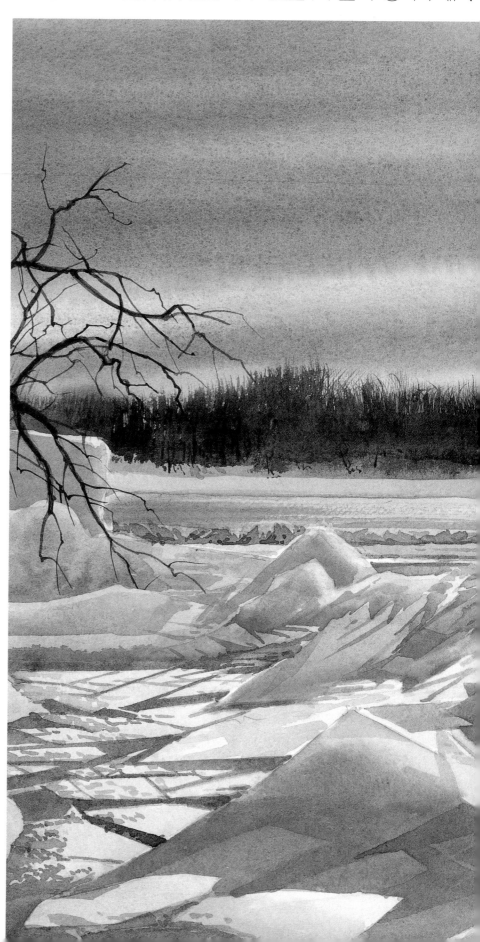

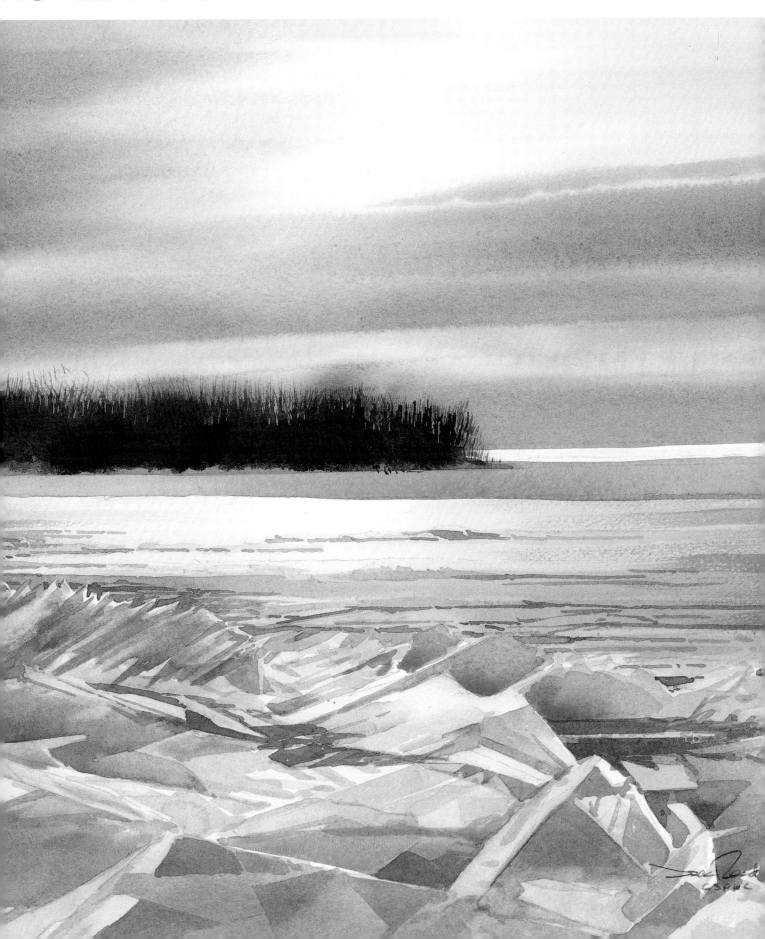

ART IN THE MAKING
CREATING LUMINOUS WINTER SKIES

I prefer painting snow and water subjects, and seldom use more than four or five colors to complete a watercolor. I often use the term "the challenge of the limited palette" when conducting workshops. I see subjects in monochrome rather than color, with strong emphasis on design and composition.

1 START WITH A ROUGH PENCIL VALUE STUDY
I do not need a detailed pencil drawing; as this demonstration was done with a brush, I only penciled in the horizon. ▶

WHAT THE ARTIST USED

Support
300lb rough watercolor paper

Colors

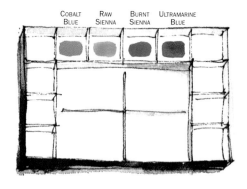

Cobalt Blue Raw Sienna Burnt Sienna Ultramarine Blue

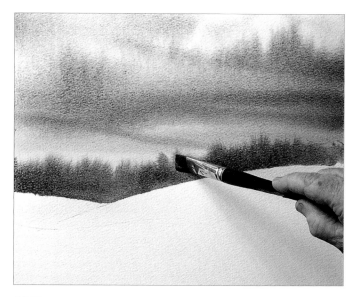

4 DEFINE THE TREES
With the same brush I add more tree line definition.

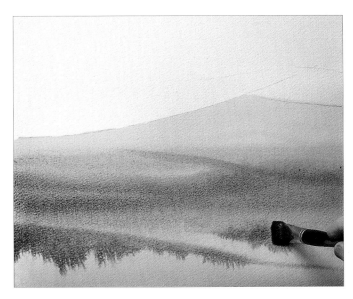

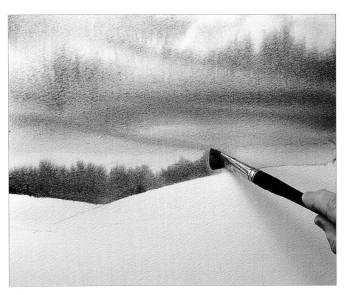

2 TURN THE PAPER UPSIDE DOWN
I paint the sky upside down as shown, beginning by wetting all the sky area with a 1" flat wash brush and charging pure raw sienna along the horizon. I gradually add burnt sienna, then add cobalt blue to burnt sienna to create a luminous gray for clouds in horizontal strokes. At the top of the upside down picture I paint the breaking clouds.

3 ADD THE DISTANT TREES
With ultramarine blue and burnt sienna, I mix a strong dark value of warm gray and render the distant blurred tree line in wet-on-wet.

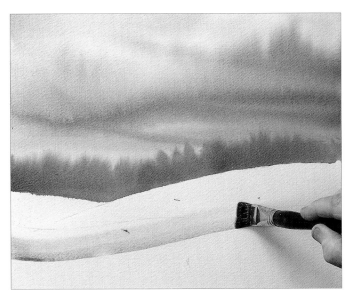

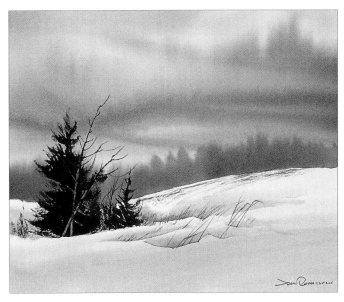

5 CREATE THE ILLUSION OF SHADOW
I make another blue gray luminous wash with cobalt blue and burnt sienna, beginning with clean water on the upper edge of the snow banks, on snow-covered rocks and distant tree trunks. I follow with a gray wash to the edge of the water, creating the illusion of shadow, and repeat this in small drifts in the foreground, followed with a diluted wash over the foreground snow.

6 ADD THE FOREGROUND TREES
When that is dry, I mix ultramarine blue, burnt sienna and raw sienna into a dark green wash and render the foreground trees on the front left with a ½" dry brush technique.

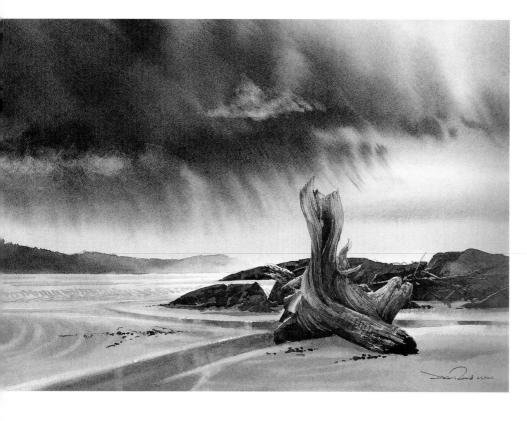

(RIGHT) WINTER SUN,
11 x 15" (28 x 38cm), WATERCOLOR

Winter and its soft, hazy light are one of my favorite subjects. I painted this picture almost entirely with cobalt blue and burnt sienna, and a touch of aureolin yellow and permanent rose.

First, I wet all of the paper using a 1" hake brush. When that settled, I made circular strokes, beginning with the sun and applying aureolin yellow and permanent rose. I progressively added the cobalt blue and burnt sienna combination. I then deepened the cobalt blue and burnt sienna, and quickly rendered the background tree line with a #8 round squirrel-hair brush while the paper was still moist. When quite dry, I mixed a strong wash of cobalt blue and burnt sienna and rendered the snow-covered rocks and tree trunks with a series of graded washes. I then indicated the open water with the aureolin yellow and permanent rose wash. Adding more burnt sienna to the blue wash, I painted the small darker areas of rock shadow and reflections in the distant stream, leaving reflected sunlight on the water.

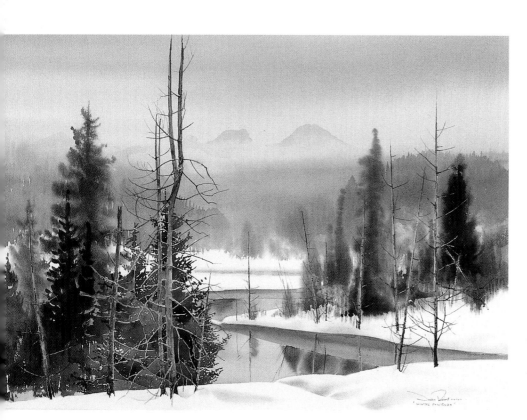

FOOTHILLS OF ROCKY MOUNTAINS – JASPER NATIONAL PARK, WATERCOLOR
I used a palette of aureolin yellow, permanent rose, cobalt blue, viridian green, raw sienna, burnt sienna and ultramarine blue for this snowscape.

The combination of a soft distant sky with subtle mountaintops and the hard-contrasting edges of the foreground trees and water make this watercolor work quite well, I think.

ABOUT THE ARTIST

In person, Jack Reid looks and sounds nothing like you think a painter should. He is a physical person, with hands that could grip a miner's sledge as easily as he wields the daintiest of brushes. His manic energy is of a man decades younger than his 78 years. And he is a talker; he offers his opinion as freely as his smile; and he is honest in both. He is kind but candid – a man born in an age when political correctness meant appreciating the right to vote rather than obeying the pressure to be silent.

Since he started teaching others his renowned techniques in 1971, more than

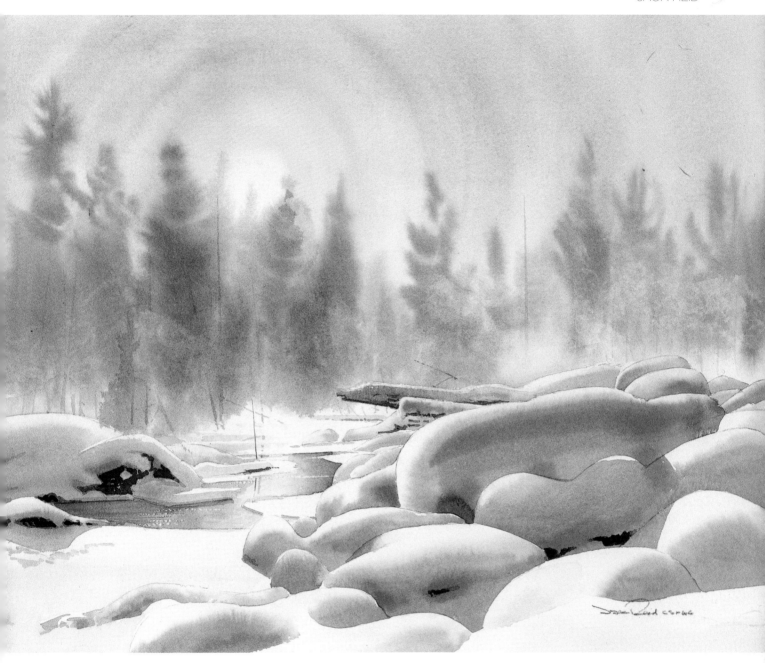

15,000 people have attended his watercolor workshops, demonstrations and foreign tours, and each year more students add themselves to the list. His passion is infectious and invigorating.

Jack Reid's career spans three decades and the honors have been many. Today, his paintings endure in the collections of major corporations, ordinary Canadians and the Queen of England's Windsor Castle as part of the Diamond Jubilee Collection of the Canadian Society of Painters in Watercolours. In 1992 he was awarded the Commemorative Medal by the federal government for his contribution to Canadian art and was honored to be Arts Person of the Year in his hometown of Brampton. He was elected a life member of the esteemed Canadian Society of Painters in Watercolours.

Jack worked as a graphic artist until 1970, and only then did he venture into the world of "pure art" full-time with little security and no formal training. What he knows he taught himself; what he paints is what he feels.

Jack lives near Brampton, Ontario, amidst the rolling fields that hug the Credit River. His home holds his studio; but, his studio can be any place he finds himself while traveling and teaching workshops.

His work is his play. His love of the art of watercolor is total.

XAVIER SWOLFS SHOWS HOW TO CREATE HARMONY

To make clouds the focal point,
give them ample room by lowering
the horizon line.

Painting with watercolors is a flowing, uncontrollable manipulation of paint and water. Much water, little water, half dry, half moist or very moist... the feeling that grows when one tries to master that wonderful creativity on smooth or lightly rough paper, in different qualities and sizes, does not bear any description. Only watercolor makes it possible.

The transparency, the lightness, the ability to make motion actually felt on the sheet of paper through the use of some more water, the pleasure of letting the excess of water flow into the dry areas like streamlets... there lies a whole world of captivating surprises.

To be able to work with full spontaneity, and fast, one has to be fully familiar with the subject and one has to know perfectly what one has to achieve. But even then the outcome remains uncertain.

It is all a play of waiting, of looking carefully and patiently, of interfering at the right moment and of reacting alertly. Everything has to be accomplished with love, because the more an artist invests himself, the better he is rewarded.

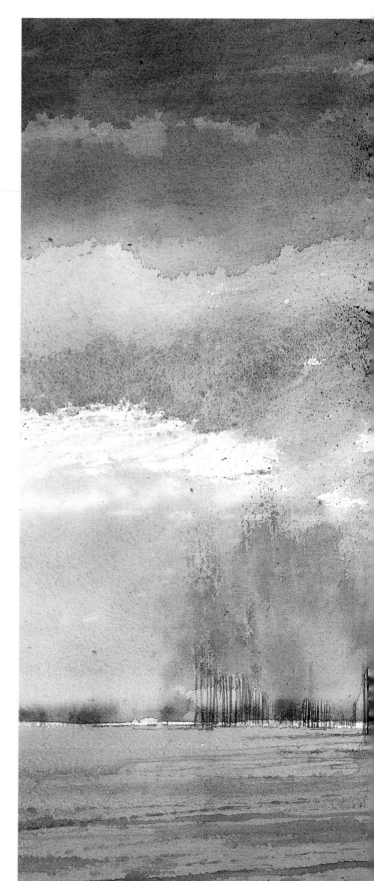

BACKLIGHT, 22 x 30" (56 x 76cm), WATERCOLOR
A low horizon line suggests the sky will be treated as a major part of the subject. Because of the effect of perspective, the trees appear as a dark band through the landscape. The clouds can add greatly to the drama in a painting like this.

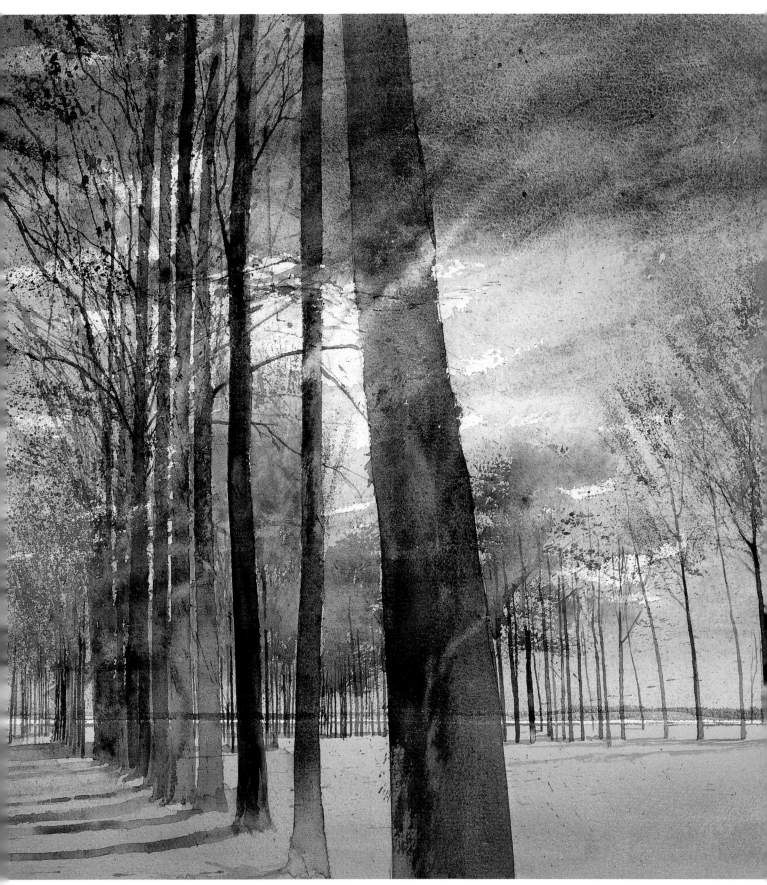

ART IN THE MAKING
ADDING DRAMA
AND MOVEMENT
TO WINTER SKIES

WHAT THE ARTIST USED

Support
Hot press watercolor board
Whatman 400gsm
watercolor paper

Brushes
1 Flat, 4 Round brushes

Other Materials
Paper towels
Soft putty eraser

Colors

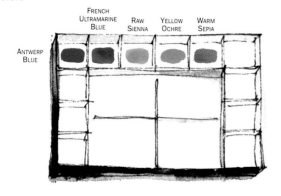

ANTWERP
BLUE

FRENCH
ULTRAMARINE
BLUE

RAW
SIENNA

YELLOW
OCHRE

WARM
SEPIA

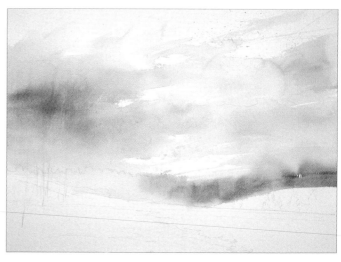

1 APPLY A QUICK WASH OVER THE DRAWING
To make a winter landscape, I start with a fairly detailed, but lightly penciled drawing. The horizon line comes at ⅔ below the middle mark. The sky is applied very quickly with a large brush, half wet, half dry. Color is added in the wet parts of the painting.

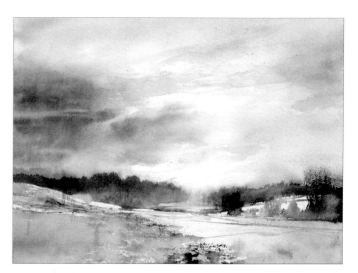

4 EMPHASIZE THE DRAMATIC ATMOSPHERE
To add atmosphere and drama, and to start pulling the painting together, a bit of raw sienna and yellow ochre is mixed into the clouds. I then mix up some sepia and French ultramarine blue across the foreground, playing with the overall patterns that have arisen as the painting has progressed. The brush is used to "sling" color onto the surface. Large drops will splash against the surface of the paper, either damp or dry. This will add texture and drama in a flash.

2 START WITH THE LIGHTEST COLORS

Other colors are added, beginning with the lightest, then the middle value while the first color is still damp. Finally, the darkest value is added, leaving white unpainted bits of paper.

3 DEVELOP THE VALUE CONTRASTS

Value contrasts that are added through more dark colors and more details in the trees not only create form, but also capture the "mood" I want for this piece. To get movement in the sky, the painting is tilted to make the color run.

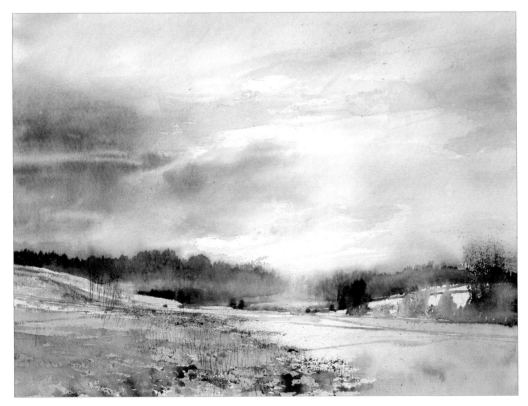

5 USE AN ERASER TO SOFTEN THE EDGES

The finishing touch: More tonal contrast in the foreground and strong tonal contrast in the trees. A soft rubber eraser softens the edges of hard, linear areas in the center and is used to blend dissimilar tones into a homogeneous color when the paper is totally dry.

TURNING POINT

NORTH SEA,
22 x 30" (56 x 76cm), WATERCOLOR
To make beautiful skies, the texture of the paper is very important. I use thick paper of top quality with a high degree of absorbency. The special surface guarantees pure color absorption. If I want to make clouds the focal point of the composition, I give them ample room. The horizon line is dropped well below the middle mark of the painting surface.

The movement of the clouds depends upon the amount of water that is used to depict the atmosphere in the painting. During the entire process, I use a passé-partout to get a better view of the landscape, the colors and the contrasts. It makes it easier to judge the work.

I studied at a technical school specializing in shipbuilding and graduated as a technical designer. For four years, I designed illustrations for magazines and poster firms. I also created illustrations for encyclopedias and other books.

This gave me perfect practice for the use of watercolor and gouache.

At the age of 35, I started painting in oils, and later, exclusively in watercolors. After the strictly realistic approach in my years as a technical designer, I started to express my feelings with much greater spontaneity.

During the Eighties, I discovered the achievements of the great watercolorists.

The European Institute for Watercolour brought me in contact with like-minded artists and I discovered the works of Turner in the Tate Gallery in London. I felt that Turner's mastery and the lasting freshness of the colors was a real revelation. The Austrian artists Gottfried Salzmann and Bernhard Vogel revealed to me a new technique and other possibilities: how to evoke a specific atmosphere and render a feeling of motion with a few energetic strokes and striking color combinations.

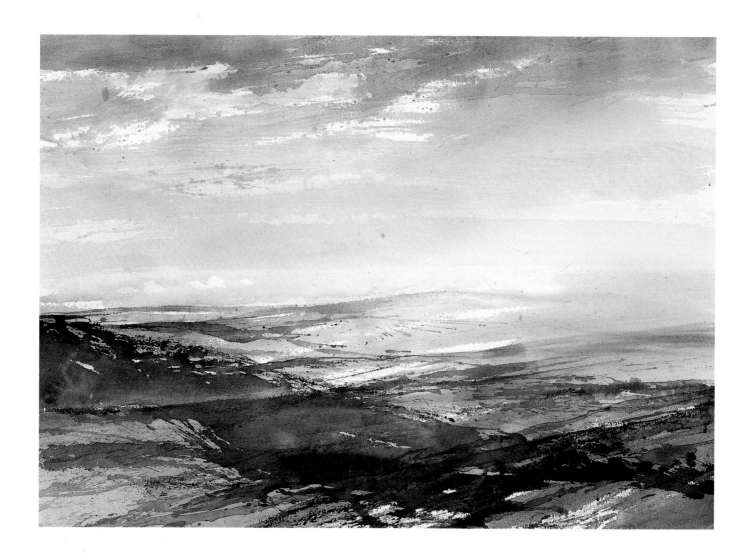

SEAGULLS OVER THE DUNES, 30 x 22" (76 x 56cm), WATERCOLOR

ABOUT THE ARTIST

Xavier Swolfs was born in Brasschaat, Belgium, in 1942. After studying at the Academy of Fine Arts in Antwerp, he began exhibiting his artwork in Belgium and abroad. In addition, his watercolors have often been published in magazine articles and in art books.

Xavier is the co-founder of the Belgium Watercolour Institute and of the European Confederation of Watercolour Societies.

He will be the coordinator of the International Watercolor Festival in Antwerp in 2005.

Xavier's artwork can be seen on the Internet at: http://users.pandora.be/swolfs.

CAPTURE FAST AND FLEETING MOMENTS THE DAVID

David Taylor emphasizes three important categories for good results: Choosing the right time of day; using color strongly to create depth and atmosphere; and using the paper to the best advantage.

I am excited when I see the skies light up with color and when a cloud seems likely to unload its contents on the world below. My eyes also love when the sun is low in the sky. Those morning skies often show the soft graded color I enjoy painting.

I find a flat gray sky seen in the middle of the day will not be as exciting to paint as perhaps an ever-changing morning sky, or that dramatic evening sky that glows with those last rays of sunlight.

To paint these fast and fleeting moments requires one to plan in advance. Good fluid brushwork is required, along with a test strip of paper to try colors and brushstrokes.

I often find myself painting under a solitary street lamp as I admire how the night sky casts a cloak of rich, deep color around the villages, cobbled streets, harbors and doorways. I love to see the warm glow of lights complementing those deep velvet washes.

Being prepared is key: It's necessary to have copious amounts of color squeezed out so that it can be used as strong as possible.

I am a great advocate of putting down a wash with enough punch to keep the resulting passage fresh and not overworked. The tonal value must finish up being correct, or else the subject is wasted.

I believe all paintings should register three values: light, middle and dark. Without these, the subject will appear flat. No amount of color changes will rescue the painting if the value is incorrectly perceived.

It's worth every single moment achieving these exciting moments. At these times, I will often be completely oblivious to who is standing next to me as they think I have lost the plot painting at this strange hour in the night. I will often jump with excitement when it is finished and celebrate with a glass of red wine.

THE RIGHT PAPER MAKES THE DIFFERENCE

The paper you choose plays a huge part in producing the result you want.

I personally like to use Arches Torchon 300gsm or 185gsm rough watercolor paper for a scene like the one shown here. These papers are quite resilient and allow a certain amount of manipulation without fear of destroying the painting.

The rougher surface provides the texture needed to produce those scattered clouds that race across the sky.

For outdoor painting, the ideal paper is the lighter 185gsm paper. It dries at a more rapid rate if worked wetly than that of the heavier papers. It's also suited to those spontaneous changing moments.

I need a paper that will allow sponging, wiping out, and washing back in order to produce important sky studies. Wasting cheap, lesser quality papers to make it work will only cause frustration and end up costing more in the long run.

RACING CLOUDS, TOOWOOMBA, ON 9 x 6" (22 x 16cm) ARCHES TORCHON 300GSM ROUGH WATERCOLOR PAPER

TAYLOR WAY

SUNRISE MINORI, AMALFI COAST, ITALY,
10 x 14" (25 x 35cm), WATERCOLOR

DO'S & DON'TS

- Don't re-wet any areas that are not thoroughly dried, otherwise you will find paint lifting off unnecessarily.
- Try to complete washes in one go. Don't patch them together.

- Practice on a separate sheet of paper the stroke you wish to make. Control the brushwork and stay flexible.
- Keep cloud shapes simple and varied.
- Don't keep altering the shape, hoping it will improve.

By using strong contrasts, a touch of gold can illuminate a painting and act as a foil for the buildings and vehicles in the foreground. Knowing how to allow the colors to mix on the paper itself is the first step in building confidence in your technique.

WHAT THE ARTIST USED

Support
Arches Torchon 300gsm rough watercolor paper

Brushes
Raphael Petit Gris Pure Mop brushes
Pocket brush
Sable brushes
Rigger brushes

Other Materials
Spray bottle
Tissues
Towel

Colors
Quinacridone Gold
Burnt Sienna
Cadmium Red
Cadmium Orange
Quinacridone Magenta
Brown Madder
Sepia
French Ultramarine Blue
Cobalt Blue

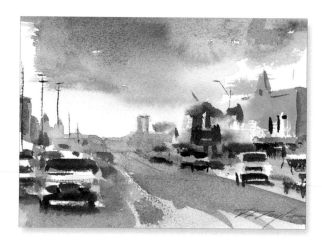

1 USE A VALUE SKETCH TO DEVELOP THE COMPOSITION
This value sketch helps to relate the values in simple form and establishes the composition. ▶

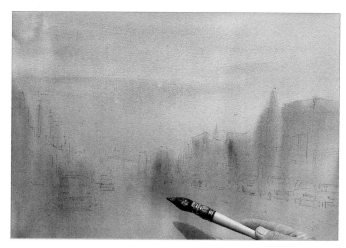

4 INTENSIFY THE SKY COLORS
The paper is re-wetted. Further washes made from a touch of cadmium red and burnt sienna are used to assist in intensifying the sky. It is extremely important to establish the correct tonal value for the warm background before adding any complementary colors or deeper touches.

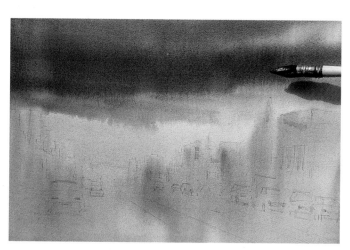

5 RAISE THE DRAMA
Once again the paper is dampened to allow major changes in the subject to take place. It is now important to establish the dramatic effect of the evening sky by flowing colors such as French ultramarine blue, cobalt blue, and some added quinacridone magenta. Allow the color to blend and mix on the paper. This change takes place high above the golden sun. The background is now on its way to becoming the key source for the overall outcome.

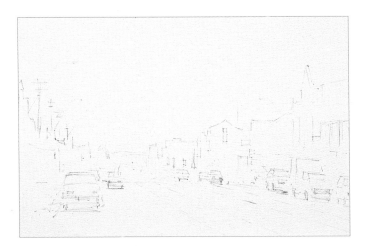

2 DRAW IN AN OUTLINE
The subject is now drawn in. Notice it is only left as an outline so as not to crowd it with fussy, unnecessary details too early.

3 BEGIN BUILDING GOLDEN COLORS
The warm sky of evening must be emphasized early with flowing golden colors on a wet surface with quinacridone gold and cadmium orange. A hint of French ultramarine blue is allowed to drift into the gold color from the top.

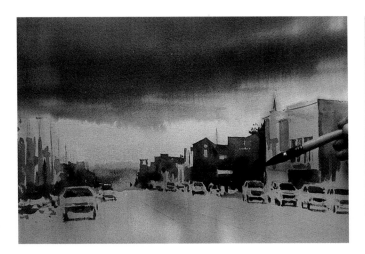

6 ADD BUILDINGS AND CARS
Now the background has been established and sets the scene. The buildings, cars and additional features are executed using brown madder, burnt sienna, French ultramarine blue, and cadmium orange mixed on the paper. This time, of course, there is a strong impacting effect from the hard outline of the buildings against a more flowing sky.

7 GLAZE IN THE SHADOWS AND FINISH WITH THE FINAL DETAILS
Glazes are added to the shadow sides of the buildings and vehicles. (The clouds above have made this possible.) Using cool applications of French ultramarine blue, a little touch of magenta and thin amounts of burnt sienna allow the shadows to give form to the overall structure. Here and there you also see bright splashes of color, which are echoed throughout the entire painting.

Now all the final details and touches are added to highlight the differences between the sky and background. Overhead wires were drawn in with a rigger brush.

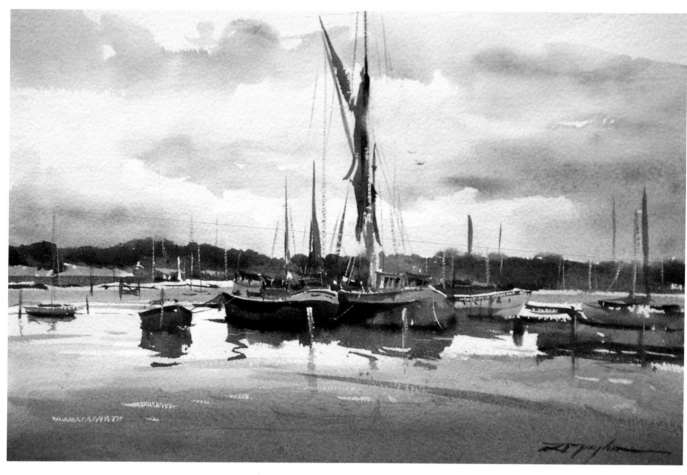

RAIN CLOUDS, PIN MILL, ESSEX, 14 x 10" (35 x 25cm), WATERCOLOR

TURNING POINT

My first turning point in painting watercolor was when I threw a painting into a corner of the room that had not quite worked.

A bucket of water had accidentally spilled across the background and I left it sitting there for quite a long time.

To my surprise some hours later, the water that had been lying there had transformed into a beautiful wetland of reeds, long grasses and rainy skies.

After so many months of trying to achieve that look, here an accident brought around the result and taught me one of the greatest lessons one could learn.

To this day, I say: Don't force it. Let it happen and see the beauty in the process.

FLEETING MOMENTS REQUIRE PLANNING AHEAD

Clouds don't stand still. The light will flicker a glowing radiance one moment, then turn dull gray the next. And the setting sun is often a mere six-minute interval. How do you capture that fleeting scene in watercolor? The key is planning ahead. Have your colors ready and in sufficient quantities. Be familiar with the sun's patterns in any season so that you can anticipate the flickering light.

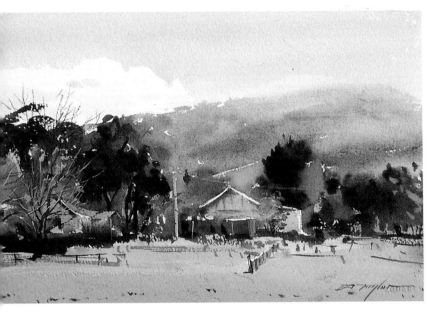

STRATHEWEN FARM, 10 x 14" (25 x 35cm), WATERCOLOR

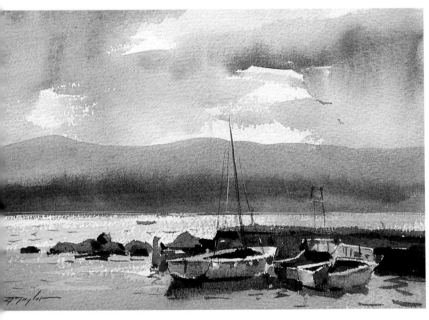

DRIFTING CLOUDS, BINALONG BAY, TASMANIA, 6 x 10" (16 x 26cm), WATERCOLOR

ABOUT THE ARTIST

Born in Melbourne, Australia, in 1941, David Taylor's early career began in etching. A six-year apprenticeship at the North Melbourne Printing School of Graphic Arts in color etching assisted his future as a painter.

David's painting career is built upon many years of studying the art of watercolor painting. He has been teaching his great love of this medium to painters both in Australia and overseas since the late Sixties.

Credit is often given by David to the inspiration he has received from the work of Monet, Turner, Sargent, Whistler and Homer, particularly in subjects that convey atmosphere, mood and feeling. David's advice and artwork regularly appear in the and magazines.

His numerous achievements include over 100 awards in watercolor. He won the prestigious Victorian Artists Society "Artist of the Year" award in 1976, 1980, and again in 1989. In 1989 he also received the Distinguished Leadership Award for outstanding services to watercolor and teaching from the International Directory of Distinguished Leadership, along with a certificate of merit for distinguished service to the community.

In April 2002 David received the Gold Medal and $20,000 prize for best painting at the Herald Sun Camberwell Rotary Exhibition in Australia, an exhibition where some 3,000 works were entered for competition.

His works are represented in numerous public and private collections worldwide.

David regularly exhibits in Australia, the United States, and in England and the Channel Islands. He has held regular one-man shows of his work since 1975.

LOIS SALMON TOOLE BUILDS VIBRANT SKIES FROM SMALL BEGINNINGS

By experimenting with miniature paintings first, you can solve many of your color choices and compositional challenges.

To me there is nothing more thrilling and visually stimulating than watching a spectacular sunset over the ocean (on the Oregon coast, for instance), from a Hawaiian beach, or the sensational glory from the top of Cadillac Mountain on Desert Island, Maine. O.K., a sunset at the Grand Canyon is pretty special, too. Of course, skies of an impending storm are pretty dramatic, even frightening considering their potential. Then there are soothing skies that calm the senses. Photographers set up their tripods to catch each fleeting moment. My satisfaction is trying to translate these sensations into a watercolor painting.

I frequently create miniature paintings to use as studies for larger work.

That way I can experiment with an approach on a small scale and hope it works when I stretch it out. Each might require a different approach. In one set, I might use masking on the highlights or the sun. Others might require a lot of wet-into-wet and layering color on color. Some are achieved by a mix of wet-into-wet and wet-on-dry techniques.

I almost never use a tiny brush, except to sign my name. You need brushes large enough to hold an adequate amount of paint – but with a good point!

There are certain things you can do to gain a new perspective as you progress on a painting. Look at it in a mirror. You'll catch a lot of mistakes. (Whew, I didn't see that the building is leaning!) Turn the painting upside down or sideways. Look at the painting in semi-darkness to get a value study.

I have learned to try not to panic at the initial "mess" I have created. I tell myself it is only an abstract lay-in, the beginning. When finished, give the painting a chance to "rest." If something keeps drawing your attention, it is probably wrong. Change it.

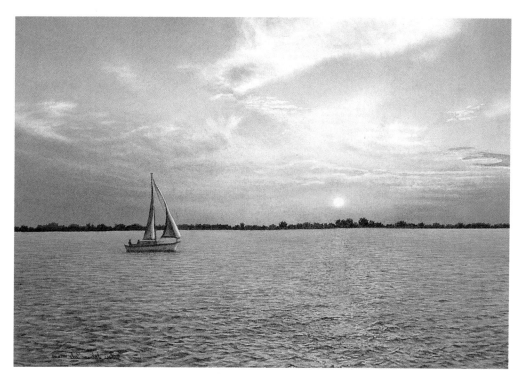

SOUTHERN SKY, 13½ x 21" (34 x 53cm), WATERCOLOR
This was a commissioned painting with wonderful reflections and a deceptively simple sky. The sun and the horizon were dead center in the resource material. There was no sailboat. I did two miniatures to experiment with the positioning of the elements, while trying to maintain the essential integrity of the desired Florida sunset. With the art collectors' permission, I introduced a sailboat to balance the sun and form a secondary focal point. This sky was tricky to do, not at all simple.

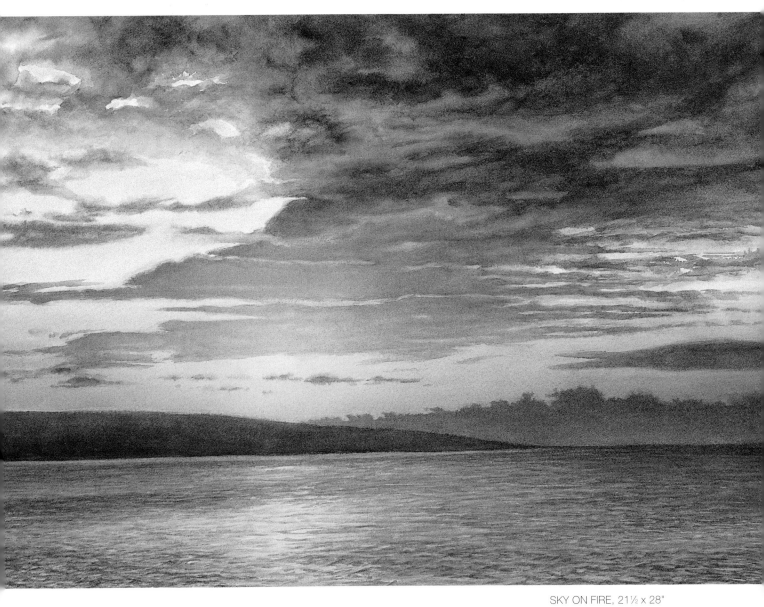

SKY ON FIRE, 21½ x 28"
(55 x 71cm), WATERCOLOR

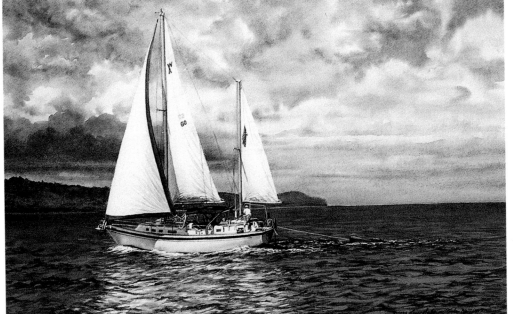

SUNSET SAIL, 13½ x 21"
(34 x 53cm), WATERCOLOR
This commissioned painting shows
the Caribbean Sea with the client's
boat in full sail ahead of gathering
storm clouds. Blues are dappled
onto damp white paper, creating the
fluffy shapes of cumulus clouds.
The pinks, yellows, and blue-grays
are charged into the white shapes.
The white sails stand out against
the darkening clouds and the
shaded land mass.

ART IN THE MAKING CREATING A DANCE ON THE SUN

I try to keep in mind the properties of the paint – transparent, opaque, and stainers – and which would be more likely to produce a grainy effect, such as cobalt blue and French ultramarine blue.

I rarely use undiluted paint at the beginning. I can always apply more paint to increase the intensity. But trying to lighten certain colors, particularly if they are stainers, can be quite a task. That is where a bristle brush comes in handy. I like to do misty skies with a glow that suggests lifting fog, like those I experienced in my New Jersey coastal hometown. I learned that if I started with an all-over wash of yellow ochre, an opaque that sits on top of the paper, I could easily lift whatever colors I painted over it.

WHAT THE ARTIST USED

Support
300lb cold press rag paper, soaked, and stapled to a board; edges taped to form a border

Brushes
3", 1½" Hake brushes
½", 1" Flat
½" Bristle brush
#6, #8 Rounds

Other Materials
Paper towels

Masking fluid (with soap and synthetic gum eraser)
Hair dryer
Hand mirror

Colors
Aureolin
Cadmium Red
Cobalt Blue
French Ultramarine Blue
Antwerp Blue
Burnt Sienna
Cadmium Orange

1 MINIATURE STUDY, GENERAL LAYOUT AND MASKING
I began with a miniature study: a lyrical, slightly provocative arrangement of cloud shapes trying to block the setting sun over Hawaii, with the sun defiantly sending its rays out from behind in every direction.

With my miniature as a guide, I establish the horizon line, draw an imaginary sun about 2/3 down and 2/5 from the left, and sketch in the cloud formations and the direction of the sun's rays. With masking fluid on a soapy brush (which I reserve for that purpose and frequently rinse), I mask highlights on the clouds and the brightest area where the rays emanate from the hidden sun. I'll be working wet-into-wet and applying several washes on wet and re-wet paper. I like my clouds to have soft edges and subtle gradations. Because watercolor doesn't always behave, you can pick up wandering edges on a damp brush or tissue. A hair dryer can hasten the drying process.

4 ADD THE CONTRARIANS: THE BALKY BLUES
Now the tricky part begins. I mix a cobalt blue puddle. After re-wetting the paper, I again use the soft 1½" hake brush to stroke blue from the top and sides toward the sun area. This is risky because cobalt blue is grainy and separates, especially on an opaque like cadmium red. As I suspected, it dried streaky and grainy. I will have to play with it to mellow the edges, soften some rays, and enhance others. For this, I use diluted Antwerp blue and French ultramarine blue, a stronger blue, wetting just those areas I wish to change. Then I turn the painting upside down to gain a new perspective and add more blue to the upper sky. Hopefully, this has been the trickiest part of the painting.

5 THE FUN PART: THE CLOUDS
It's time to start erasing the masking fluid. Sometimes masking can create more problems than it solves, because by now the edges around it are hard. So first, I'll try to soften those edges with my bristle brush before I erase. In a large dish I stir a puddle of French ultramarine blue and put a dab of cobalt blue and another of burnt sienna on the side. This way I can draw a little burnt sienna into the ultramarine blue for the darkest clouds. By now the paper has been re-wet several times, so I'll wet only the areas where I plan to put the denser cloud forms. For my "dancing shapes," I'll use my ½" flat brush and, for the first time, my #6 and #8 rounds for the fleeting edges. I add some cadmium orange and cadmium red to the cloud highlights, as well as to the lower sky. With my #8 round I'll tap in the fluffy upper clouds on barely damp paper. If it's too wet, the paint will bleed and spread all over. As it is, I have to tame some edges with a damp brush and tissue.

2 START WITH THE SUN GLOW

With a 3" hake brush I wet the entire sky down into the water. With the 1¹/₂" hake I stroke moderately-diluted aureolin from the sun area, following the direction of the rays upward and outward and diminishing color as I go. When completely dry, I re-wet and apply a bit more aureolin to the brightest areas. Then I mask more cloud edges where aureolin melds into white.

3 INTRODUCE THE SPICY REDS

I re-wet the paper with the 3" hake brush. Dipping my smaller hake brush into a puddle of diluted cadmium red, I make long strokes, following the direction of the sun's rays and diminishing color toward the sunbright area and fading out toward the top. The heaviest dose of pigment is applied near the horizon. I keep the paper moist to prevent unintentional streaking. When dry, I mask the cloud edges I wished to remain pink.

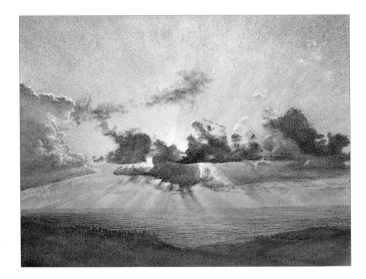

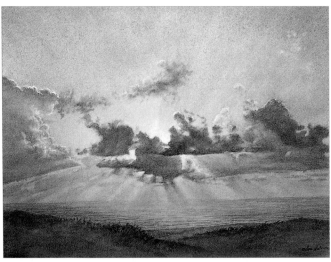

6 PAINT THE WATER AND LANDSCAPE

Using my 1" and ½" flats, I pick up the blues of the sky for the water ripples and wave action, keeping the sunray influence this time by working mostly on dry paper. Bear in mind that water reflects the sky. I decide to keep the illusion of those rays descending right into the water. I want the foreground landscape fairly continuous. I moisten that area so I can stroke moderately-diluted blues across it without creating hard edges. I want virtually no detail here to distract from the sky, just some suggestion of landscape. All along I have been checking my progress in my hand mirror.

7 REFINEMENTS AND CORRECTIONS

After viewing my slides and looking at values in semi-darkness, I see I need to darken the left and right sky areas, including the cloud forms, to heighten the dramatic contrasts. Again, I lightly re-wet these areas with care so as not to disturb the underlying paint. I see I definitely need to tone down and darken the too-blue distracting foreground to direct the eye to the sky. I use a burnt sienna glaze to gray down the blues to be compatible with the clouds. When I am satisfied with the sky, I use a damp brush and tissue to lift a few light, faint cloud forms in the upper sky.

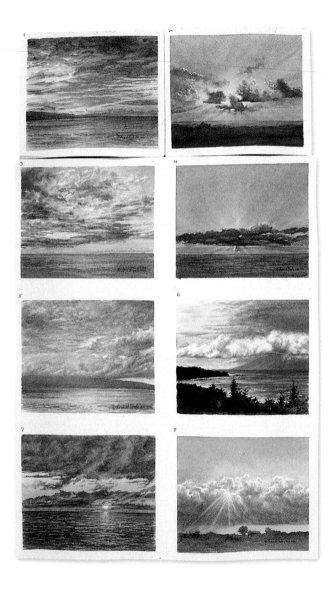

SKY MINIATURES

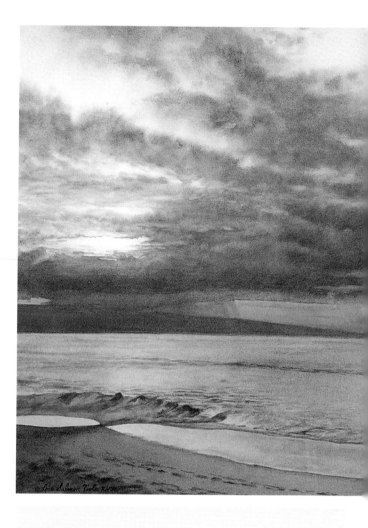

TURNING POINT

Definitely a most important turning point in my art career was my move to Ohio, a transitional state that was leading in the exploration of all forms of watermedia.

I saw there was infinitely more to watercolor than the classic approach I had been taught in college. That approach had been full of no-nos, shoulds, should nots, always, and nevers, such as: Never put wash over wash. It will become, heaven forbid, muddy!

Not fun, too intimidating.

I found my satisfaction in oils until my eyes were opened in Ohio to the joys of watercolor.

Another turning point was a question – a challenge, really – by a gallery owner to whom I showed my earliest watercolors. She said they were wonderful, worth the price I was asking, but, "Who are you?"

That's when I realized that to be credible I needed to establish credits. So, with encouragement from my wonderful instructor, I began to enter shows. As one success led to another, and as I built up confidence, I began to think, "Maybe I can do this after all." This is why to anyone who has had to take a hiatus from creating their art, music, writing, or whatever, I say, "Don't be afraid to leap back in. You haven't lost it."

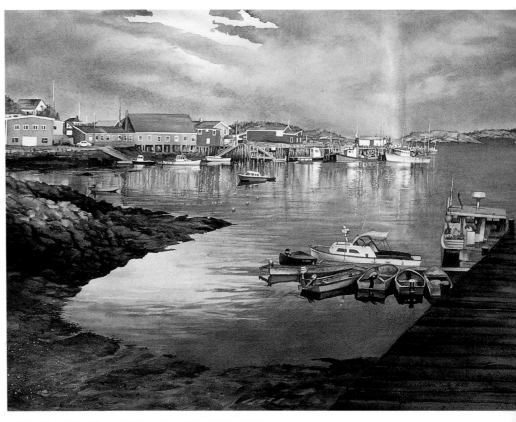

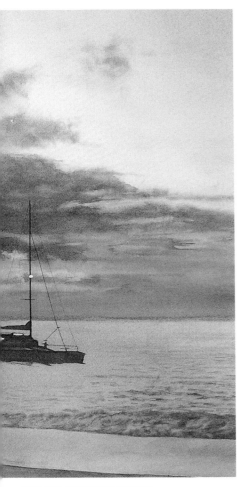

SPOT O' GOLD, 20 x 28" (51 x 71cm), WATERCOLOR
This breathtaking aftermath of a shower over Stonington, Maine, is from one of my favorite places. It shows how the brightening sky and double rainbows illuminate the docks, islands, and water to focus finally on the white boat. The shaded mudflat and foreground lead the eye to the sunlit area. It was full of wonderful contrasts.

NIGHTSHADES OVER MAUI,
20 x 28" (51 x 71cm)

ABOUT THE ARTIST

Lois Salmon Toole received her B.A. in fine art from Douglass College, Rutgers University. After a short career in advertising display, she became an Army wife, then a corporate wife. Her art career was put on hold while she raised two young sons and managed through seven corporate moves in 15 years. It was not until her last move to Ohio, where watercolor painting was burgeoning, that she gathered the courage in 1976 to take a course in that daunting medium. Thus began a love affair with transparent watercolor.

With encouragement, in 1977 she exhibited in her first local juried show, and with trepidation, entered and was accepted in her first national show. Since then she has exhibited in 375 national juried exhibitions, receiving 115 awards and election to signature membership in 17 art organizations, including the National Watercolor Society, Rocky Mountain National Watermedia Society, Allied Artists of America, American Society of Marine Artists, National Association of Women Artists, Transparent Watercolor Society of America, the watercolor societies of New Jersey, Kentucky, and Ohio, and Miniature Artists of America.

Her work has been featured in numerous books and magazines. Her work also is in private and corporate collections all over the world.

Though her career plans never included classroom teaching, she has done some private teaching, demos, and jurying. For 15 years she was the coordinator of the Chagrin Valley Chamber of Commerce Art in the Park, helped found a local gallery, served on the board of the Valley Art Center, and is currently on their advisory board. She has received two commendations from the State of Ohio for her contributions to the arts.

PIERRE TOUGAS SHOWS HOW TO CAPTURE THE

By balancing shape, color, tonal value, and edges, you can create individual cloud effects for a more realistic painting.

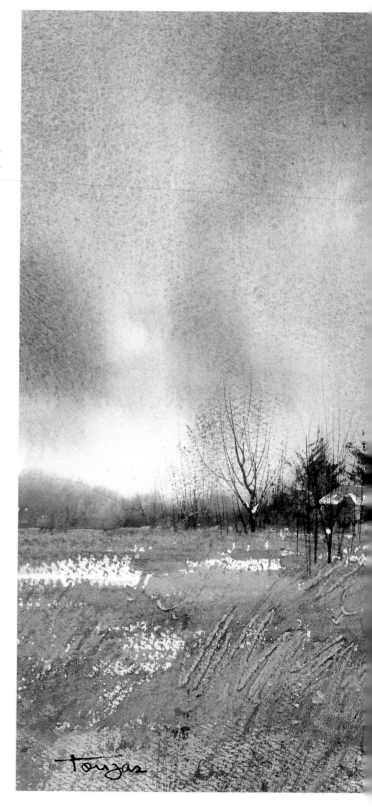

Considering the sky as a source of light, the energy and the key to the landscape, it is paramount for artists to have a minimum of respect for it. As far as I can remember, the beauty, the personality and the individuality of skies have always impressed me.

In 1992 I saw a retrospective of the French artist, Eugène Boudin, in Honfleur and realized how this master impressed me by the great diversity of his skies.

Different seasonal conditions should trigger the imagination of a serious artist and stimulate one to paint the great variety of clouds that we find in the atmosphere.

My approach to painting skies in watercolor is based on four vital elements: design principles of shape, colors, tonal values and edges. With its gentle effects, watercolor is a perfect medium for creating skies of all types. The handling of washes, the control of sharp and soft edges, and the juxtaposition of warm and cool colors are all important elements to painting a successful sky.

The artist should consider that a cloud is like the different shapes and sizes of cylinders floating in the atmosphere, being pushed away by the wind... always in movement! You have to give them a certain rhythmic quality and character, and finally integrate a personality of your own.

Sometimes it is valuable to push yourself to practice rearranging a sky. Make a careful observation, experiment by drawing, reinforce the design, get the softness of the clouds, and give them their individual shape.

To obtain good results when you paint skies in watercolor, you should paint the lower values first, the middle and the darkest ones at the end. Sometimes, it is worth painting the same sky many times merely for the sake of practice.

The last important aspect to cover is to reach a certain harmony in your sky with the rest of the painting to get a unified whole.

In conclusion, give your sky a personality and make it the expression of your personal vision.

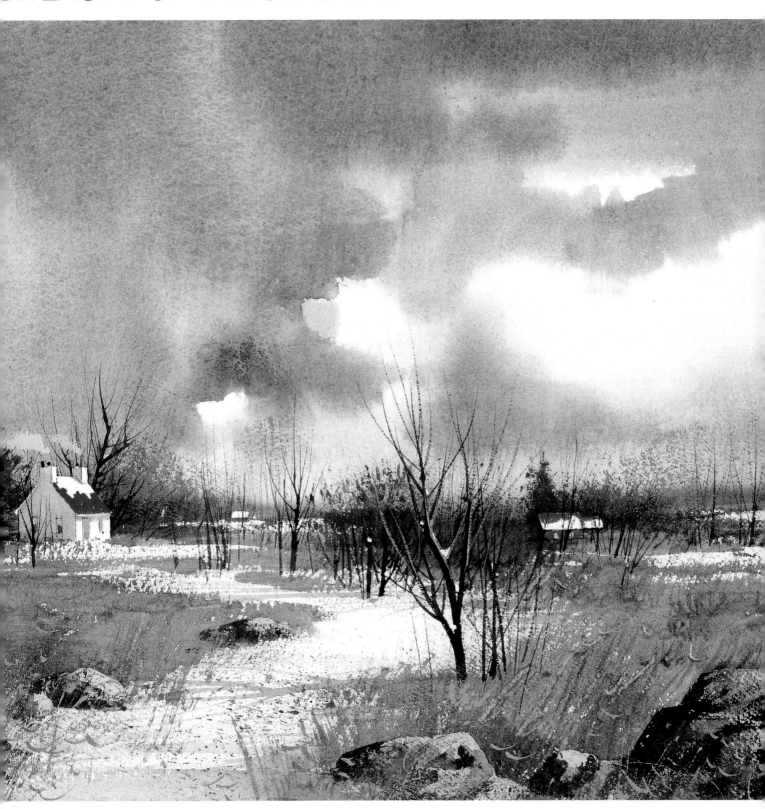

COMING STORM, 12 x 20", (30 x 51cm) WATERCOLOR

ART IN THE MAKING A GOOD DRAWING ENSURES A BETTER PAINTING

WHAT THE ARTIST USED

Support
Arches 300lb rough
watercolor paper

Brushes
#3, #6, #9 Round Red Sable
#14 Round White Sable
1", 2" Flat Red Sable
#3 Rigger Red Sable
#4 Fan

Other Materials
HB pencil
Masking fluid
Masking tape 1" wide
John Pike palette
Fresh water

Colors

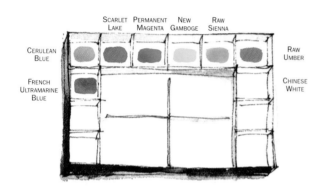

SCARLET LAKE · PERMANENT MAGENTA · NEW GAMBOGE · RAW SIENNA

CERULEAN BLUE

FRENCH ULTRAMARINE BLUE

RAW UMBER

CHINESE WHITE

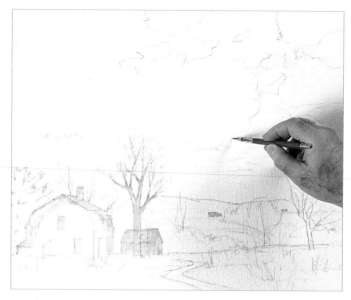

1 BEGIN WITH AN ACCURATE DRAWING
Drawing is important for all forms of art and is definitely crucial for the watercolorist. On a 16 x 20" (41 x 51cm) sheet of rough watercolor paper, I do an accurate drawing of my subject with an HB pencil. Once this is done, I use masking fluid for blocking off the white house on the left, the tree, the barn and a few roofs in the distance. Now, I get enough information to start using color.

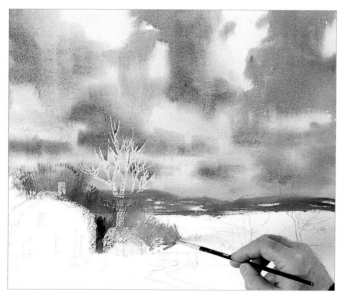

4 SUGGET THE ILLUSION OF DISTANCE
Considering that the sky had dried out, I use clear water to wet the lower part of the sky and introduce the distant mountains. With a #6 round brush, I mix cerulean blue and permanent magenta so that the edges at the top of the mountains are softened and, by the same token, depth is accentuated. Once this is finished, I use a fan brush for the trees and the shrubs at the back of the house. I use the dry-brush technique with raw sienna and burnt sienna for the lighter values and add French ultramarine blue to these colors for the darkest accents.

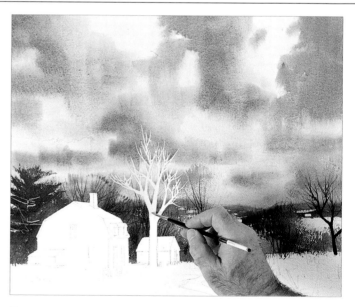

5 SWITCH TO DRY-BRUSH
Before removing the masking fluid on the house, I paint the pine tree on the left with French ultramarine blue and raw sienna. As the painting progresses, I use the fan brush on the right part of the field, using a fairly dry mixture of new gamboge, raw sienna, burnt sienna and French ultramarine blue. At this stage of the painting, the choice of paper allows me to get the desired effect. When the middle ground of the painting is done, using a #3 round brush, I start to paint the tree with a mixture of pure water and a bit of raw sienna for its lightest value.

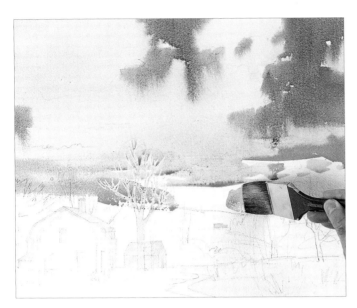

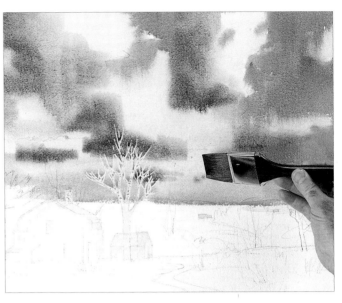

2 START WITH A WASH

With a 2" wide flat brush, I first lay down a wash of raw sienna, adding a bit of scarlet lake for the clouds. Before this has completely dried, I start to paint the sky at the top of the painting using French ultramarine blue and proceed to fade gradually towards the horizon line by smoothly adding cerulean blue.

3 CREATE THE SOFTNESS OF THE CLOUDS

For the shading, while the "peach" color of the clouds is still damp, I introduce a mixture of cerulean blue, raw umber and a touch of scarlet lake on the left side and underneath the clouds. It is important to ensure a smooth transition in this process. Here, the free movement of the clouds provides a certain consistency of character to create the mood in the future stages of the painting. Essentially, the sky is painted quickly in a continuous and spontaneous movement.

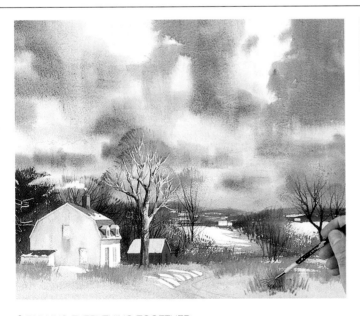

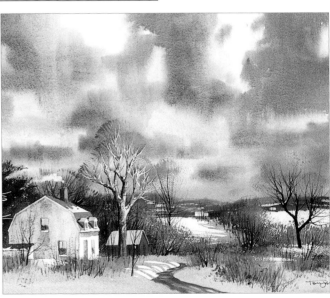

6 PULLING EVERYTHING TOGETHER

With a mixture of cerulean blue and permanent magenta, I apply a light wash to create the shadows of the shrubs in the distance, and cover the foreground, leaving some white spots for the highlights in the snow. The same mixture is used for the shadows of the white house, with the exception of a touch of added raw sienna. The little red barn is painted with scarlet lake and a bit of new gamboge. The complementary color, French ultramarine blue, is used to create the shadows. I paint the dark tree on the right with the aid of a #3 rigger brush, using French ultramarine blue and burnt sienna. In order to create atmosphere, I use Chinese white and a touch of cerulean blue for the smoke coming out of the chimney. The fan brush is used to apply raw sienna on top of the trees and on the bushes in the foreground area.

7 FINISHING OFF

I remove the masking fluid left in the windows of the white house and paint the reflected light with a pale cerulean blue, which is a lighter value than the shading side of the house. I paint a few shrubs in front of the house and the footpath is done using cerulean blue and raw umber with a #9 round brush. For the final touch, I apply pure Chinese white with a #3 round brush to depict the snow accumulated in the forks of the trees. "Morning Light" is then complete.

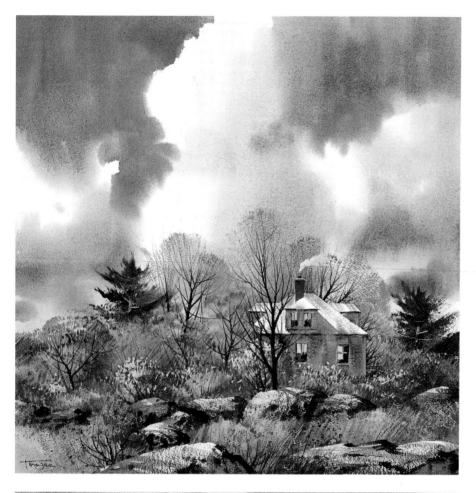

FALL ON THE EAST COAST, 17 x 17"
(43 x 43cm), WATERCOLOR

This subject inspired me with the quality of its light and the softness of the clouds.

Here we can observe the contrast of a cool sky and the warm colors of autumn in the foreground. These turbulent clouds were moving very fast, probably pushed away by a wind from the sea. Really stunning!

The warm white of the clouds was made with a touch of raw sienna diluted with plenty of water. French ultramarine blue and cerulean blue were applied at the top of the sky, whereas a light wash of cerulean blue was used near the horizon. Before this stage was completely dry, I painted the shading under the clouds with French ultramarine blue, raw umber and burnt sienna. The idea when painting skies is to let the shapes connect as they melt one into another.

To paint glorious skies, try to compose your own grays. Then you will discover good vibrations in your watercolors.

(RIGHT) SUMMER SKY,
12 x 16", (30 x 41cm) WATERCOLOR

Movement is definitely the most important aspect of this painting. The big cumulus clouds and even the flowers in the foreground seem to bring the viewer's eye towards the horizon. In the distance, we can observe a smooth transition between the land and the sky.

The upper part of the sky was painted on a damp paper using an intense French ultramarine blue, while downgrading to a diluted cerulean blue near the horizon. Because of the greenish fields bouncing in the air, the shady parts of the clouds were painted with a mixture of warm grays made of cerulean blue, raw sienna and a touch of scarlet lake. In the composition of the clouds, broken edges create an interesting variety for the light and shadows. It's a small watercolor with a lot of character.

TURNING POINT

At the age of 17, when I was a student at the Art Academy in Montreal, the teacher showed us a short film by the American artist, Eliot O'Hara, painting a marine scene in watercolor. It was a shock! To see the colors flow into the water was very exciting for the apprentice artist that I was. The subtlety of the colors and the rapidity of execution with that medium was a revelation.

Since that day, I have painted in watercolor with perseverance, enthusiasm, and great respect for the medium – and have never looked back.

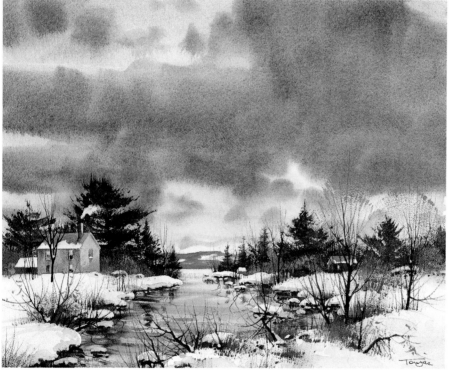

LATE AFTERNOON, 16 x 20", (41 x 51cm) WATERCOLOR

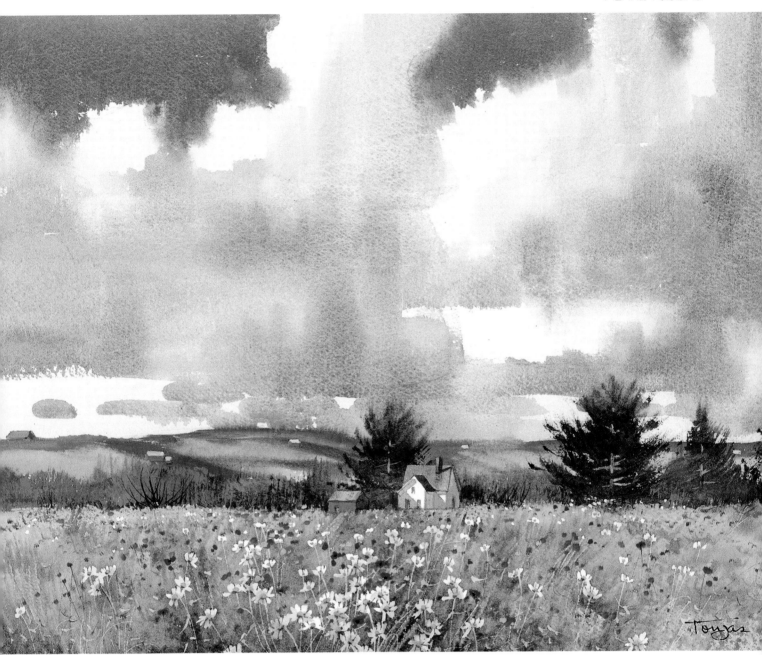

ABOUT THE ARTIST

Pierre Tougas was born in 1949 in Saint-Jean-sur-Richelieu, Québec, Canada.

He studied fine arts at the Canadian Art Academy from 1965 to 1968 in Montreal. A professional artist since 1982, he co-founded the Société Canadienne de l'Aquarelle (SCA) in Montreal. In order to acquire further knowledge, he studied watercolor with Don Stone in 1979 and with Tom Nicholas in 1989.

He has held over 25 solo exhibitions and many group shows across Canada. Pierre has painted in Canada, the United States, Mexico, France, Italy and Spain. In 1996, he became a full member of the Canadian Society of Painters in Watercolour (CSPWC) in Toronto.

Two major retrospectives of his work have been held in Canadian museums (Ramezay Museum in Montreal in 2002, and Laurier Museum in Arthabaska in 1998).

In the last few years, he has won two gold medals and many top honors for his watercolors. His work has been published in two books: Signatures and L'eau et la lumière.

His work is displayed in private and corporate collections in Canada, the United States and Europe.

Pierre is represented by the Clarence Gagnon Gallery, Montreal; Au P'tit Bonheur Gallery, La Malbaie; Archambault Gallery, Lavaltrie; and the Richard Hevey Gallery, Sainte-Adèle.

MANUS WALSH CREATES A RHYTHM OF SKY, LAND

By seeing the skies as ready-made abstractions, you can feel freer to let the watercolor change as it crosses the page.

I live in a unique area of the West of Ireland called The Burren, or "rocky place." Here the skies are constantly changing, sometimes dramatic, at other times tranquil. They are already abstractions, so I tend to work with them in this way.

I let the brush and pigment shift and change as they cross the page. I never sketch an outline first, but rather let the colors and shapes take me where they will, relying on the experience of my many walks and cycles through the landscape to give me the "ingredients" for the work.

Using the wet-on-wet technique, I love the soft, radiating effects I get. The colors merge and change, just like the skies. I can see it and make it happen by giving my imagination full rein, using a light touch and allowing for spontaneity.

Of course, with watercolor, one can go too far and quickly! Never mind. With experience, there will be fewer and fewer "failures." I always remember that there is plenty of paper and paint out there anyway. I never give up.

One can always recycle by over-painting with acrylic.

With today's papers and paints, there is such great potential for trying new colors and finding your own technique just by letting yourself go.

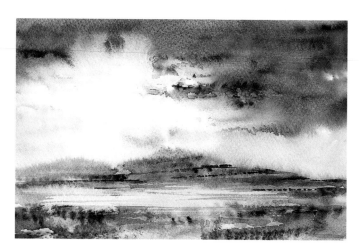

PASSING SHOWERS, BURREN, 16 x 12" (40 x 31cm), WATERCOLOR

TURNING POINT

My turning point came quite early on in my career, after meeting the Irish painter, George Campbell.

He encouraged me to take up painting and invited me to spend some months with him in Spain. It was a hugely formative time for me as a young man of 25. He gave me great help and encouragement until I was up and running as a full-time painter.

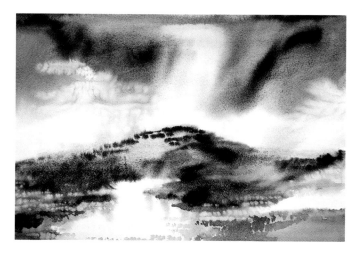

MOVING SKY, BURREN, 22 x 15" (56 x 38cm)

AND WATER

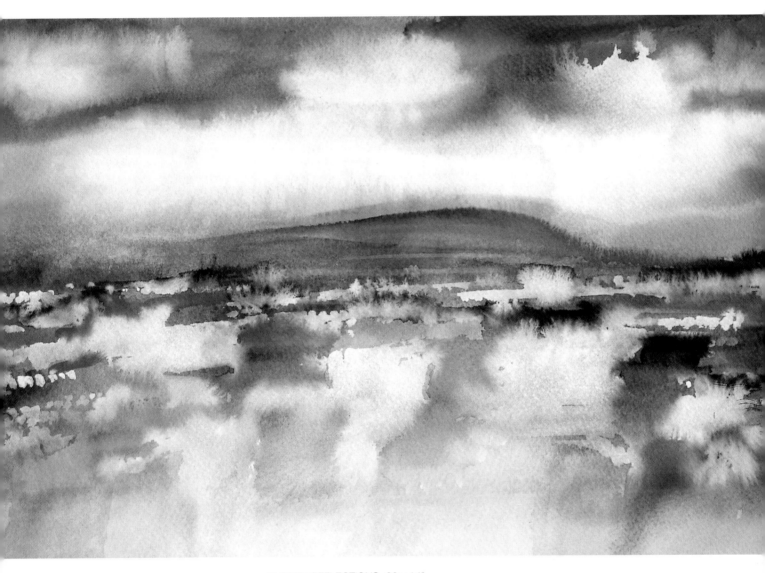

BURREN REFLECTIONS, 20 x 14",
(51 x 36cm) WATERCOLOR
On top of ultramarine blue, neutral tint, and
some yellow ochre, I apply a heavier use of
white gouache to give a stronger "floating" feel
while the paper is still very wet.

ART IN THE MAKING

LEARN TO BUILD SHAPES WHILE WORKING WET-ON-WET

A part from a few touches at the end, this demonstration painting was all done with the wet-on-wet technique as I gradually built up the tonal values and allowed the pigment to almost make its own abstract shapes.

 As you proceed through these steps, keep in mind that you have to be very delicate with re-wetting paper.

WHAT THE ARTIST USED

Support
Guarro Spanish 300gsm watercolor paper, gummed on one side

Brushes
1" Flat Sable
#10 Round Sable

Other Materials
Paper towels

Colors

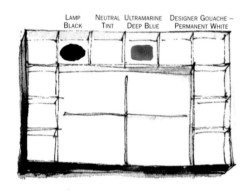

LAMP BLACK NEUTRAL TINT ULTRAMARINE DEEP BLUE DESIGNER GOUACHE – PERMANENT WHITE

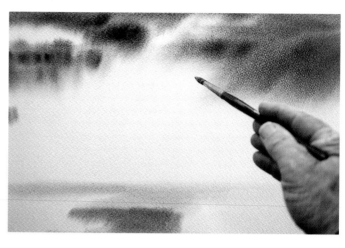

1 USE LIGHT WASHES IN AN ABSTRACT MANNER
Using well-soaked paper for this wet-on-wet process, I start with very light ultramarine blue and gradually strengthen the pigment at each stage. With my #10 round brush, I lightly wash random areas in an abstract manner. Let your brush have free rein across the page; I almost let things happen in front of me. I tilt the paper to spread pigment in whatever way I wish.

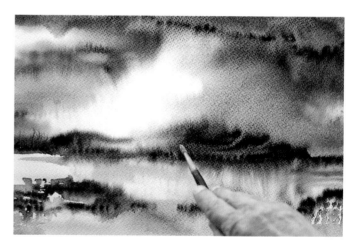

4 BUILD UP THE SHAPES
I strengthen the colors and shapes even more during this wet-on-wet phase, allowing the brush to follow the shapes of the clouds and other forms with a light touch.

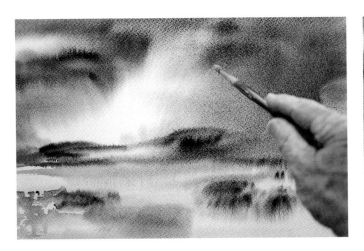

2 ADD SPONTANEOUS, QUICK STROKES
Using the same brush (and still working wet-on-wet until the final stage), I make quick strokes with a light pigment of lamp back in a spontaneous way. This gives a marvelous radiating effect. (You can first try it on test paper.) Here, I lightly brush in hill and water forms also.

3 CREATE EFFECTS THROUGH "SPOTTING"
While still working wet-on-wet, I work on judicious strengthening with lamp black, neutral tint (for hills and rocks) and ultramarine deep, using quick "spotting" strokes for effects.

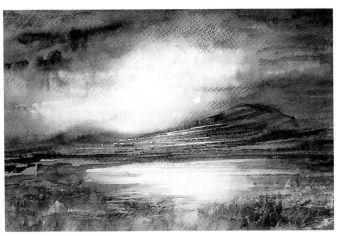

5 USE GOUACHE TO CREATE RADIATING EFFECTS
Here I introduce little spots of designer white gouache. This acts like the lamp black, radiating out from the center. This is an optional extra, but useful for night effects.

6 STRENGTHEN THE COLOR AND ADD THE MOON
Finally, I strengthen all areas to my taste. With the same limited palette, I "spotted" with lamp black and neutral tint on almost-dry paper, and added the moon with white gouache.

FALLING SKY, BURREN,
20 x 18", (51 x 46cm)
WATERCOLOR
I painted with a much heavier use
of watercolor pigment (and white
gouache) here to give really strong
rhythms of sky, mountains and
stone walls. It would be very easy
to go too far.

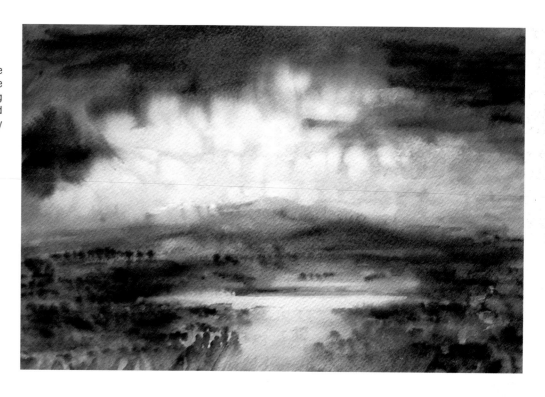

NIGHT FALLS, BURREN,
16 x 18", (41 x 46cm)
WATERCOLOR
Again I use ultramarine deep blue, a
touch of cerulean blue at the edges,
lamp black, neutral tint, and final
touches with white gouache.

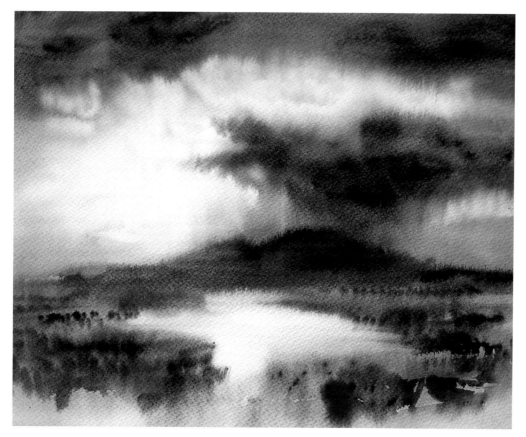

ABOUT THE ARTIST

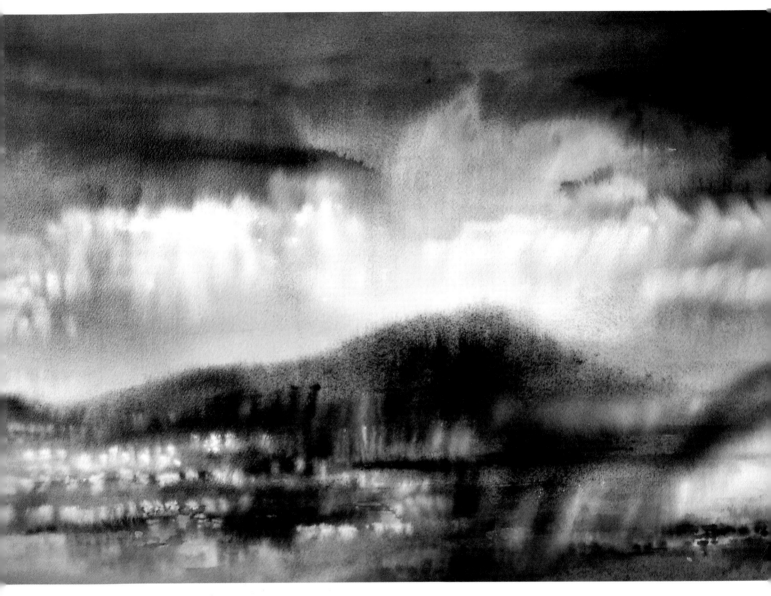

BURREN DUSK, 22 x 15" (56 x 38cm)

Manus Walsh was born in Dublin in 1940. His first job was as an apprentice in the famous Abbey Stained Glass Studios. (He has five windows in Galway Cathedral from that period of his career.) It was there that he met George Campbell, who encouraged him to take up painting full time. George also gave Manus a lifelong interest in things Spanish, having spent some very formative months there with him.

After a move to Ballyvaughan in 1976 with his wife Claire and the family, Manus set up a craft workshop and gallery in this small village on the shores of Galway Bay.

The dramatic and unique landscape of this area, the Burren, has had a profound effect on his life and work, Manus says.

In recent years, Manus has had the opportunity to spend time in Chile and Spain, where the change of color and light has inspired many new works in all media, both cityscape, as in Valparaiso, Chile, and the rich, earthy colors of Andalucia, Spain.

As an accomplished craftsman in enamel on copperwork, Manus also has created a number of works in this media.

To date, he has had about thirty solo shows, plus many group shows, four exhibitions in Chile, and one in Spain.

His work is in many private collections in France, Germany, Spain, USA, Canada, Chile, England and Italy.

His paintings are exhibited on a regular basis in the Kenny Gallery, Galway; Origin Gallery, Harcourt St., Dublin; and Kilcock Gallery, Kildare.